3000 800011 51761

St. Louis Community College

F-V

WITHDRAWN

St. Louis Community College

Library

5801 Wilson Avenue
St. Louis, Missouri 63110

D0938665

RICHARD LONG

RICHARD LONG

R.H. Fuchs

With 244 illustrations, 29 in color and 215 in duotone

Solomon R. Guggenheim Museum, New York

Thames and Hudson

Richard Long was most generous with his time, giving information
and providing criticism. I thank him for that.
I am also grateful for the kind help and assistance
of the Anthony d'Offay Gallery, especially
Judy Adam, Anne d'Offay and Anthony d'Offay.

R.H.F.

Pages 6-7: *River Avon Mud Drawing* 1986

Any copy of this book issued by the publisher as a paperback
is sold subject to the condition that it shall not
by way of trade or otherwise be lent, resold, hired out or
otherwise circulated without the publisher's prior consent
in any form of binding or cover other than that in which
it is published and without a similar condition including these
words being imposed on a subsequent purchaser.

© Thames and Hudson Ltd, London 1986
and The Solomon R. Guggenheim Foundation,
New York 1986
Illustrations © Richard Long 1986

First published in the United States in 1986 by
Thames and Hudson Inc., 500 Fifth Avenue,
New York, New York 10110

Library of Congress Catalog Card Number 86-50222

All Rights Reserved. No part of this publication
may be reproduced or transmitted in any form or by any means,
electronic or mechanical, including photocopy, recording or
any other information storage and retrieval system, without
prior permission in writing from the publisher.

Printed and bound in Japan by Dai Nippon

Contents

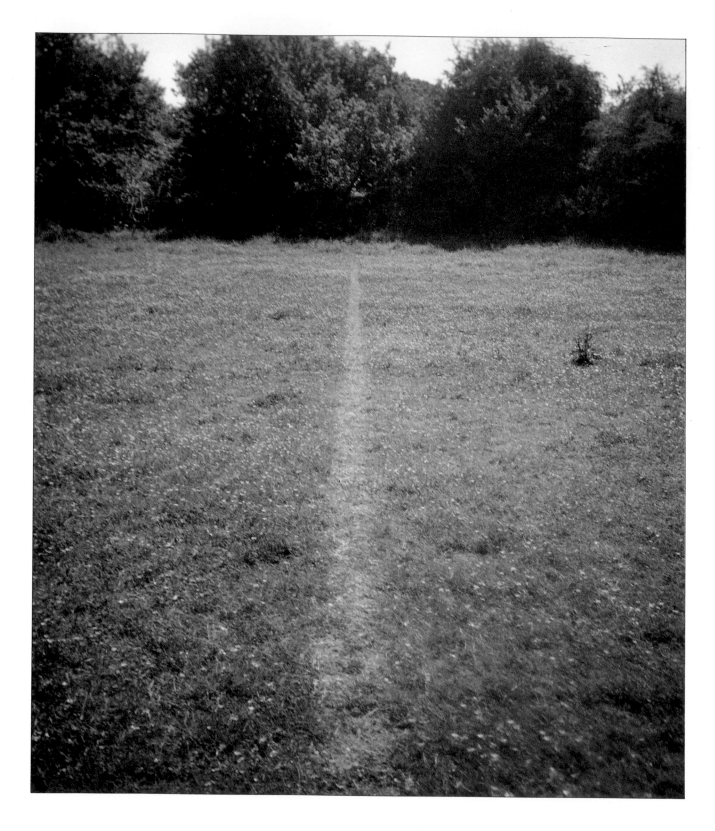

A LINE MADE BY WALKING

ENGLAND 1967

My art is in the nature of things

SNOWBALL TRACK

1964

A SCULPTURE IN BRISTOL

1965

AN IRISH HARBOUR

1966

A SQUARE OF GROUND

THE DOWNS BRISTOL 1966

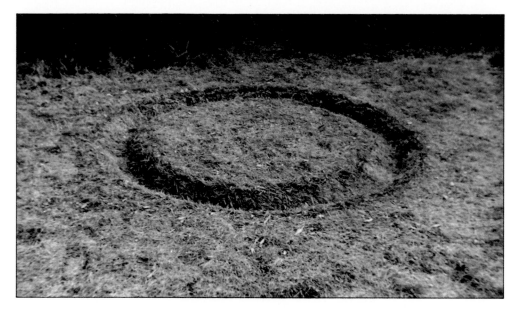

TURF CIRCLE

IRELAND 1967

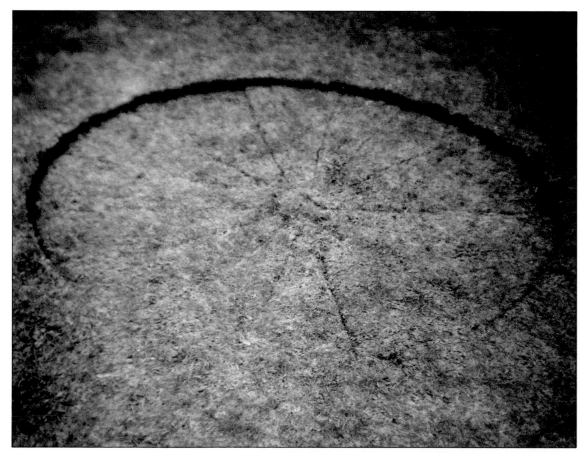

TURF CIRCLE

ENGLAND 1966

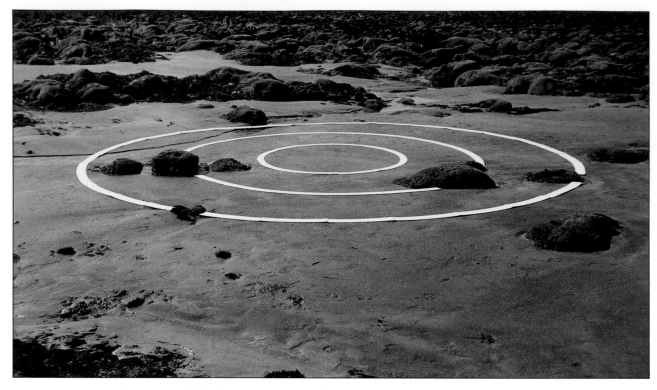

IRELAND

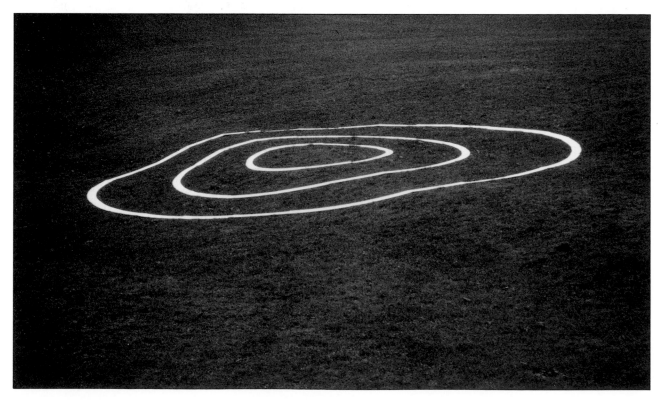

ENGLAND

1967

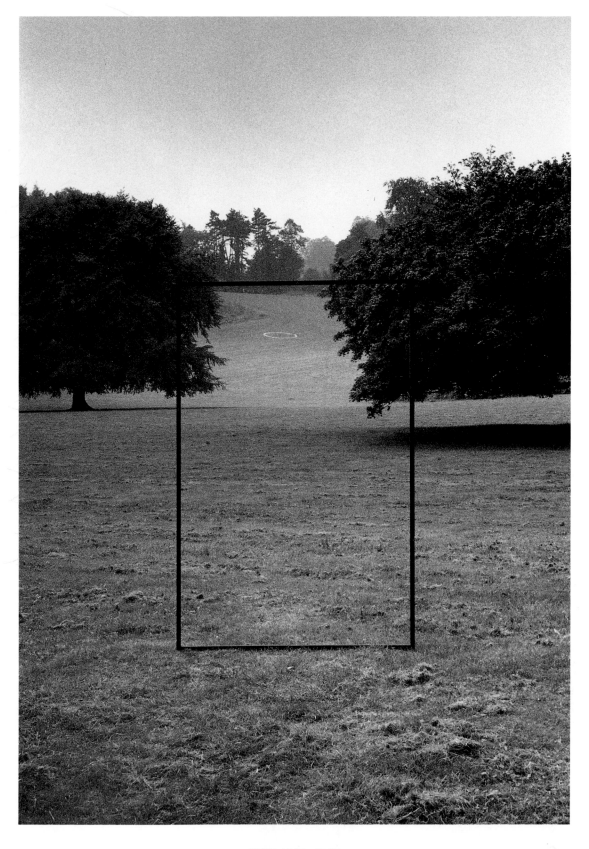

ENGLAND 1967

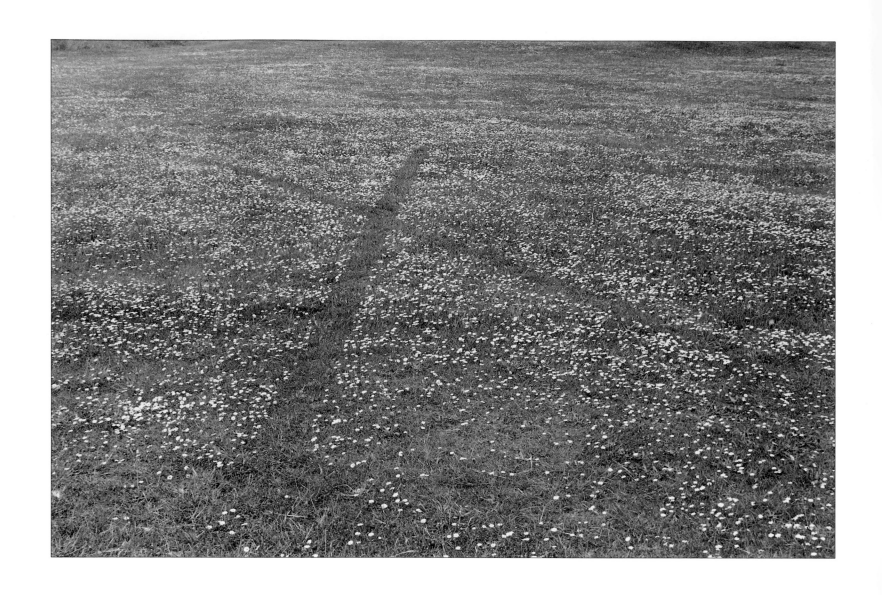

ENGLAND 1968

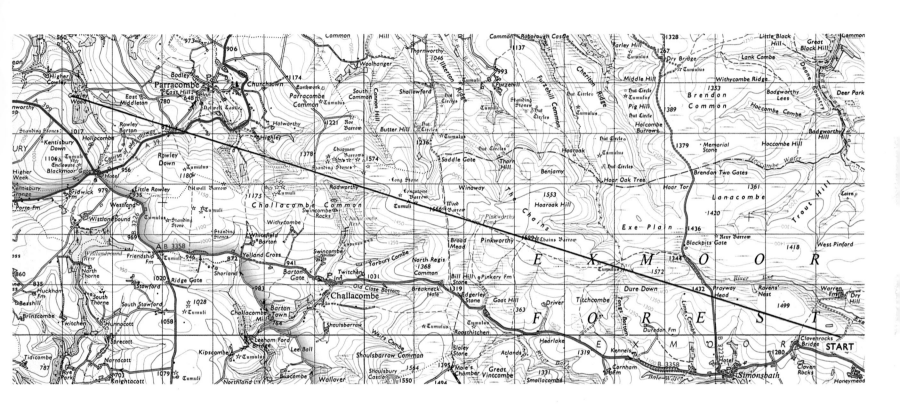

A TEN MILE WALK

ENGLAND 1968

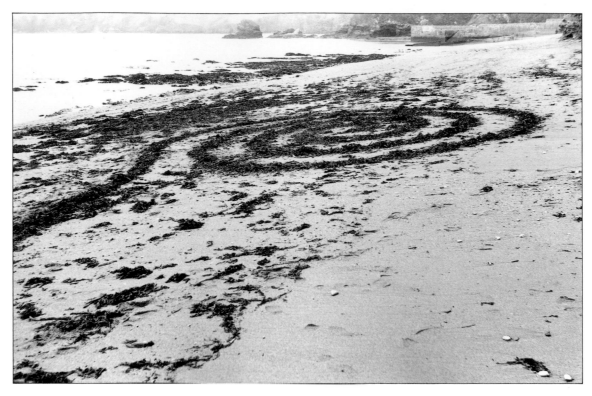

A SCULPTURE LEFT BY THE TIDE

CORNWALL ENGLAND 1970

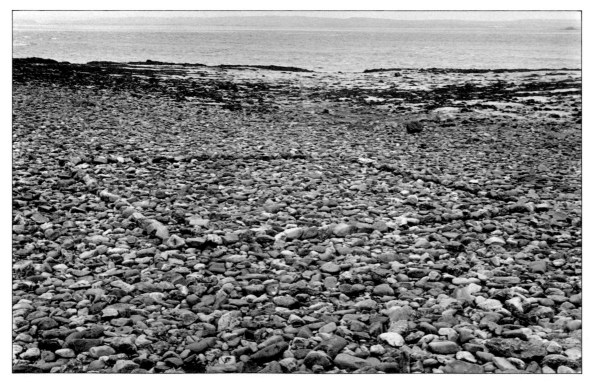

A SOMERSET BEACH

ENGLAND 1968

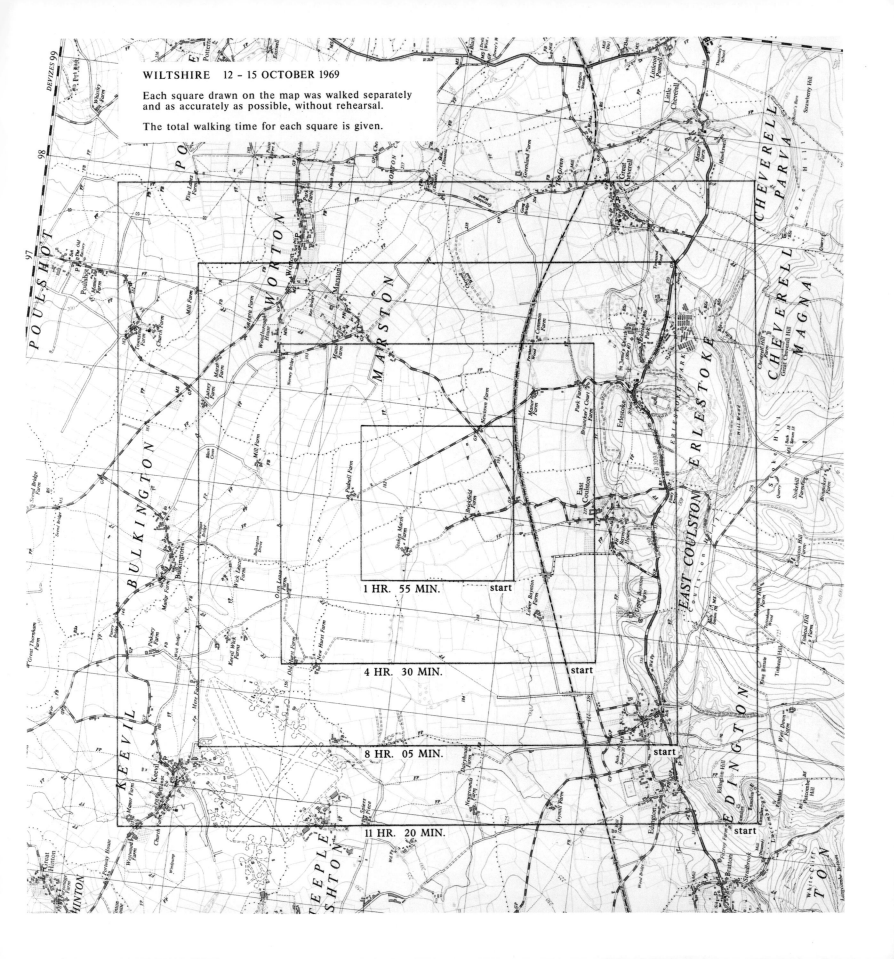

WILTSHIRE 12 – 15 OCTOBER 1969

Each square drawn on the map was walked separately
and as accurately as possible, without rehearsal.

The total walking time for each square is given.

1 HR. 55 MIN. start

4 HR. 30 MIN. start

8 HR. 05 MIN. start

11 HR. 20 MIN. start

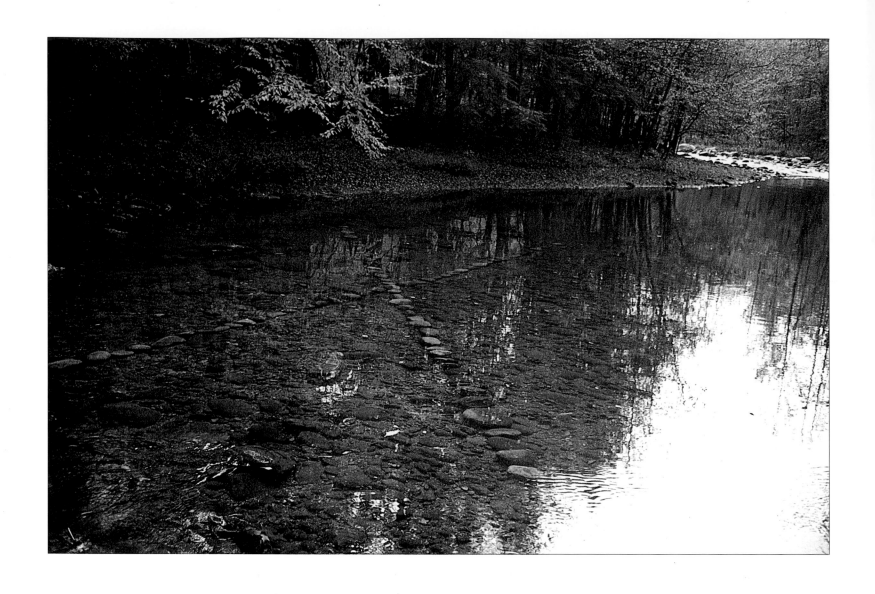

REFLECTIONS IN THE LITTLE PIGEON RIVER, GREAT SMOKEY MOUNTAINS, TENNESSEE.

1970

I keep a close watch on this heart of mine
I keep my eyes wide open all the time
I keep the ends out for the tie that binds
Because you're mine
I walk the line.

Johnny Cash

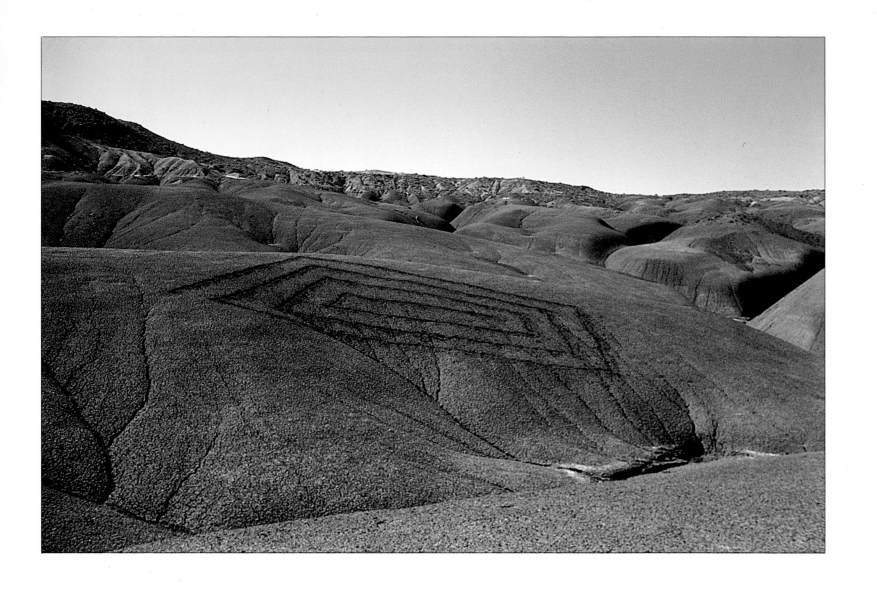

ARIZONA 1970

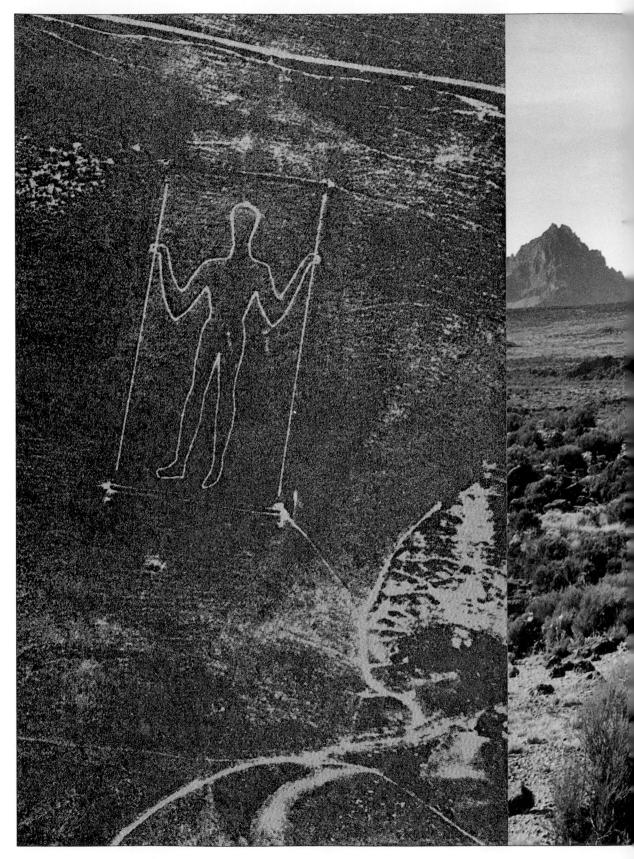

HILL FIGURE ENGLAND 600

CLIMBING MT. KILIMANJARO AFRICA 1969

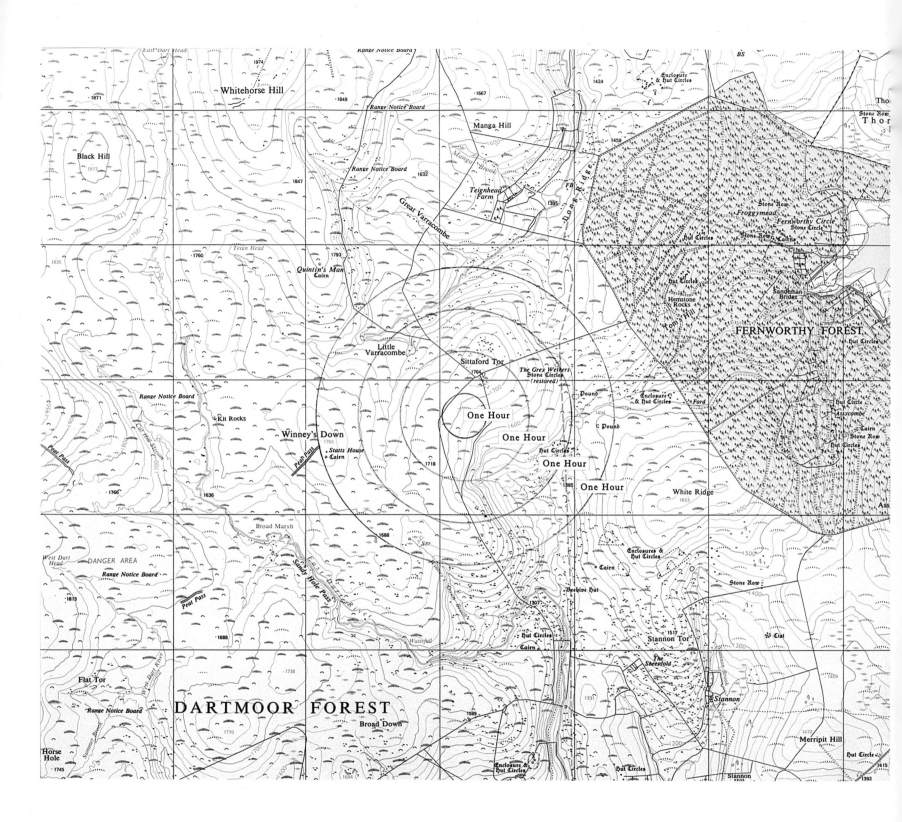

A WALK OF FOUR HOURS AND FOUR CIRCLES

ENGLAND 1972

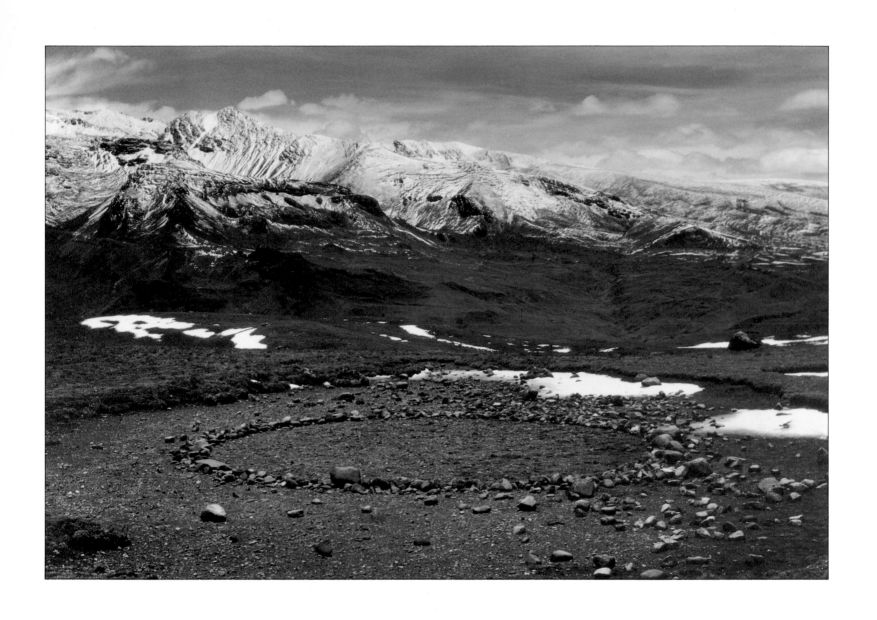

CIRCLE IN THE ANDES

1972

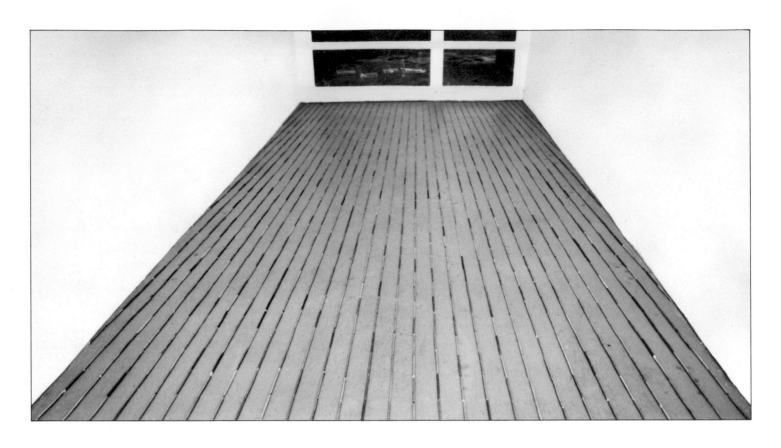

DÜSSELDORF 1968

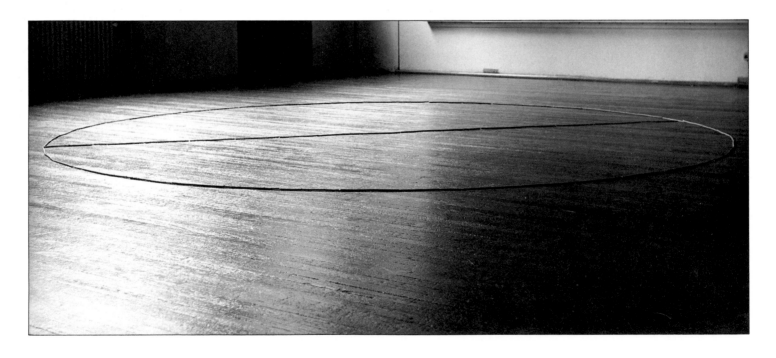

LONDON 1967

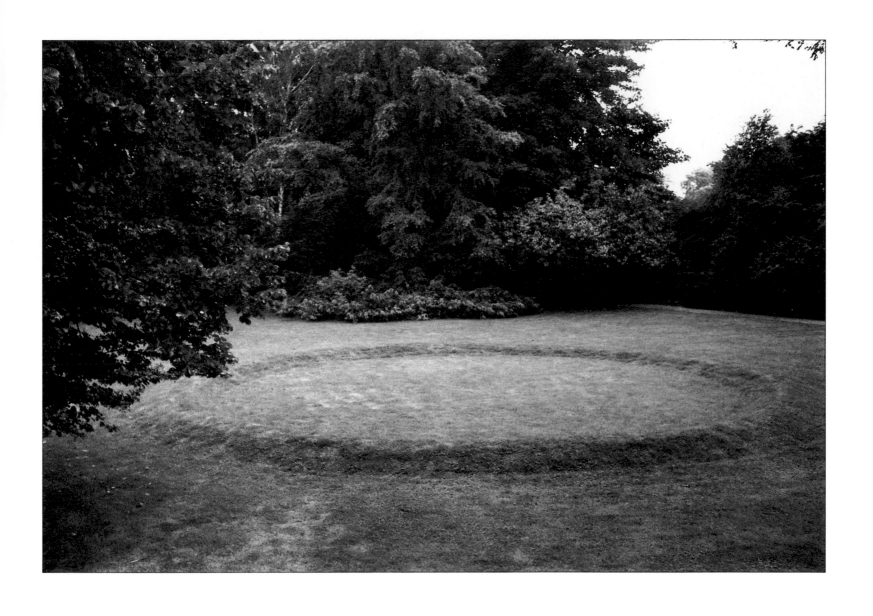

TURF CIRCLE

KREFELD 1969

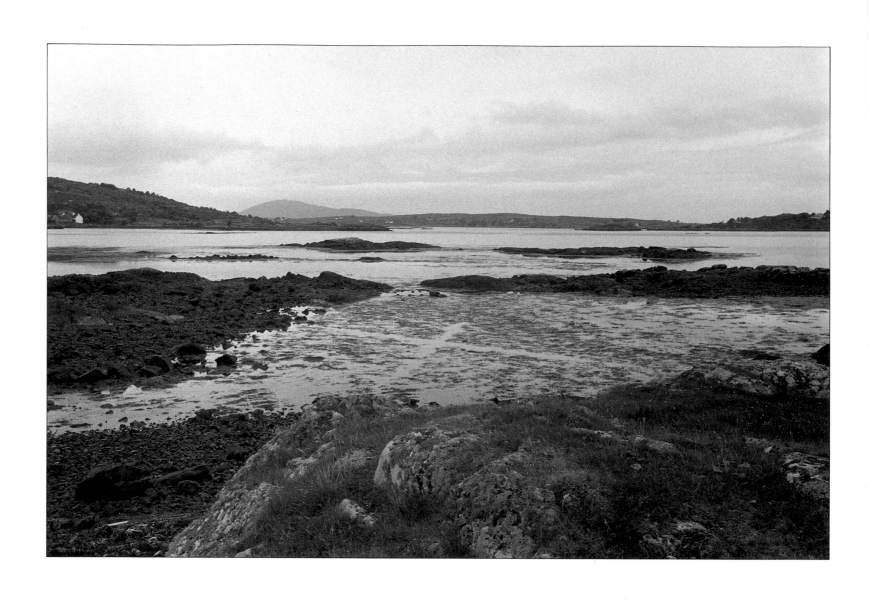

HALF-TIDE

BERTRAGHBOY BAY IRELAND 1971

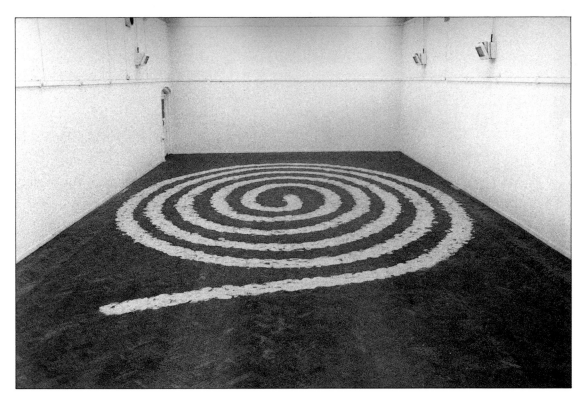

A LINE THE LENGTH OF A STRAIGHT WALK FROM THE BOTTOM TO THE TOP OF SILBURY HILL

LONDON 1971

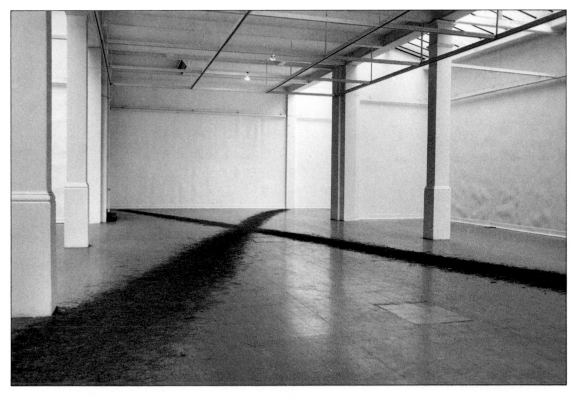

PINE NEEDLES

LONDON 1971

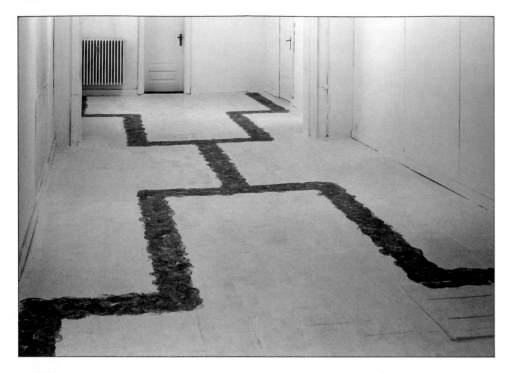

ANTWERP 1973

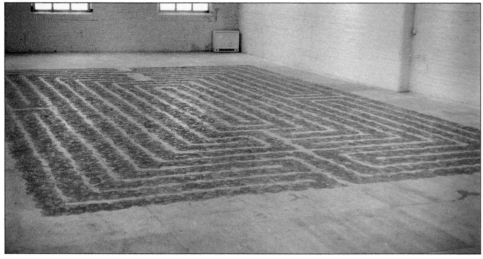

OXFORD 1971

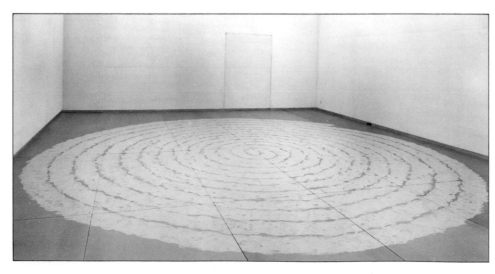

A LINE THE LENGTH
OF A STRAIGHT WALK
FROM THE BOTTOM TO THE TOP
OF GLASTONBURY TOR

AMSTERDAM 1974

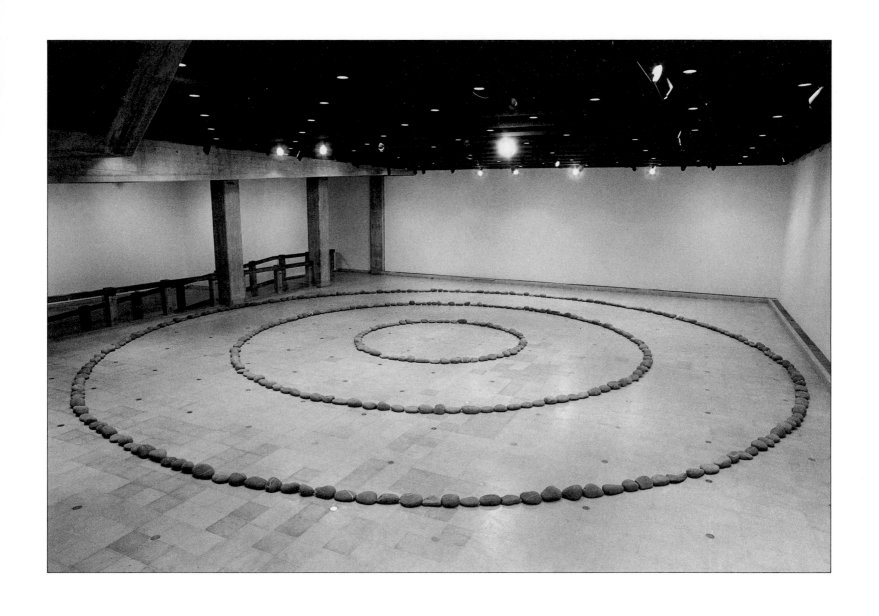

THREE CIRCLES OF STONES

LONDON 1972

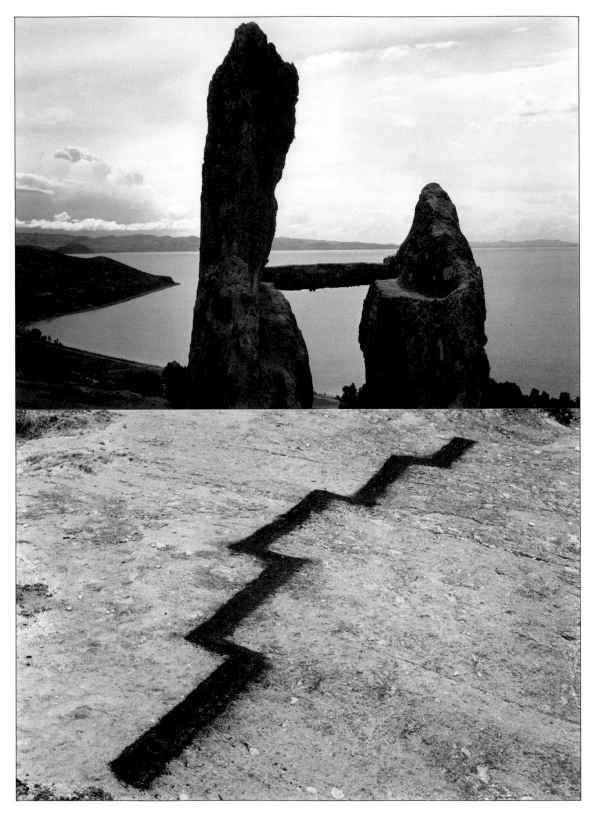

INCA ROCK
CAMP-FIRE ASH

BOLIVIA 1972

PUMA

SUN

SPIRAL

MOON CONDOR

FALCON

RAIN

SOUTH AMERICA
1972

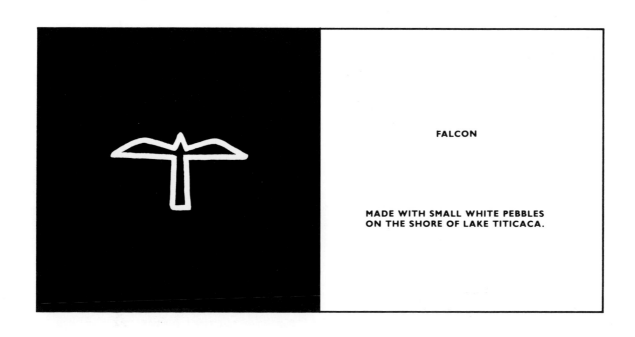

FALCON

MADE WITH SMALL WHITE PEBBLES
ON THE SHORE OF LAKE TITICACA.

MOON

DRAWN WITH MY HAND
ON THE SURFACE OF
LAKE TITICACA AT NIGHT.

SUN

A CIRCLE MADE FROM
GOLD PARTICLES PANNED
FROM A STREAM ON
THE CUZCO-LIMA ROAD.

PUMA

A WATER DRAWING ON A
DRY SANDBANK ON THE
BED OF THE RIO PAMPAS.

SPIRAL

TWO WALKS MADE SLOWLY
ALONG AN ANCIENT PERUVIAN
GROUND DRAWING NEAR NAZCA.

RAIN

MARKS SCRATCHED WITH A
STONE ON THE GROUND OF THE
ATACAMA DESERT IN CHILE.

CONDOR

A DRAWING IN THE SNOW AT 20,000 FEET
ON MOUNT ILLAMPU IN BOLIVIA. AS I SAT
ON A ROCK NEAR THE DRAWING A CONDOR
SUDDENLY GLIDED STRAIGHT OVERHEAD.
IT FLEW SO CLOSE I COULD HEAR
THE AIR WHISTLE IN ITS FEATHERS.

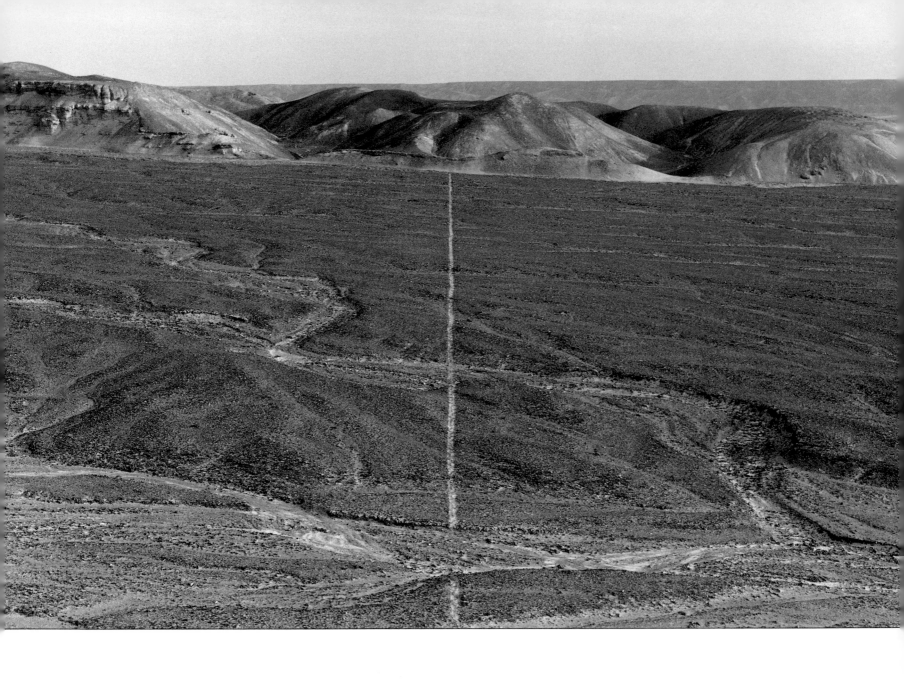

WALKING A LINE IN PERU

1972

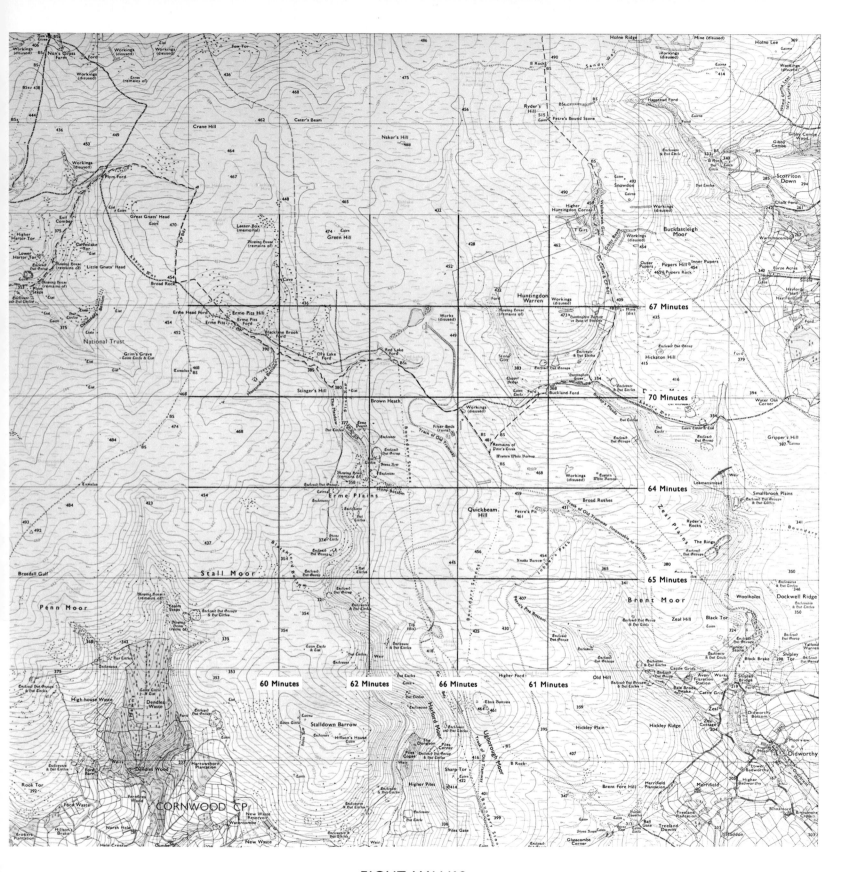

EIGHT WALKS

DARTMOOR ENGLAND 1974

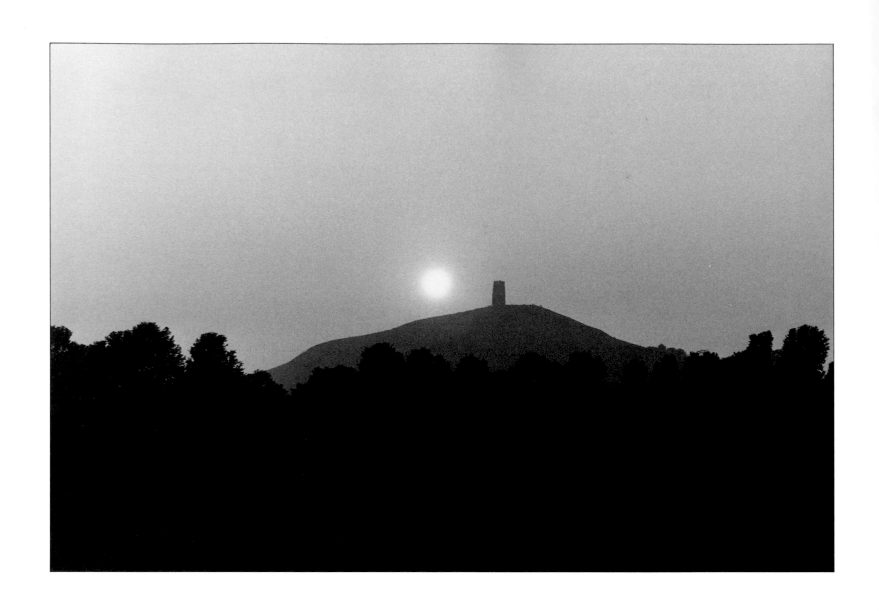

ON MIDSUMMER'S DAY
A WESTWARD WALK
FROM STONEHENGE AT SUNRISE
TO GLASTONBURY BY SUNSET
FORTY FIVE MILES FOLLOWING THE DAY

1972

A THOUSAND MILES
A THOUSAND HOURS

A CLOCKWISE WALK IN ENGLAND SUMMER 1974

39

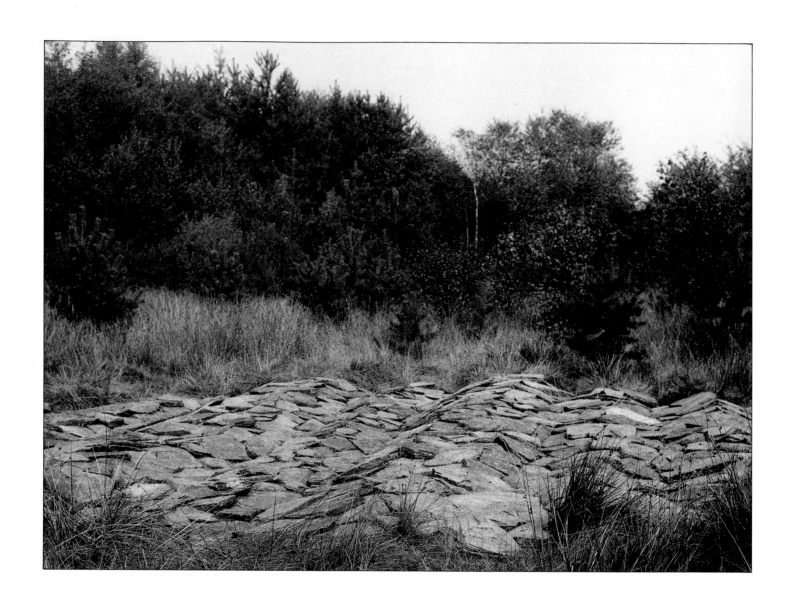

I SEE A LAKE AS A FIELD
A FIELD AS AN ISLAND
AN ISLAND AS A WOOD
A WOOD AS A LAKE

BERGEYK HOLLAND 1972

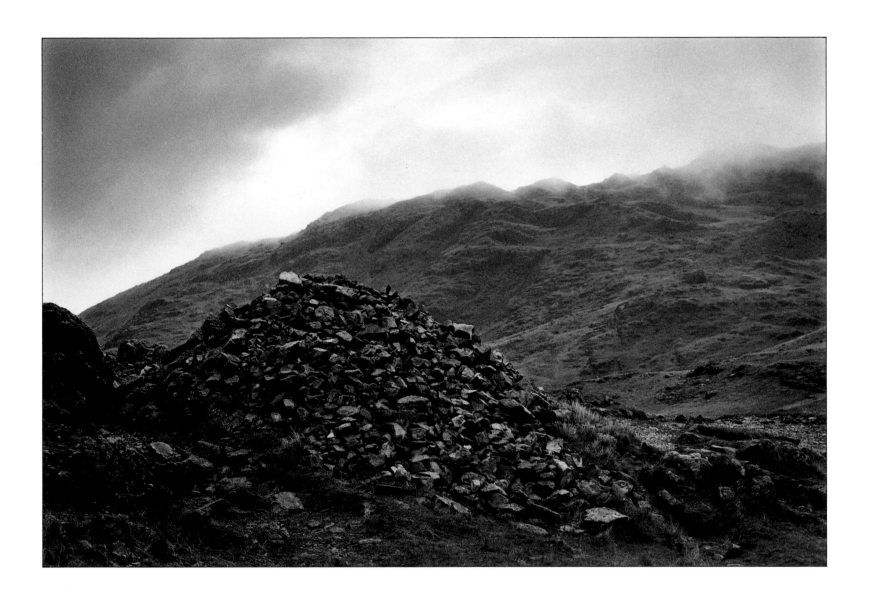

A THOUSAND STONES ADDED TO THE FOOTPATH CAIRN

ENGLAND 1974

Walking the Line

He had, he said, always been attracted to the outdoor life, ever since he was a boy. He often liked being on his own. Now, he likes the ease and naturalness with which things come one after the other: walking, climbing, camping, gathering wood, lighting the fire, boiling water, packing up and walking again. Walking, he said to me, with its hardships and its pleasures, the surprise of discovery and growing experience, relaxation and concentration: walking is a good way to think. Steady rhythms. Your feet can take you anywhere in the world, except where there is no water or the water is too deep. When machines break down there are always your feet. A lot of ideas come while walking, or when sitting down to rest. The landscape puts them into your head.

He makes a work of art in the place he chooses, with the materials that are there, on the slope of a mountain, high under the sky – a line of stones if there are stones lying about, or if the place wants a circle, a circle. When there are no stones, he can walk up and down the footpath as often as necessary for a line to become visible, or with his boot he can scratch a mark in the soft earth, or he can make a line by pouring water from his flask. After a while the sun dries the line away; it may be gone when he moves on. There is no special reason, aesthetic or political, to make such works of art. The work is there because of the artist's desire to make it. The artist makes art because he is an artist.

The works are traces of staying and passing: each marks what was the centre of the world when he was there. The forms are forms of movement, like the straight line or the spiral, or forms of staying, like the circle and the cross. Many things come together in those forms. It is impossible to ascertain when and where a walk, moving lightly ahead, pauses for a while, curls up into a sculpture like a cat, and goes on its way again. In the end there is one giant work stretched out across the world, crossing and overlapping, an epic of art. I shall have to unravel something of

the slow growth of this work: how the walk crosses over the sculpture like water passing underneath the bridge like the footpath going over the mountain like the valley rolling through the mountains like water slipping into the sea, walking slipping into sculpture like a cloud drifting in the wind.

There is a temptation, when one is writing about this extraordinary art and trying to understand it, to be romantic or poetic. The twentieth-century art world, the places where Richard Long's art is being seen, appreciated and evaluated, is urban and nervous – the total opposite, one would say, of the world in which the works are made. They have an other-worldliness, another sense of time, like things happening in a fairy-tale. But one must take care not to present them as such. The idea of a natural landscape, even when wild and occasionally dangerous, as a landscape one can walk in, is profoundly different from that of a savage nature one has to live in – without the possible refuge of the city. Richard Long's landscape is, consequently, as modern (in feeling) as the city of Bristol from which he sets out for a walk. Modern life, modern equipment, modern means of transport – and modern ideas – have given him these landscapes.

He himself tends to see the choice of place in rather practical terms, playing down as much as he can the romantic, poetic connotations. The fact that the vast majority of people do not spend three weeks walking in the mountains of Ladakh, does not make it abnormal or eccentric to do so. To him Ladakh is as important as any cosmopolitan city, and maybe even more so; and the possibilities that it offers him for his work are different from those of any other place in the world.

The work he can do there, or in Lappland or East Africa or Alaska, may at times be formally very similar to works done near home, in the West of England; but it is different because the place is completely different in spirit and in scale. Even on Dartmoor, which is fairly wild

ground, the heap of tinner's stones looks an almost intimate work compared to the vast and 'raw' circle of stones high in the Andes.

In some way we all know such feelings in relation to landscape: sitting by a narrow river, looking at the water, or standing on a high cliff in a roaring wind overlooking the grey, cold ocean. In Richard Long's work form and experience and memories and feelings come together, mysteriously and beyond the words of the prose-writer: so there is the intimation of poetry.

Obviously it is not quite so simple as that. The artist, even when he makes his first work, has a history behind him – his own history, the history of other art made before his time, and his perception of that history. In fact, the personal history of the artist, what makes him decide how to make his first work, in what formal language, *is* his perception of the history (and the presence) of other art. Then he makes his first work, and that first work, if it is any good, is already new and independent of previous history. There are always art-historical links and other aesthetic considerations to be pointed out, but they serve only to define the independence and the autonomy of the new work. Its present existence can never be deduced from what came before. The great *Black Square* of Malevich was, in its stunning absoluteness, not announced in his previous work. In retrospect one can, maybe, understand that it was he who made that painting and not Picasso – because he was working within historical and aesthetic circumstances that permitted or fostered such radicalness more than the atmosphere of Picasso's Paris.

What then made Richard Long make his basic work, *A Line Made by Walking*, in 1967, right in the middle of the Swinging Sixties in London? There was very little in the atmosphere of the time to suggest the almost intolerable simplicity of that piece – a line made by walking up and down in a field until the flattened grass caught the sunlight from a different angle and became visible as a line. Thus the photograph which recorded the artwork was made.

His education, up to that point, did not simply lead him to walking that line. All that education can do is clarify the mind and clear things away. In 1967 he was still at St Martin's School of Art, in London, at that time famous for the 'New Sculpture' of welded painted metal practised by artists like Anthony Caro and Phillip King, the best-known teachers at the school. At St Martin's he had made artworks that used the floor or the flat roof of the school in conjunction with 'simple' materials like sand or water: works that resembled gently undulating landscapes, or dammed shapes of water within the rectangular ridges of the roof. Earlier pieces from 1965 were heaps of sand or heaps of blankets. Maybe it was the school's atmosphere of speculative innovation, its absence of doctrine, that encouraged a young artist to undertake such things. There were his contemporaries at the school too, Barry Flanagan and Gilbert & George and Hamish Fulton (each of them different and becoming artists in their own right); but there were, Richard Long recalls, no programmatic discussions among them about which course art, new art, should take. Artists talk and think about things directly at hand, how to get something right, and not so much about the distant future. Visual art, as Long's work shows, is the most concrete form of thought, because whatever you may invent in your head has to be actually made.

In any case, coming to London in September 1966 he had already brought a certain artistic formation, even a certain 'style', with him from his native Bristol, where he had been at the West of England College of Art from September 1962 to March 1965. In Bristol in 1966, he had made, among other works, a *Turf Circle* by cutting into the soil, first cutting the circle and then its segments and taking them out, removing an even layer of soil, then putting them back to make the sculpture a lowered, circular plane of ground. It looked like a bicycle wheel. In 1965 he had created a sculpture by digging out hollows, lines and holes in the grass and filling or lining some with white plaster. Like the *Turf Circle*, this was a work made by a young artist to test how to use materials and the idea of negative space. What is surprising is how close Richard Long, barely twenty years old, already was to what was to become his 'language'. The circle had appeared, the basic form, as well as the intention (almost a natural instinct) to treat his materials with gentleness, not wasting them. The turf was used and laid back, its tissue only momentarily severed; after a while the segments would grow back into the earth that produced them. In the plaster piece the white liquid, hardening while finding its way along the folds of the ground, marks a pattern which was already there: that too became a fundamental condition in his later work.

Concurrent with the plaster piece, he made two small 'models' of actual pieces of landscape, in plaster, carefully and realistically painted: *An Irish Harbour* (drawn on his first visit to Ireland in 1966) and a *Square of Ground* on the Bristol Downs. Even if here, too, the basic occupation is with ground, the idea is considered in a different way. The pieces are in a sense miniature copies; thus they are narrative – as was a work of 1965, environmental in character: an undulating, winding plaster path curving into the corner of the studio. It could be walked along. To indicate that idea, he placed a plaster figure of a walking man, with a hat, facing towards it. The work thus explored the idea of a walking viewer, moving, and a static walking sculpture. But its further development would have led Richard Long towards illustrative structures he did not want and away from the simple materials that, like the turf in the circle, stay simple. In the models and in the walking man the material was absorbed and hidden in the form, static and for ever.

In conversation Richard Long remarked that he liked many of his works to be impermanent. That way they were more human, their limited physical existence in the world resembling the impermanence and reality of human life; and he mentioned that already in the winter of 1964 he had made a ground-drawing by rolling and directing a snowball over the snow-covered plateau of the Bristol Downs. This, one of his very first artworks (of which only a casual photograph exists), is in retrospect an already rather perfect one: the meandering line is the path which the uneven ground forces the snowball to take as it gathers weight and slows down. The procedure of the work is beautifully circular, and is completed when the drawing melts away in the sun, leaving no trace at all. The piece is delicate as one's warm breath condensing against a cold window-pane and then evaporating. This principle of 'disappearance' was also taken up by *Turf Circle* and even more decidedly by *A Line Made by Walking*, in the spring of 1967.

Impermanence lies at the very heart of Richard Long's conviction as an artist. It has rendered possible the idea of walking as his comprehensive art form, containing all the other forms through which his art chooses to express itself. That the idea of physical impermanence was in his mind as early as 1964, when he was rolling a snowball over the grass, is an impressive fact of artistic conviction

and of resistance, even if subconscious, against the dominant belief in most cultures that art is not only there to be used and enjoyed in the present but should also promote that present into an eternal future. It was a resistance born out of instinct and practice. Even if Richard Long, young as he was, did not then know what precise direction his art should take, his instinct told him that the area he was entering had rich possibilities. He had somehow slipped into it by just doing what he liked to do without worrying about how art should *look*. (In one of the notes he sent me he observed how art carried the pleasures of childhood into adult life: damming streams, throwing stones or bouncing them across rivers, making sand castles – 'not so different in spirit from making my work'.)

One wonders, actually, whether an artist ever worries about the physical future of his work. The artist's business is I think always in the present: making a work leaves the previous work behind, while the next one is still beyond the horizon. His concern is to make the present work as powerful as he can. The beauty of art, the spiritual and visual density of the artwork, actually seems to derive from that absolute concentration on one moment – never, it seems, from an artist's direct, conscious involvement in history. Because when making a work (wherever he is, in a city or alone on a high mountain pass) the artist is momentarily absent from history: he is confronting history, intervening in order to change it. Thus, when he makes a work of art, it is precisely in that tense moment that art history is cancelled, denied its course – in a way denied its already shaky permanence. Nothing in history is permanent. The present modifies the past, most of the time by a slow, almost imperceptible process of erosion. Sometimes, however, changes are abrupt and dramatic, as when a major, irrevocable artwork appears in the world.

The *Black Square* of Malevich is a painting which cancelled previous art in one grand, abrupt statement of conviction – the conviction that something was over and that there was no need to hang on. The *Black Square* slapped the face of history, in order to wake it up. I believe Richard Long's *Line Made by Walking* to be a work of equal importance. Like the *Black Square* it is a work with almost no formal characteristics, using the simplest form, the line. Thus, as it is hardly characterized by its form, it is overwhelmingly distinct in its passion and conviction. Its origin is a mystery. I have sketchily indicated Richard

Long's involvement, from a very early moment in his career, with all the separate elements and aspects one again encounters in the *Line Made by Walking*: ground, soil, nature, simple forms, common materials. But all the previous works did not by necessity lead up to that line. Such logic in art does not exist.

Only two years before (admittedly a long time for a young artist), he was hesitating, trying the miniature models and the walking man, circling as in other early works around something without quite touching it. One month before the *Line* he made his first travelling and walking piece. That work was made into a panel showing an outline drawing of Britain marked with six pairs of square photographs of the ground and the sky, each bearing the name of a day. The typewritten text reads: *April 1967. A journey, by hitch-hiking and walking, out and back, from London to the summit of Ben Nevis, Scotland – Two photographs taken at 11 A.M. each day at the position shown.* This piece is an invisible sculpture in space and time – in fact what excited Richard Long about it was its vast scale in time and distance. Still, one feels there is something congested about it; in relation to the *Line* it is, in structure and procedure as well as in presentation, overly complicated, as if several ideas were present in it without really joining. The same is true, I think, of a bicycling piece he made later that year: transporting and leaving 16 separate parts of a sculpture around an area of 2401 square miles of central and eastern England. This was presented as an outline map and text, including the statement: 'No photographs'. The fact that the bicycle work was made after the *Line Made by Walking* shows how different ideas were germinating in his mind at the same time.

Although the *Line Made by Walking* does not in principle contradict these large-scale works, it has a different quality: it is very much about laying down a perfect, controlled and yet vibrant form, intimate but without real scale – not overwhelming like the Ben Nevis or bicycle works, which did, however, establish the possibility that pieces could encompass vast geographical areas. The *Line*, moreover, cleared up something about the lightness there could be in making art: it was made exclusively with the elements that were there and remained there, after the sculpture ended, without having been physically affected: the ground, the grass, the form of the line, the artist walk-ing, the light of the sun. The *Line* is the result of the coming together, precisely in that place and moment, of these elements. Therefore, because there was nothing left out and nothing included that wasn't there before, this sculpture became somewhat of a prototype, or a matrix, a form so perfectly simple, open and resolved that it also became a clarification, even a revelation of how to make sculpture. Walking slipped into line, line slipped into form, form slipped into place, place slipped into image. It irrevocably cleared the air, just as the *Black Square* had once done, by suddenly, unaccountably, being there. The *Line Made by Walking* became classic the moment it was done; it made all the other early work look tentative and experimental, though surely it itself had started out as another experiment: an idea put to the test of practice.

In a note Richard Long commented that in making the *Line* he discovered that its visibility depended only on the quantity of walking. Walking once he left almost invisible footprints in the grass; walking up and down many times left a visible path. He realized that between the two 'states' there was no real 'conceptual' difference. It led him to think about visibility and permanence. Even the visible line would in the end disappear, only less quickly. Another idea that came to him was that, instead of going up and down a line, he could continue walking a line that would grow longer and longer, without changing form or identity (visible or not, that did not matter); that led to a new dimension of scale in execution. In that sense too, the *Line* was crucial because it indicated a way of encompassing the large scale indicated by the bicycle work or the hike to Ben Nevis. The *Line* revealed that the traditional, common means of walking could be used to make art.

The discovery of a new, expanded scale, in distance as well as time, was not just of formal importance in Richard Long's art. It is true that the *Line Made by Walking* looks like a carefully executed formal study, an essay in technique and procedure. But the fact that it used the real earth, without adding or subtracting other materials, hardly disturbing the ground that was walked on, opened up an enormous new range of content. In principle a walk could traverse different landscapes, at different times of day and night, in different conditions of weather and through different states of mind on the part of the walker – thereby making all these aspects of the real world part of the sculpture. The sculpture became a part of the world,

an articulation of it – not an addition, not a stable object. While being made, the sculpture was also moving along; it had a form but not an unalterable permanence of form – its form ultimately consisted in the direction of its movement and the shape of the land. A walk crosses over the surface of the earth which carries it with pleasure. The earth becomes the companion of the artwork, walking with it as the artwork takes pleasure in the world.

Around the time that the *Line Made by Walking* was executed, spring 1967, Richard Long made several other works which, without actually contradicting the principle of the *Line,* nevertheless took a slightly different direction, in practice as in spirit. One was a landscape-piece, constructed on a stretch of parkland near Bristol. In the foreground he put up a thin vertical rectangular frame of wood, while much further away in the background, where the land sloped slightly upwards, he placed a flat circle of plywood, painted white. The idea was to make a work of three places (at the same time): the place of the circle, the place of the rectangle and the place of the viewer – and for the work to become 'complete' when the three were in alignment and the viewer could see (as in the photograph) the circle within the frame of the rectangle. But the work does more: it also demonstrates the character of the terrain. Its visibility is actually dependent on the fact that, beyond the trees, the land slopes upwards. Thus the construction offers, in its way, a picture of the place – more precise and articulated than if the photograph had been taken without it, because now perception has become literally pointed, structured and quite different from the 'roaming' glance practised in, for example, Romantic landscape painting. The work then is more of a landscape than the *Line Made by Walking,* which concentrates on the line as form itself.

In a somewhat different manner, the conscious use of the character and condition of the terrain as an aspect of content and expression was explored in a work executed in various places in England and Ireland, using three concentric circles made of segments of plywood painted white. The *Line Made by Walking* had been walked on a nondescript piece of flat grassland – abstract and anonymous. That was what made it so uncompromisingly pure and simple and real. The construction in the park made the perception of landscape abstractly formal by projecting a precise viewpoint and line of vision. The concentric circles touched the ground. They were a transportable sculpture, to be laid out in various places and on various types of ground. The circles would fit snugly to the ground and visibly follow its uneven surface to the point of being interrupted by stones, as in the Irish version. Circles showed ground and ground showed circles, perfectly matched to the surface of the earth. They could be looked at from any point. The sculpture then demonstrated that no two places were alike, each place *making* the shape of the work each time. From here it was only a step to making circles in the landscape, tracing the earth's surface in a similar way, using the materials provided by the earth itself (stones, driftwood and so on) instead of carrying prefabricated circles to the place where the sculpture could be made. To come to that conclusion, which is simple only after the fact, a radical clarification was needed. That clarification, once again, was the *Line Made by Walking.* It presented a standard and a level of possibilities which other early pieces did not have.

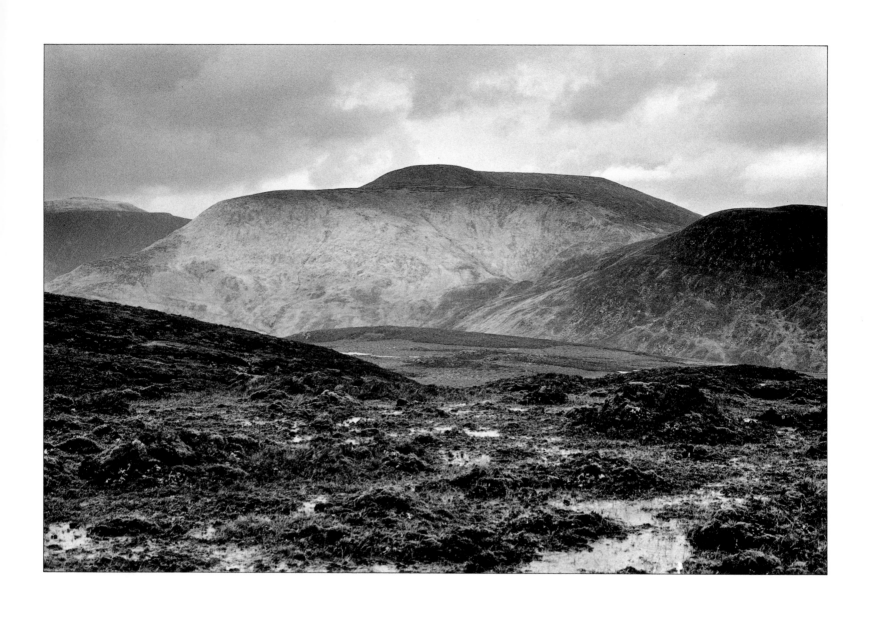

A HUNDRED MILE WALK ALONG A LINE IN COUNTY MAYO, IRELAND.

1974

ROISIN DUBH

A Slow Air

A THOUSAND STONES MOVED ONE STEP FORWARD ALONG A SEVENTY FOUR MILE WALK IN COUNTY CLARE

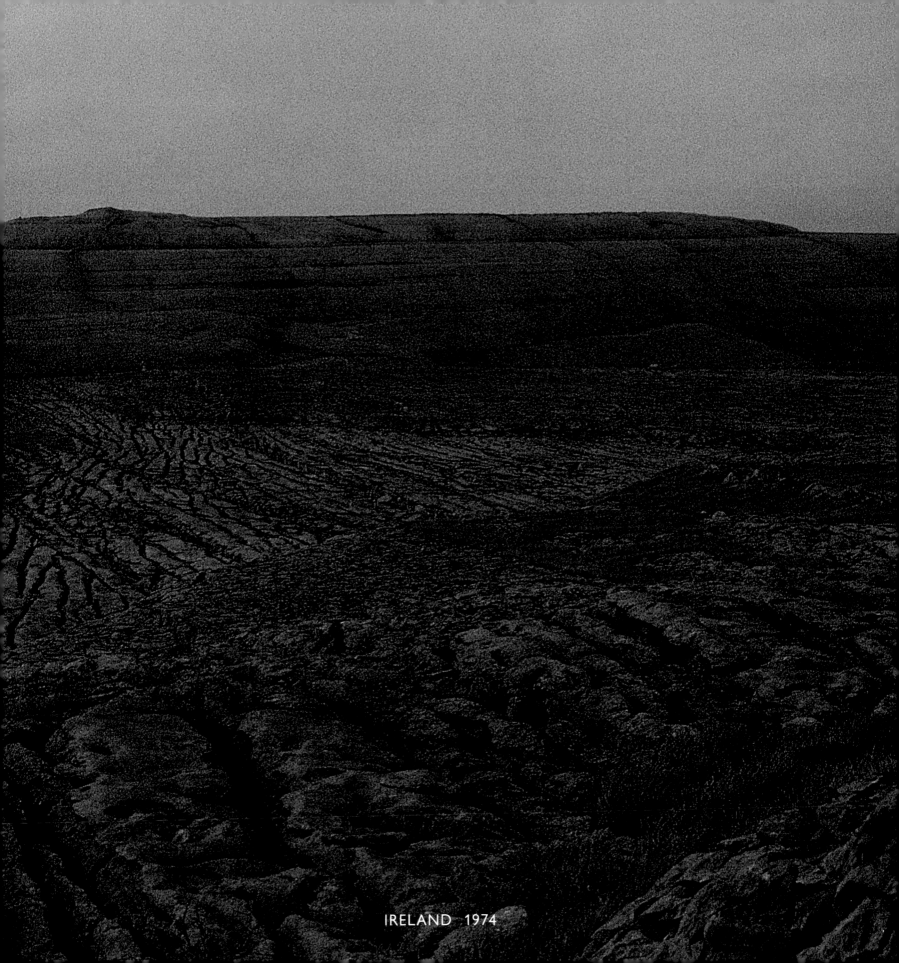
IRELAND 1974

A LINE OF 164 STONES
A WALK OF 164 MILES

A WALK ACROSS IRELAND, PLACING A NEARBY STONE ON THE ROAD AT EVERY MILE ALONG THE WAY.

CLARE	49 STONES
TIPPERARY	38 STONES
KILKENNY	27 STONES
LEIX	9 STONES
CARLOW	20 STONES
WICKLOW	21 STONES

1974

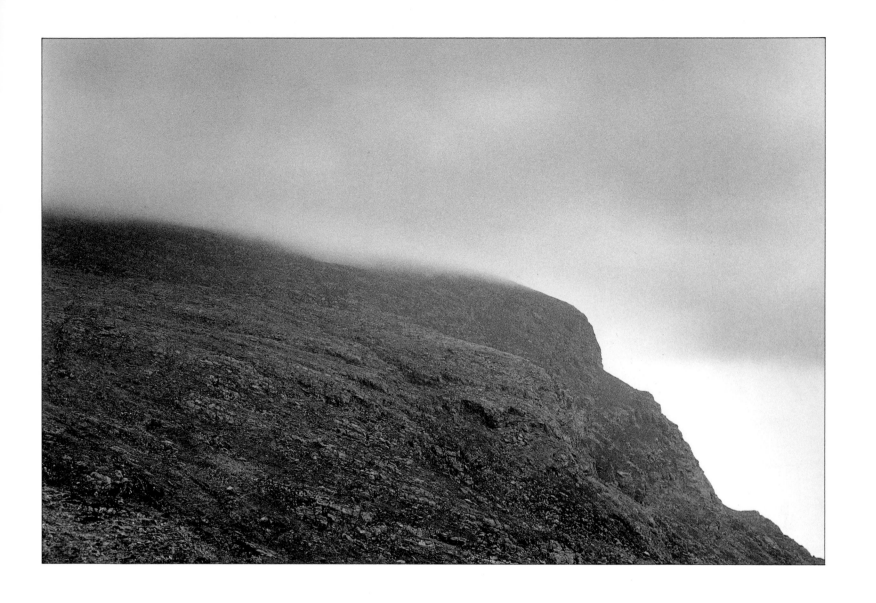

THROWING A STONE AROUND MACGILLYCUDDY'S REEKS

A 2½ DAY WALK 3628 THROWS

STARTING FROM WHERE I FOUND IT, I THREW A STONE, WALKED TO ITS LANDING PLACE AND FROM THERE THREW IT FORWARD AGAIN.
I CONTINUED THROWING THE STONE AND WALKING IN THIS WAY ON A CIRCULAR ROUTE, ENDING AT THE PLACE WHERE I FIRST PICKED UP THE STONE.

COUNTY KERRY IRELAND 1977

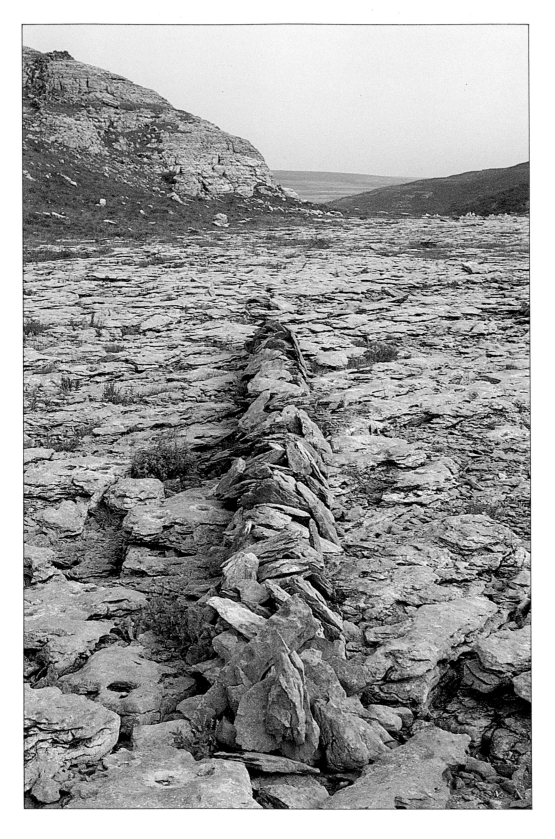

A LINE IN IRELAND

1974

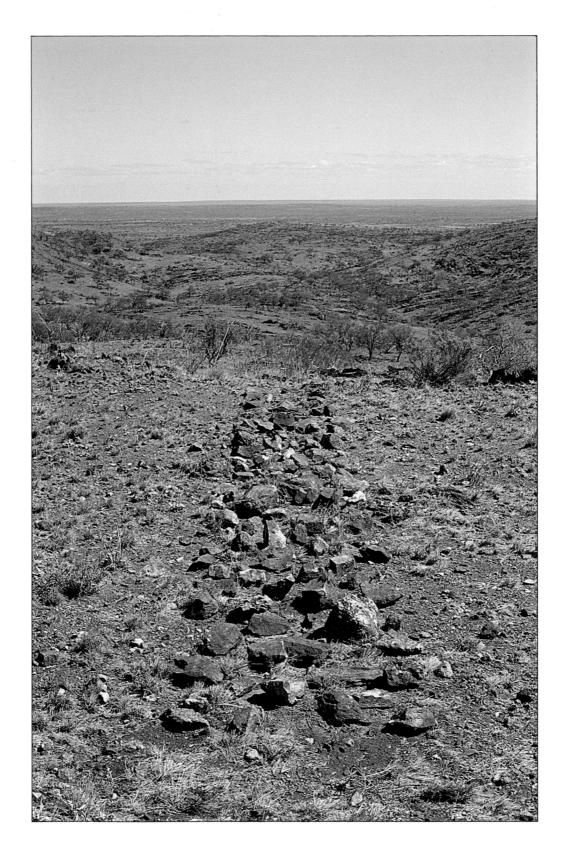

A LINE IN AUSTRALIA

1977

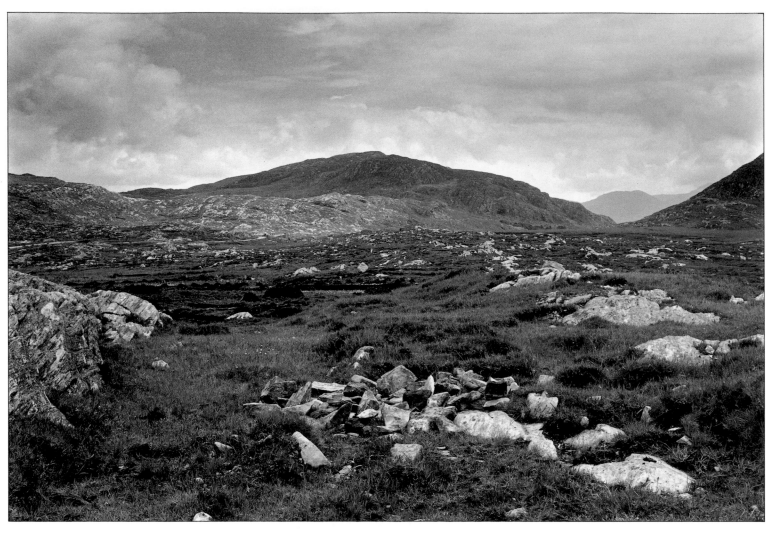

169 STONES AT 169 MILES

MILESTONES

A 300 MILE WALK FROM TIPPERARY TO SLIGO,
PLACING FIVE PILES OF STONES ALONG THE WAY.

57 STONES AT 57 MILES

162 STONES AT 162 MILES

169 STONES AT 169 MILES

229 STONES AT 169 MILES

284 STONES AT 169 MILES

IRELAND 1978

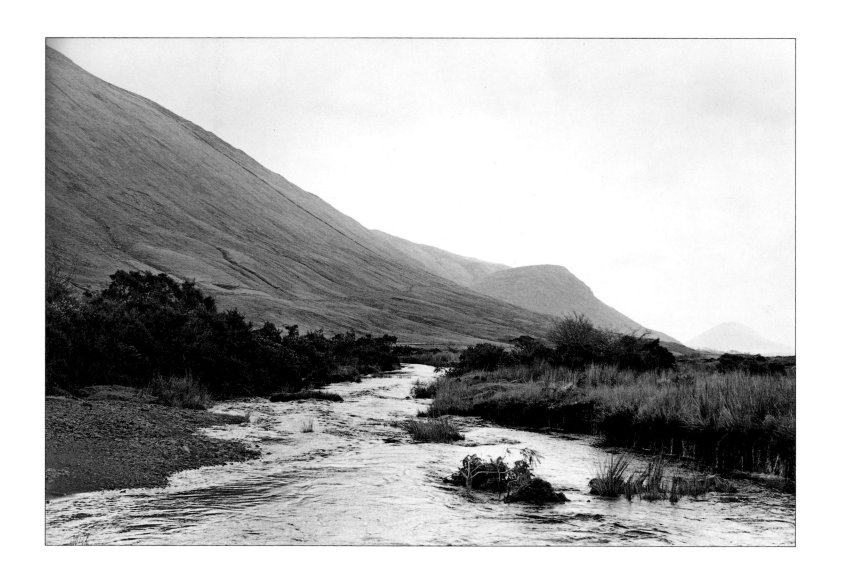

WITH THE RIVER TOWARDS THE SEA

A WALK DOWN A RIVERBED IN JOYCES COUNTRY, COUNTY GALWAY.

IRELAND 1974

MOUNTAINS TO MOUNTAINS

A 138 MILE WALK
FROM THE COMERAGH MOUNTAINS
TO THE MONAVULLAGH MOUNTAINS
TO THE KNOCKMEALDOWN MOUNTAINS
TO THE GALTY MOUNTAINS
TO THE BALLYHOURA MOUNTAINS
TO THE NAGLES MOUNTAINS
TO THE BOGGERAGH MOUNTAINS

WATERFORD TIPPERARY LIMERICK CORK
IRELAND 1980

THE HIGH PLAINS

A STRAIGHT HUNDRED MILE WALK ON THE CANADIAN PRAIRIE

1974

A STRAIGHT HUNDRED MILE WALK IN JAPAN

MADE ACROSS A MOUNTAINSIDE ON HONSHU

1976

A STRAIGHT HUNDRED MILE WALK IN AUSTRALIA

A WALK ALONG A LINE, RETURNING TO THE SAME CAMPSITE EACH NIGHT.

1977

A LINE IN CANADA

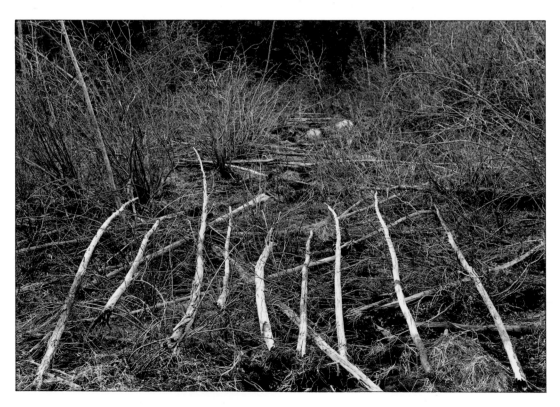

STICKS IN THE NORTH WOODS

MANITOBA CANADA 1974

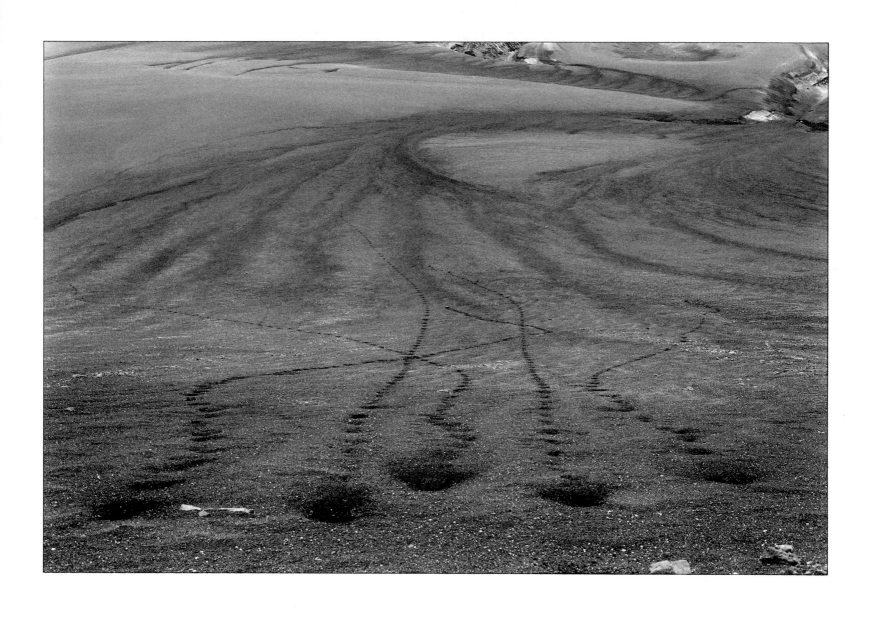

FIVE STONES

ICELAND 1974

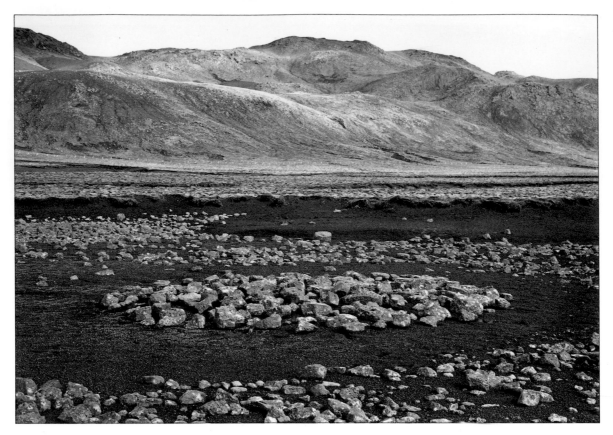

A CIRCLE IN ICELAND

1974

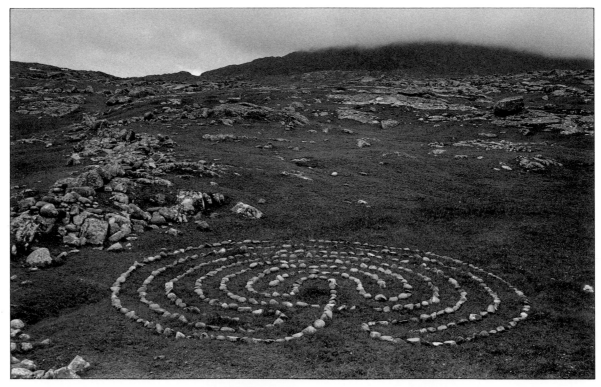

CONNEMARA SCULPTURE

IRELAND 1971

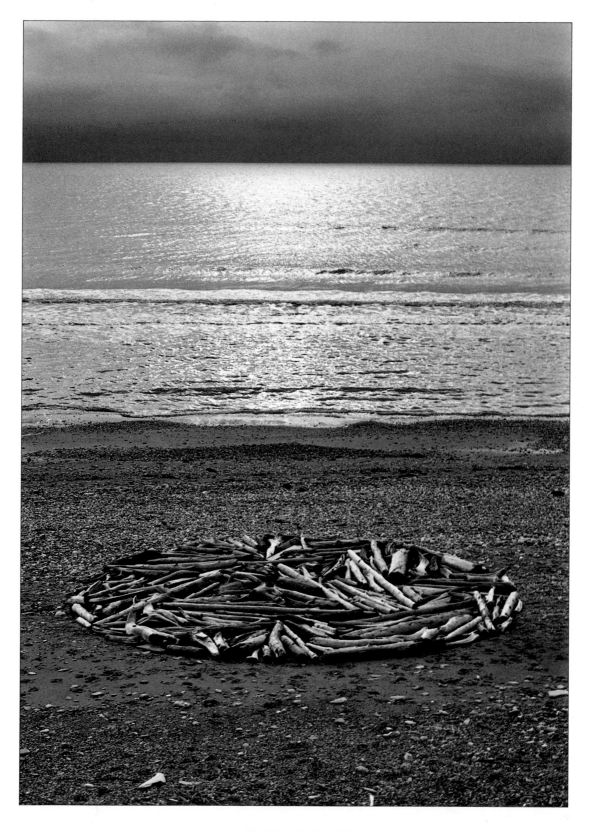

A CIRCLE IN ALASKA

BERING STRAIGHT DRIFTWOOD ON THE ARCTIC CIRCLE

1977

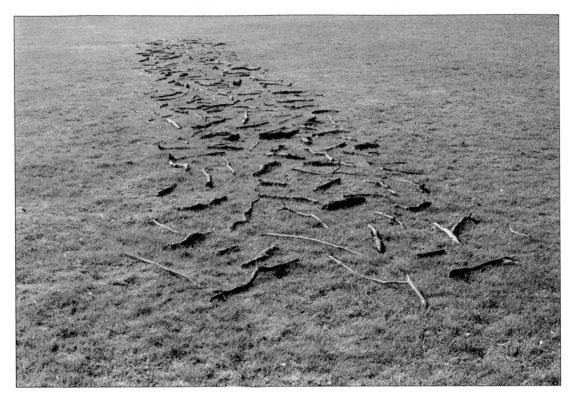

A LINE OF STICKS IN SOMERSET

1974

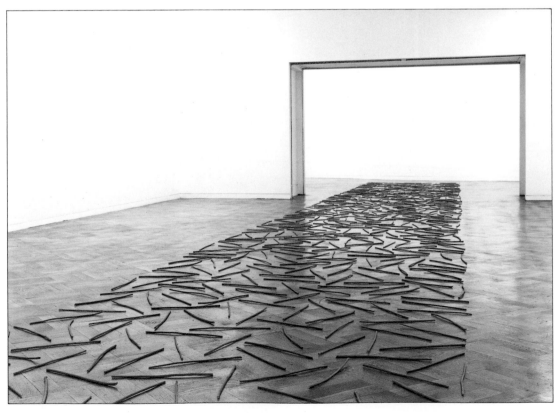

SOMERSET WILLOW LINE

LONDON 1979

MISSISSIPPI RIVER DRIFTWOOD

A THOUSAND PIECES OF DRIFTWOOD
PLACED FOLLOWING THE WATERLINE
AND ALONG THE WALKING LINE

MYRTLE GROVE WEST POINTE-A-LA-HACHE DIAMOND
PORT SULPHUR NAIRN TROPICAL BEND
EMPIRE BURAS TRIUMPH BOOTHVILLE
VENICE THE JUMP TIDEWATER CAMP

THE MISSISSIPPI DELTA LOUISIANA 1981

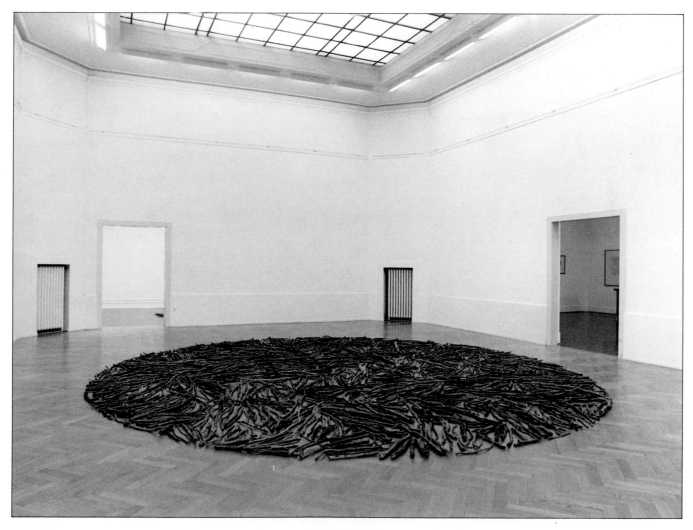

WOOD CIRCLE

BERN 1977

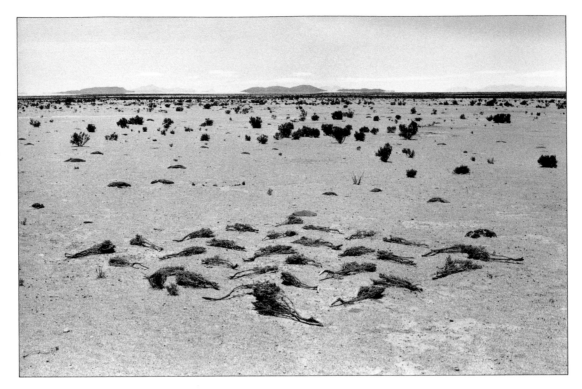

BOLIVIA 1972

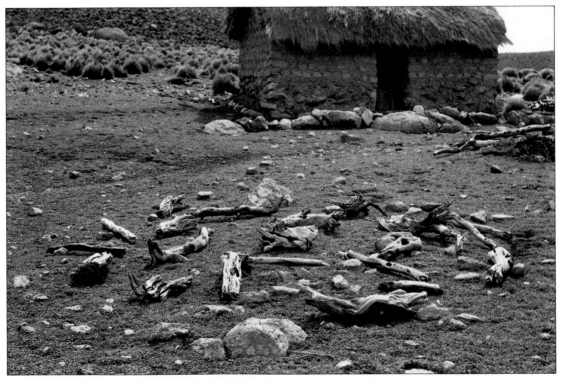

VILLAGE FIREWOOD

BOLIVIA 1981

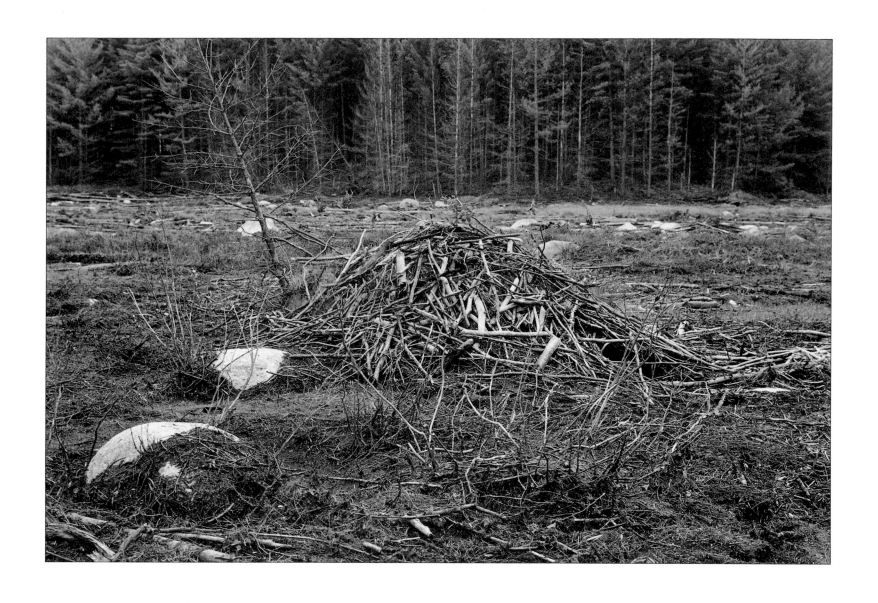

A HUNDRED STICKS PLACED ON A BEAVER LODGE

A SIX DAY WALK IN THE ADIRONDACK MOUNTAINS,
THE FOOTPATH CROSSING BEAVER DAMS ALONG THE WAY.

NEW YORK 1985

Interior Spaces

Richard Long installed his first one-man show in Düsseldorf in 1968, in the gallery of Konrad Fischer, who had seen a stick work mailed from Ireland to a small exhibition in Frankfurt. From the beginning he had worked both in the open space of landscape and indoors. On one occasion he had brought an outside work indoors. That was in 1967, when he transported a circle of sticks with a centre line pointing, at the moment of placing, to the sun, from the North of England, where it had been laid out in a field, into a room in St Martin's. Now, however, he had to confront the idea of showing in a gallery, that is participating in a well-defined modern system of art presentation. The gallery-space is neutral, grey floor and white walls and more often than not fluorescent light: a situation Richard Long had not encountered before and which he decided to use, in his usual practical manner.

He went to Düsseldorf with a bundle of sticks, cut from trees along the River Avon, and laid them out on the gallery floor, in straight lines slightly converging towards the end, which provided a kind of visual horizon for the viewer placed in front of it (a low partition made it impossible to enter). As the gallery was not an even rectangle, a number of lines ended prematurely where they met the side walls. Thus the floor with sticks could be seen as a cut, made by the shape of the gallery, into a field of evenly lined sticks. The work therefore looked as if it were a fragment – or, in any case, as if its overall shape were governed by the shape of the gallery. As with the three white circles, it was congruent with the form of the support, which was not quite rectangular and very flat.

The Düsseldorf show was important because it discovered certain principles of how to make art in an interior space. It demonstrated the possibility of doing so without sacrificing the *lightness* which he wants his works to have – they should have a certain ease, and their complexity should not be technical or physical but mental. (If a work is very complicated and difficult to make, he once

observed, there may be something wrong with it.) The lines of sticks touch the floor very gently, without intruding; their presence is like a whisper. The sculpture hardly disturbs the space, just as the *Line Made by Walking* hardly disturbed the grass. Neither of the works seems to possess the place; nor, in their state of physical fragility (but visual strength) do they set out to do so. The sculpture is, for a sculpture, incredibly unmonumental; yet its image is powerful and unforgettable. As an exhibition this work was as fundamental to the formation and expansion of Richard Long's art as was the *Line Made by Walking.*

As I have said, the lines of sticks on the floor could be seen as a fragment because they were cut off abruptly by the walls of the gallery. The walls were accepted as a spatial intervention in the sculpture – otherwise Richard Long would have adjusted the lines precisely to the wall. He did not do that because the pattern of lines was more important to him than any other consideration. The sticks laid out in lines, slightly uneven because the pieces of stick did slightly vary in length and thickness, recall also the laying out itself: the activity and the time spent in doing it. The lay-out, moreover, shows another important feature in his art: an artwork is always *his* pattern laid upon another existing pattern. This is clearly shown in the Düsseldorf work, where Richard Long's pattern of lines intersects with the architectural pattern of the gallery's floor-plan. Other early pieces, made in the landscape, demonstrate this formal principle with equal clarity: the crossing lines in a field of daisies, made by picking off the flower heads (England 1968) or, also in 1968, the rectangle on *A Somerset Beach* which was made by discreetly rearranging the pebbles, stones on stones.

But, if the sculpture looks like a fragment, what is it a fragment of? The only plausible answer would be: of a walk. The sticks for the Düsseldorf sculpture came from the Avon Gorge, Bristol. In fact, the card for the show sent out from the Gallery (a commercial picture-postcard

then available in Bristol) showed the Avon Gorge with Brunel's Clifton Suspension Bridge spanning it. On the towpath in the foreground a cyclist poses watching the bridge. The only pieces of information on the card were the names of the artist and gallery and the dates of the exhibition, but the artist must have had in his mind, when planning and preparing and making the sculpture, a sense of the relation between the two things. What was transported from Bristol to Düsseldorf was not a sculpture but its material; the material came from the Avon Gorge but the sculpture was in Düsseldorf. It was turned into a sculpture by following and adapting the given conditions in a gallery-space.

Two years later, in 1970, he made an exhibition at the Dwan Gallery in New York which focused even more upon the enigmatic relationship between walking and presenting work in galleries. With muddy boots he walked a spiral on the floor of the gallery. The length of the spiral line was something he had brought with him from England, just as he had taken the bundle of Avon sticks to Düsseldorf: *A Line the Length of a Straight Walk from the Bottom to the Top of Silbury Hill.*

The basic 'form' then of the sculpture consisted of a line of a given length in combination with its method of measurement: walking. The spiral is the obvious form which the line takes in order to fit into the space of the gallery. A year later, it was presented again in the upper gallery of the Whitechapel Art Gallery, London, in Richard Long's first show there. On that occasion the spiral was slightly different owing to the dimensions of the space. (Given a gallery long enough the same work could in theory be executed in the form of a straight line.) The identification of the line is given in the title, which explicitly mentions Silbury Hill in Wiltshire, the largest prehistoric man-made mound in Europe. It is a specially mysterious place of which the function and the meaning are unknown; Richard Long brought its mystery into play. On the mailer for the New York exhibition he again used a postcard with, under a photograph of the hill, one of the more popular regional legends concerning its origin. A similar sculpture presented as a spiral line was later shown in Amsterdam in 1973: *A Line the Length of a Straight Walk from the Bottom to the Top of Glastonbury Tor, Somerset.* Once more a historical dimension is woven into the work: close to the Tor stand the ruins of the great Benedictine Abbey, the first Christian foundation in Britain.

In both these cases, the relation between walk and gallery sculpture is undeniable: in spirit, in the way of making and even in its formal logic. As the round spiral is the most logical and simple way of presenting the straight line in a narrow space, so the straight line of the walk was the most economical way to walk up the gentle slope of both hills. Although Richard Long does not specifically look for historical or mythical references to become part of his work, he does not avoid them either. Obviously Silbury Hill interested him; he passed it many times when hitchhiking between Bristol and London on the old A4 road. There is also, as always, a practical reason for the choice of location. Precisely because it is man-made, the slope of Silbury Hill has an inclination which makes it possible to walk to the top in a straight line. With most natural hills and mountains this is not the case – an exception is Glastonbury Tor, whose shape made it the obvious choice for a shrine. The two hills are strange twins – which no doubt was one of the reasons why Richard Long made these two related works. Some places offer sculptures, other sculptures look for places.

Clearly the two spiral sculptures are not fragments. They present the physical form of a walk in an appropriate second form which equals the first form. They are not fragments because, also, outside their presentation in a gallery, they do not otherwise exist. Similarly, then, the sticks in Düsseldorf are not a fragment but an autonomous piece – only it is not explicitly identified with a place of origin. The same applies to the various gallery pieces (lines, spirals, circles) made with River Avon driftwood. In other cases the emphasis may be less on the origin of the material than on an 'abstract' idea of walking: the untitled walk in red clay (Oxford 1971) or the untitled sculpture, also in red mud, made for the Wide White Space Gallery in Antwerp in 1973.

Along the Way

The matrix for Richard Long's work is the surface of the earth. Everything he makes relates back to the earth: even if, in many works made in galleries, the relation with a walk (or with walking in general) is there only in the background, as a point of reference; still the stones or the wood or the clay or mud and water used are from the earth; and the form of each piece reflects and recalls similar forms encountered, discovered and employed while walking the surface of the earth. Sometimes the walks are performed in a random way; if so, they are identified as such, and that then is their loose but still definitive form. Normally their form is precise and identified in various types of measurement: by length in distance or in time, by form, by start and finish, by passing points along the way – or by any combination of these characteristics. Sometimes the distance and the form and the place are set, and the walking time results from these factors. Sometimes the walking time and the place (condition of terrain) are first established, resulting in a distance which can then be identified (*A 24 Hour Walk*). There can also be a combination of time and distance, affecting the pace of the walk. The number of possible permutations is endless. The advantage of this methodical repertoire of forms, related in time and distance, is its openness. Because the forms are so clear, there is never the danger that they become muddled or lose their formal identity. They are eminently suited to the enormous variations of scale through which Richard Long's art takes them. At the same time they are discrete because, unlike irregular forms, they do not need to be visible in order to be completely imaginable. They are forms that can be invisible and yet real.

When I said earlier that Richard Long's art should not be seen in the tradition of romantic travelling, I meant that this art has a very strong basic formal component which is not alien to typical Modernist concerns in contemporary art; in that sense it would be wrong to say that he is a 'primitivist' who takes up where the builders of Stonehenge left off. Long's stone circles, if enigmatic in effect, have in their conception nothing mystical: they are as real and concrete as the work of his contemporaries. When still at school he realized that the classical procedures of art left large areas of the world or of Nature untouched by art. His interest was, roughly, in landscape and not in sculpture as such (which is one of the fundamental differences between his work and the work of colleagues like Carl Andre or Ulrich Rückriem), and he set out to invent a way to deal with landscape in the direct way typical of the Modernist aesthetic. He employed the basic geometric forms, as old as mankind itself, which Modernism abstracted from their cultic and anthropological context, and which have subsequently gained new currency in the formal language of modern art. The circle, the square, the line, the cross are simple forms, immediately and entirely recognizable, and they can be used in a most precise way, leaving little room for metaphysics. At the same time these forms are also common, universal and shared by many cultures. The art of Richard Long consists, at least on the formal level which after all is what is most visible in it, in leaving such marks on the surface of the earth.

The aesthetic of Modernism, of course, is not the point of departure. No artist puts into practice the rules of a style – he slips through the maze into a new territory of adventure. Walking, placing stones, was, Richard Long discovered, a free and open way to look at a landscape – to make art in the landscape without using the typical pictorial imagery associated with nature – and the obvious forms for walking were circles and lines having a distinction and precision all of their own. He places these forms and invents all kinds of permutations of them, forming an irregular personal grid on the map, unlike abstract meridians, following the lie of the land. 'I am interested,' he commented, 'in walking on original routes: riverbeds,

circles cut by lakes, a hundred miles in a straight line, my own superimposed pattern on an existing network of roads – all these are original walks The surface of the earth, and all the roads, are the site of millions of journeys; I like the idea that it is always possible to walk in new ways for new reasons.'

Seen in this light, Richard Long's art has a chronology, certainly, but not in the sense of evolution and change. Over the years his work has expanded in ideas and in experience. *A Line Made by Walking*, an early work, is no different in formal terms from the *Water Lines in Ladakh*, made seventeen years later in 1984. Of course the place is elsewhere and the method of making is different; the spiritual idea is unchanged – apart, maybe, from the fact that the *Line Made by Walking* was the first one and that the Ladakh line comes after many other lines, in a number of materials, in many places on the earth. That means that the line, in the course of Richard Long's work, changed from almost an intuitive idea into a form of belief. The development of Richard Long's art is therefore not one of change but of continuation and expansion and variation. He has in this way retained an enormous freedom for himself; he has complete command over all his forms, and is free to use them again and again if the place, a new idea, or the occasion requires.

One should not, however, have the impression that his is a relaxed, slowly drifting body of work – nor that there is anything routine or mechanical in its variations. There is, over the years, the element of keeping the edge and maintaining the challenge. Maybe the long walks in often fairly difficult places like Alaska or Africa or Lappland function partly in this sense – as might, in general, his walks in unknown terrain, which he continues to seek out. They are obviously more difficult, requiring more effort, than walks in rural places; their difficulty challenges body and mind in new, unexpected, exciting ways.

The last major walk (at the time of writing) was in November 1985 in Lappland, where conditions were met which he had not, in that form, encountered before. It produced a number of works of which wind is the most important common denominator – and a new aspect in Richard Long's work. The toughness of the walk in the cold is clearly visible in the bleak image of a work like *Arctic Spindrift. A day walking through snow, wind and sunlight on a fifteen day walk in Lappland.* Another of these works is a word piece, *Wind Stones. Long pointed stones. Scattered along a 15 day walk in Lappland 207 stones turned to point into the wind* – on which he sent me the following note, sketching intention and conditions: 'It is about the shape of the walk, the places of the right stones along it and the ever changing direction of the wind at those precise moments of the walk at just those places. Also, placements were determined by the conditions along the walk. On some days there was no wind, on others snow had covered up any stones, and on another day the wind was so strong and cold there was a total concentration on survival and walking and not on placing stones.'

To call this work heroic would be wrong (as it is wrong to call other works romantic). What he did was to take the challenging conditions to discover new forms, using tested 'techniques' in a new situation and place and adding to their excitement.

By November 1968 Richard Long had apparently worked out the implications of the *Line Made by Walking*, and he made another fundamental work, *Ten Mile Walk*, along a straight line on Exmoor. He thought that the most obvious and artistic way to walk was in a straight line. It seems to be in the nature of man, and possibly also of most animals, to move in a straight line, deviations occurring only when one has to go around natural obstacles like lakes or mountains; that, of course, is how roads came into existence. The straight line is a basic form which furthermore can be described precisely and completely.

There is a desire in his work to be precise and simple about everything: line, circle, quantity, distance, geographical location. Thus when he deviates from that principle the work becomes special, a category in itself, as in *Straight Miles and Meandering Miles. A 294 mile walk from Land's End to Bristol walking nine straight miles along the way. England 1985.* The work, which is a word-piece, then lists nine places where the chosen straight miles were walked because owing to the terrain they *could* be walked. The nine straight miles bring a firm punctuation into the walk, each one changing the character of the actual walking. Following roads is a comparatively leisurely way of walking. One can look around at the landscape, notice details, listen to the song of birds: one has time to observe. Walking a straight mile, however, is

an intense business, the eye constantly on the compass or on an orientation point ahead, the walker absorbed in the walking. Doing a really straight line is artificial – it is laying down a distinct pattern foreign to the unevenness of the earth's surface, or it is ritualistic, observing the physical world, the ground, in a different rhythm: less dance-like, more like a solid hymn.

Ten Mile Walk is a map work. After concluding that he wanted to make a work of art ten miles long, and realizing that the obvious, and the purest, way to do so was to walk straight, Richard Long had to find a place where he actually could walk a straight ten miles. He chose Exmoor in Somerset, a tract of high moorland bordering on the Bristol Channel, largely covered with heather and coarse grass. It was conveniently near, and apart from its great beauty, which added to the pleasure of the walk, it had the right topography, being open and rolling. On the ordinary Ordnance Survey map, scale one inch to the mile, he then drew a ten-inch straight line. The route was chosen carefully. The map showed no great obstacles. There were no rivers to cross, and while he would walk most of the way at a height of approximately 1500 feet, without much going up and down, the last three miles towards Cowley Wood where the walk ended would be more or less downhill. In fact, looking at the map one can see that the route chosen following the lie of the land was probably the only one which had no obstacles or great variations in height for a distance of ten miles.

He made the walk directed by the compass: simple and practical in the event of the low cloud and mists which are common on British moorland. It would be a straight, uninterrupted and, in terms of covering the projected distance, smooth walk – direct and uneventful. This is a quality that the *Ten Mile Walk* shares with the *Line Made by Walking*. I want to emphasize that point because, contrary to what many people seem to think, Long's walking has nothing to do with an exploration of the hidden splendour and mystery of Nature, or with a romantic, elegiac longing for a purity forever lost to our urban and industrial present. Thus, a lot of the places he uses have no particular natural beauty; that is, they do not have an artistically codified beauty. Although he is, as he remarked to me, often overwhelmed by the places he chooses to work in (sometimes not knowing them beforehand), the purpose of the artwork is not to illustrate that beauty but to give, as purely as possible, the idea of the walk. 'Behind my work', he wrote, 'is the idea that I have seized an opportunity, won a fantastic freedom, to make art, lay down abstract ideas, in some of the great places of the world. So even with storms or bogs or blisters or tiredness, the way I can make my work is intensely pleasurable and satisfying. Even in the more modest ambience of a road walk, the labyrinth of country roads, the inns, the Bed & Breakfasts, the fabric of country life is still an enjoyable part of making the work and, although not specifically the subject of it, it is implicit in the idea of the work and the place of it.'

Similarly, going to distant parts of the earth like Ladakh or Alaska or Bolivia or Nepal, names with a spectacular ring to them, he does so according to the principles of his art: in those vast, empty areas of near-wilderness certain types of walk are possible that are impossible in the more familiar terrain of Dartmoor, Ireland or Scotland, or would not have the same quality. The notion of distance is, of course, extremely relative. Richard Long literally considers the whole world as a single space to make work in, when opportunity or desire provide chance and motive, and he seems to be very free of cultural preconceptions. He recognizes no geographical hierarchy, although he is deeply aware of the differences between places. Somehow these differences, encountered and experienced while walking, can be felt in the conception of particular walks – not maybe in their actual form but in their melody and pace. Once he made a walk in southern Ireland, *Mountains to Mountains*, a 138-mile walk, walking over seven smallish mountain ranges, going from highest point to highest point. The difference between this walk and a work done in 1984, *From Pass to Pass. A 12 day walk from Lamayuru to Dras in the Zanskar Mountains of Ladakh, Northern India*, was, among other things, that the Irish mountains ranged between 540 and 900 feet in height whereas in Ladakh he walked at an average height of 14,000 feet. In Ireland he had, over a relatively short distance of 138 miles, to cross over roads and pass through towns and villages. Ladakh is of course much more lonely, the air thinner – a walk in a different atmosphere of nature which puts the artist into a frame of mind that permits the making of *Water Lines in Ladakh*: an image of gentle poetry which would not have emerged amid the chatter of Ireland. Somehow, the atmosphere

comes through in the photographs that are used to present the work.

A sense of awe must come over you when you are in such places as Ladakh for the first time. That may be the reason that most walks in those distant areas are relatively simple as to their formal structure, almost as if to leave enough room for the atmosphere to slip in. But there is also a practical reason for this. A structurally complex work, or even a formally simple but very precise work like the Exmoor *Ten Mile Walk*, takes a certain amount of preparatory planning – which is virtually impossible to do for an area which you do not know and of which the existing maps are often rather scanty. In 1981 he embarked, together with his friend and colleague Hamish Fulton, on a walking trip in Bolivia. First they went to the Royal Geographical Society in London to study maps. These did not say much except that there seemed to be a fairly large area, blank on the map with only the generic indication 'rocky'. That was where they decided to go. It is clear that for such a walk one cannot plan intricate walking patterns ahead. One must make decisions along the way. About their first visit to South America in 1972, he wrote: 'It was a very imaginative trip; we were light on our feet, and wits, travelling freely, by instinct and circumstance, making decisions as we went along.'

Structurally more complex walks tend to be performed on ground well-known to the artist, like Scotland and, most of all, Dartmoor, which from Bristol is an hour and a half on the train. Many other works, too, are executed and were conceived for places close to Bristol (where he was born and where he lives), and a fair number of pieces are connected, one way or another, with the River Avon. The works done in south-west England, many of them on existing roads and lanes, are works which that area permits, works that it is sensible to do there. For instance there is a walking piece (presented on a map) made in Dorset in 1975: *A Six Day Walk over all Roads, Lanes and Double-tracks inside a Six Mile Wide Circle Centred on the Giant of Cerne Abbas*. Even though the walk took six days to complete, it is small in scale (certainly absolutely different from the scale of the Ladakh and Nepal mountains). It nevertheless has a precise structure. It is like a miniature; form and structure respond perfectly to the intimate character of the English landscape. The walk (within a place, or circle, and not linear like the Ladakhi *From Pass to Pass*) actually articulates that intimacy, which is also intimately known to Richard Long himself.

If the art that comes out of great walks in wide open spaces like Nepal or Bolivia or Peru uses and emphasizes the large scale and tends also to be more atmospheric, the works closer to home tend to be formally intricate, in a sense almost close-ups. This goes especially for Dartmoor, which he himself has called a prototype landscape, 'or an archetypal place: on a bigger scale landscapes in Scotland, Lappland, Alaska, the American prairies and many treeless mountain areas have similar characteristics'.

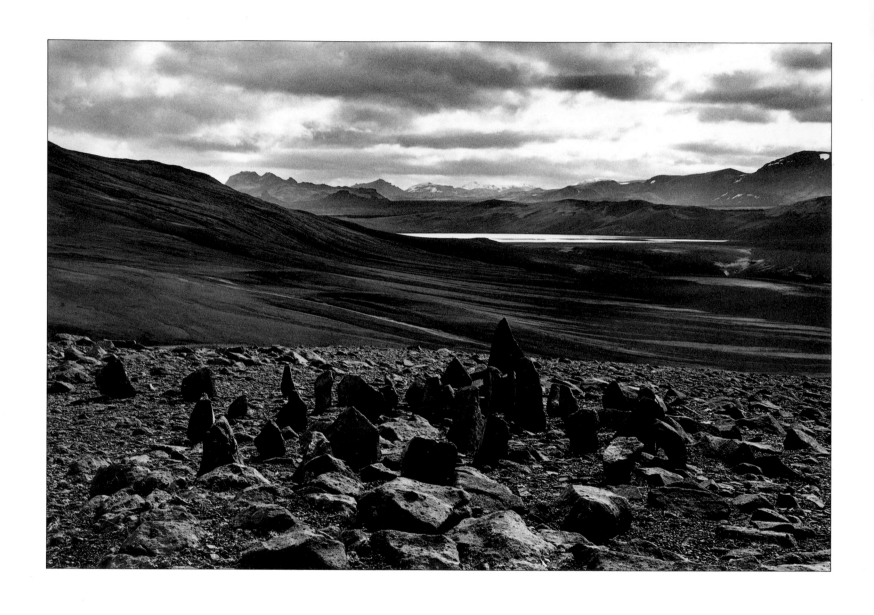

STONES IN ICELAND

1974

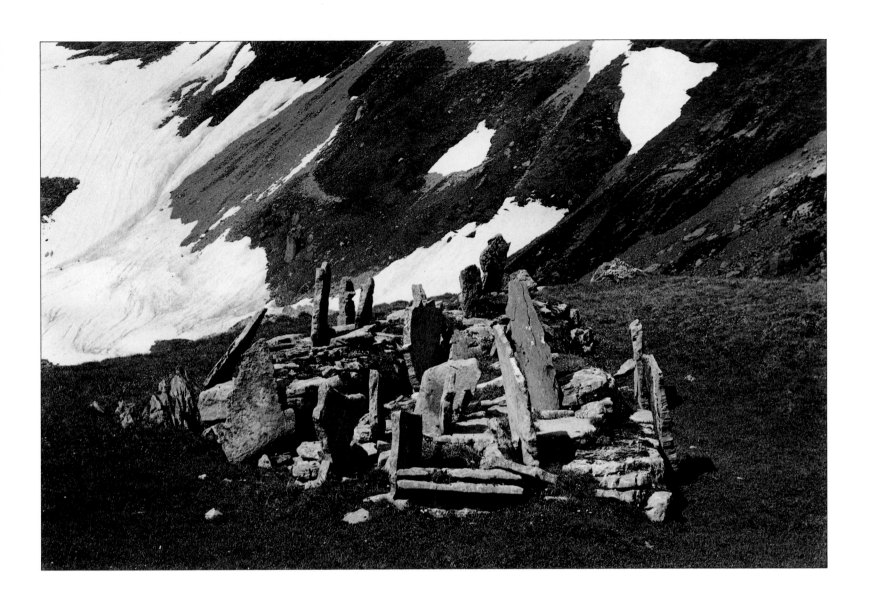

STONES IN SWITZERLAND

1977

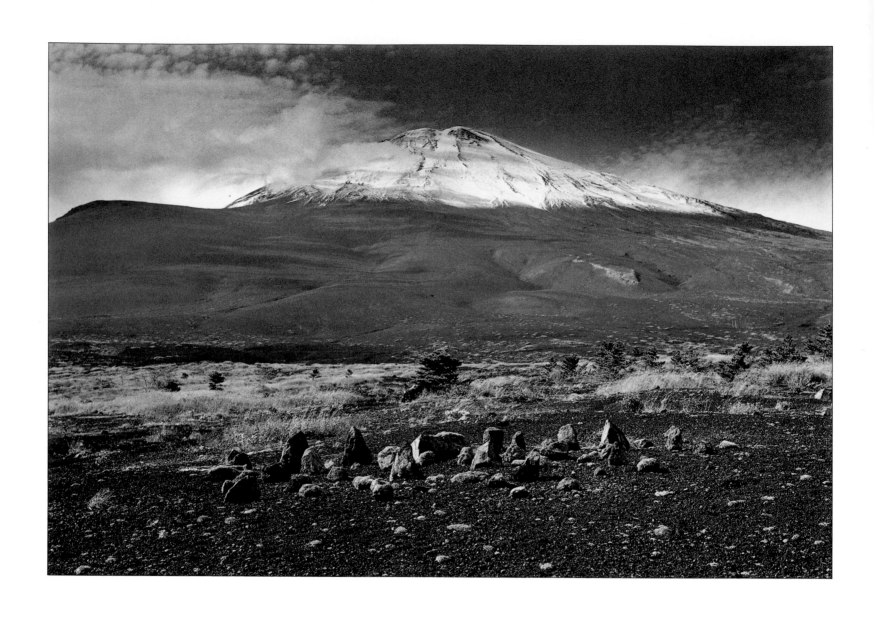

STONES IN JAPAN

1979

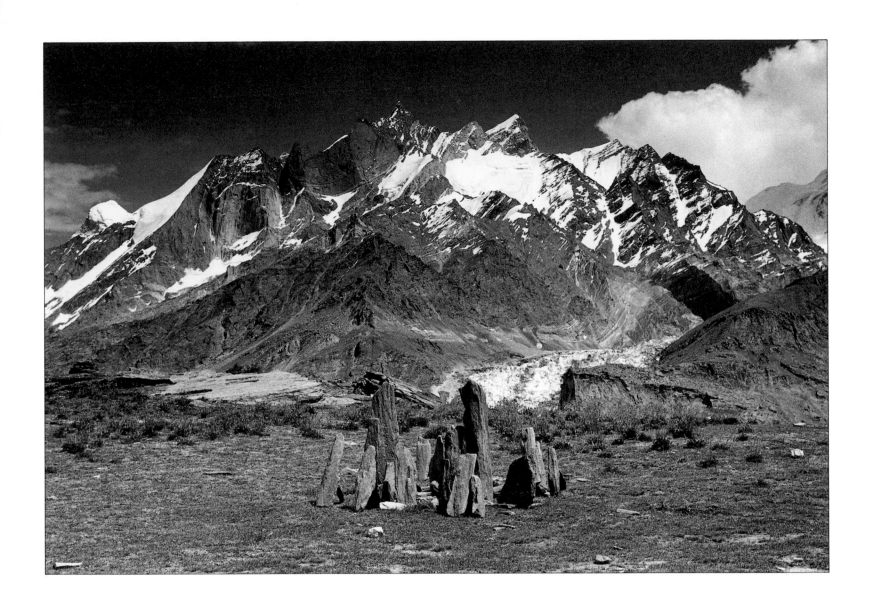

STONES IN LADAKH

PARKACHIK LA NORTHERN INDIA

1984

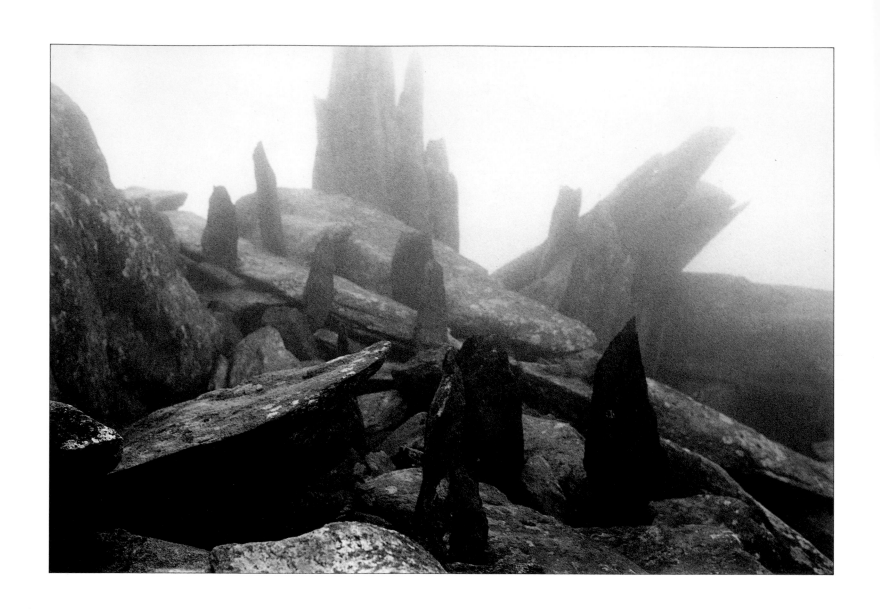

STONES IN WALES

CASTELL Y GWYNT

1979

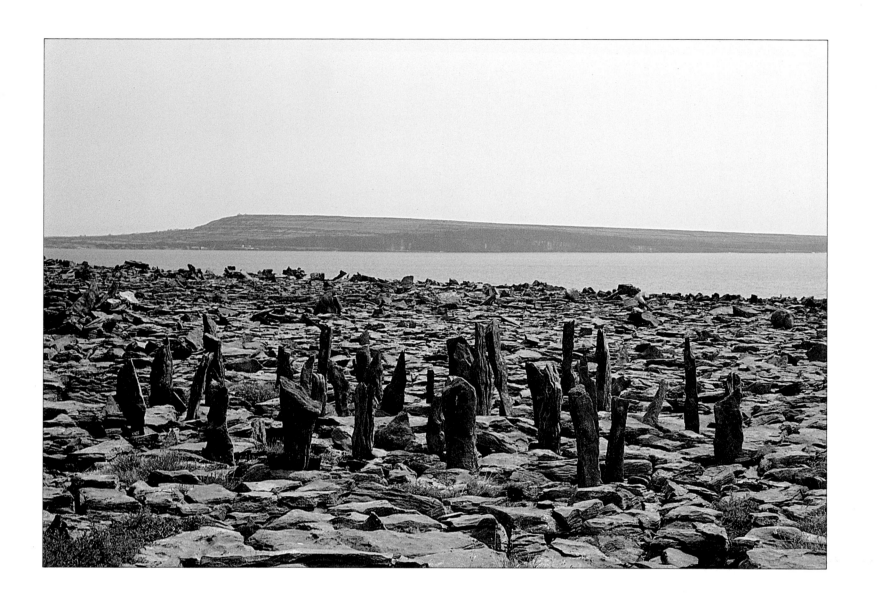

STONES ON INISHMORE ARAN ISLANDS

WEST COAST OF IRELAND

1975

A TWENTY FIVE DAY WALK IN NEPAL

1975

DAY 11 CROSSING THE DUDH KOSI RIVER FOR THE FIRST TIME

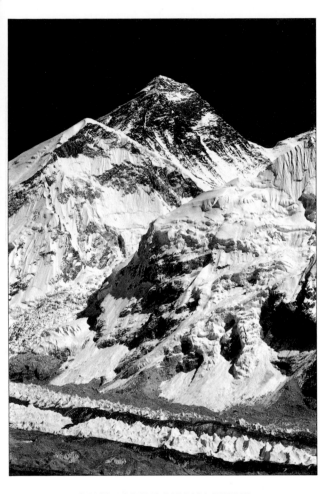

DAY 20 LOOKING TOWARDS EVEREST
FROM THE HIGHEST POINT OF THE WALK

DAYS 15 AND 23 PASSING THE IMPACT MARK OF A FALLING ROCK

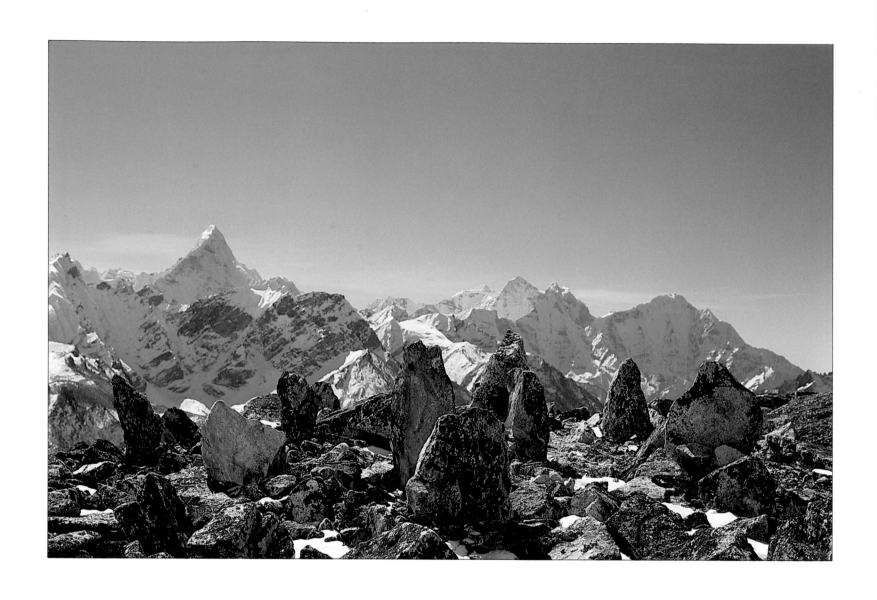

STONES IN NEPAL

1975

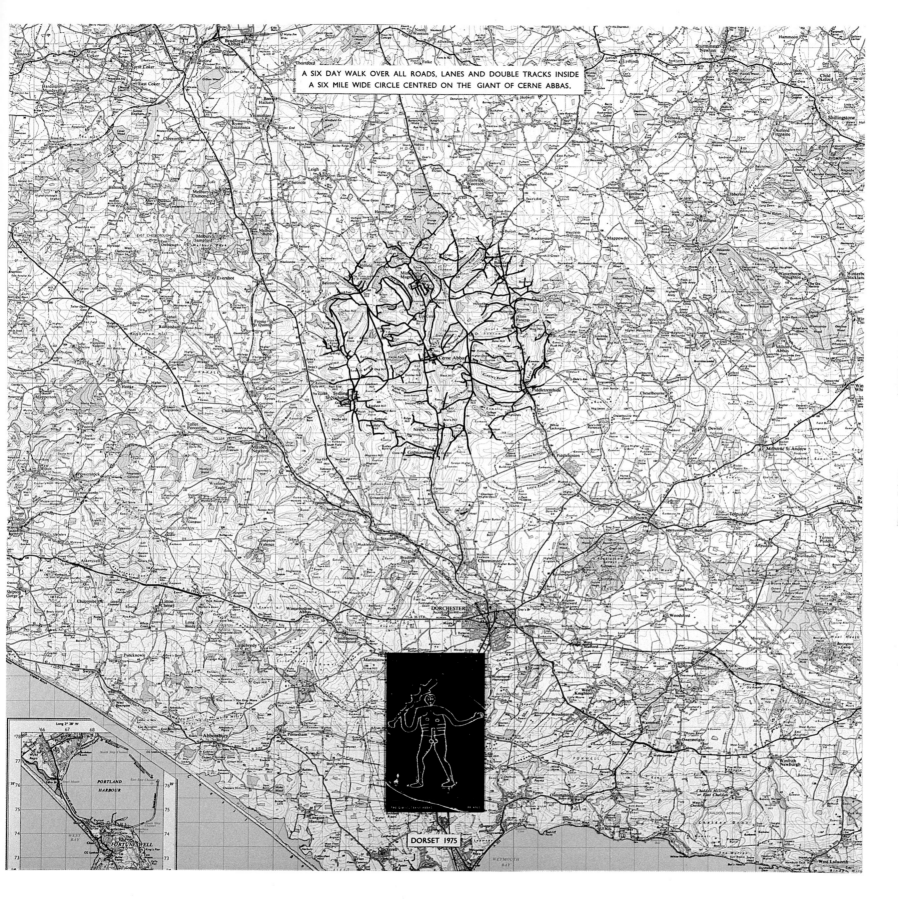

A SIX DAY WALK OVER ALL ROADS, LANES AND DOUBLE TRACKS INSIDE A SIX MILE WIDE CIRCLE CENTRED ON THE GIANT OF CERNE ABBAS.

DORSET 1975

85

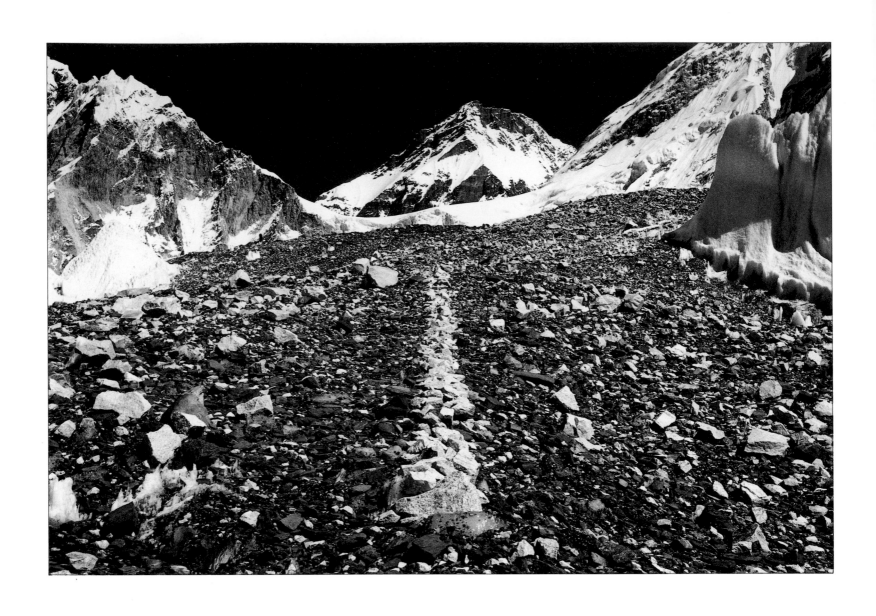

A LINE IN THE HIMALAYAS

1975

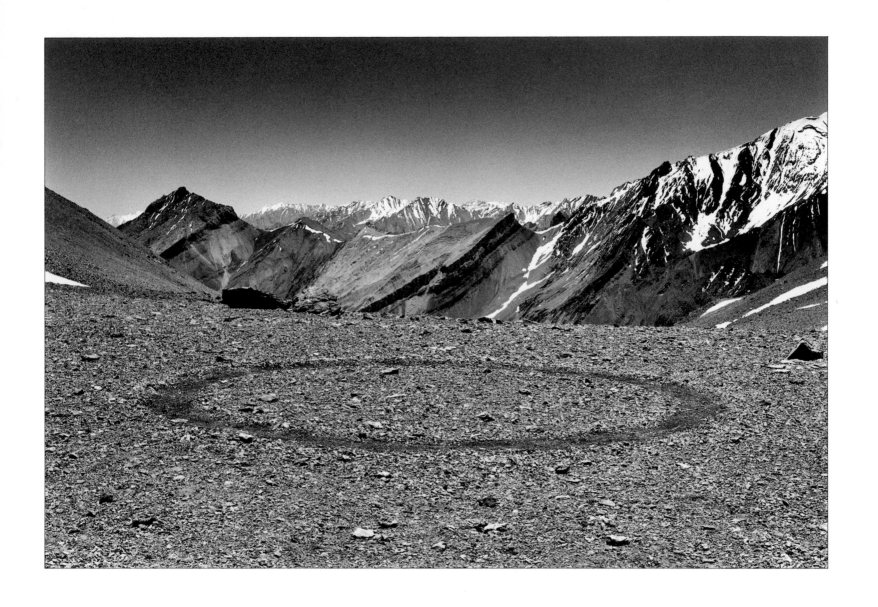

WALKING A CIRCLE IN LADAKH

16,460 FT. PINGDON LA

NORTHERN INDIA 1984

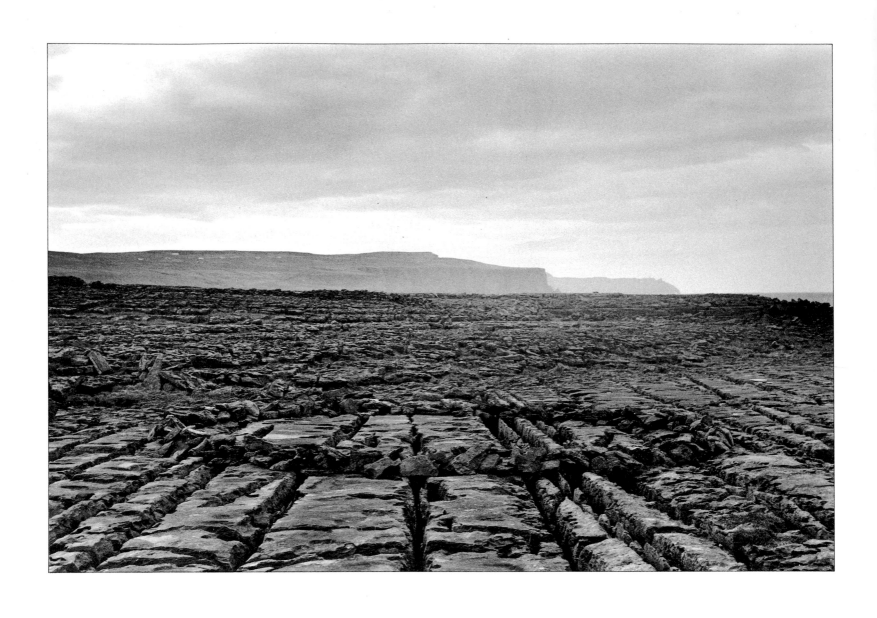

A CIRCLE IN IRELAND

COUNTY CLARE 1975

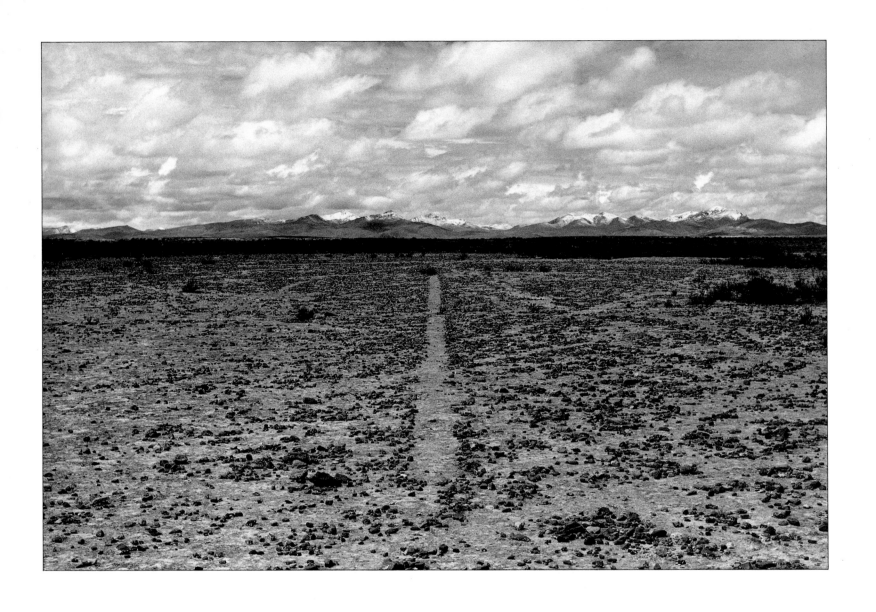

A LINE AND TRACKS IN BOLIVIA

1981

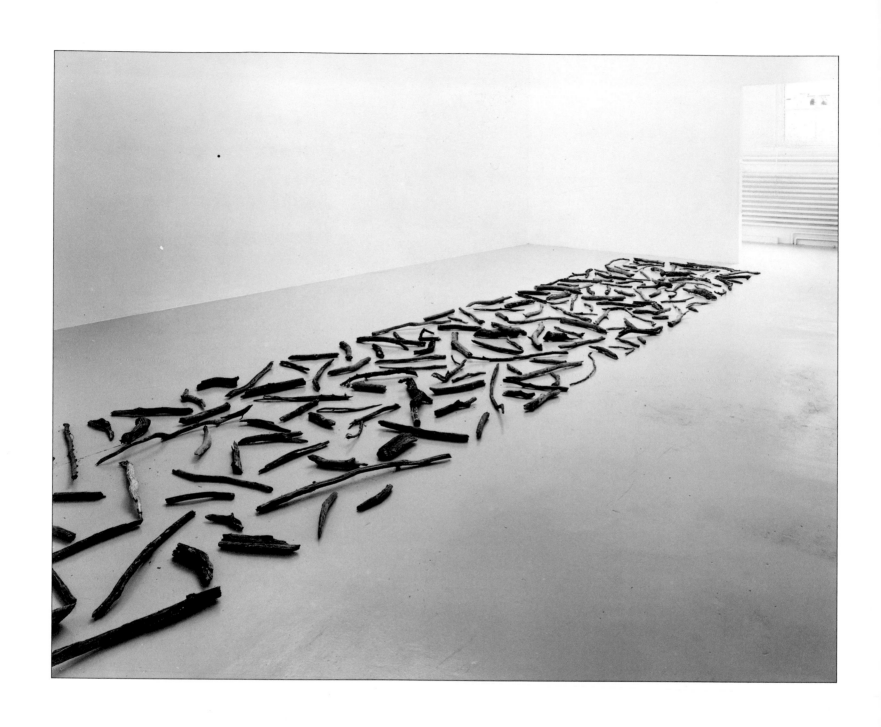

192 PIECES OF WOOD

SWITZERLAND 1975

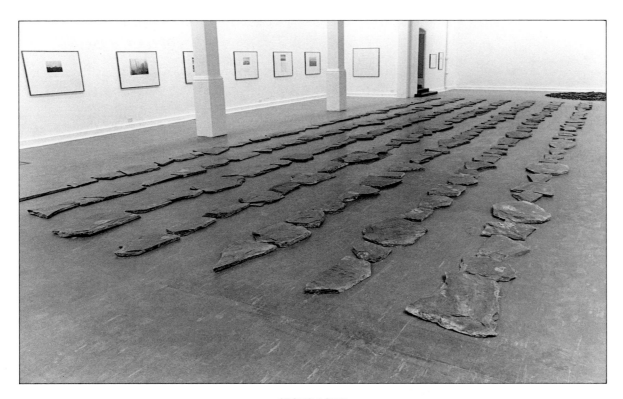

STONE ROWS

LONDON 1977

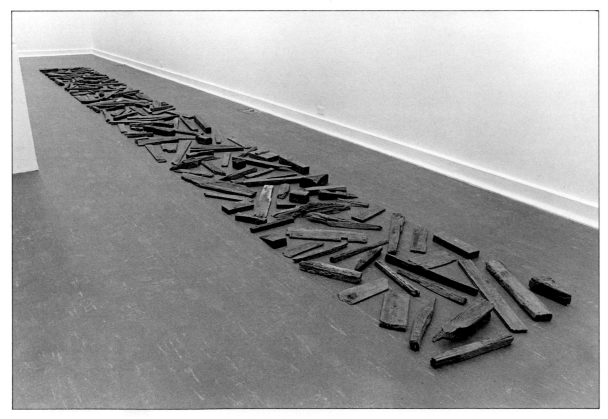

RIVER AVON DRIFTWOOD LINE

LONDON 1977

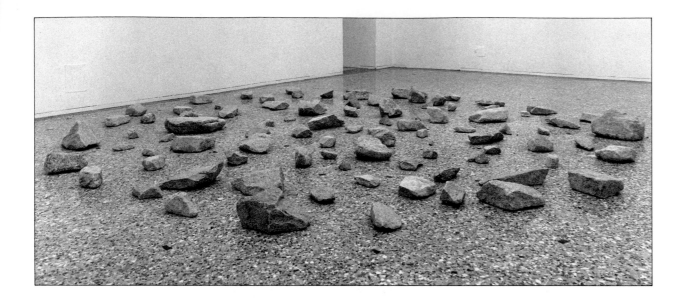

ABOUT 100 STONES

MILAN 1976

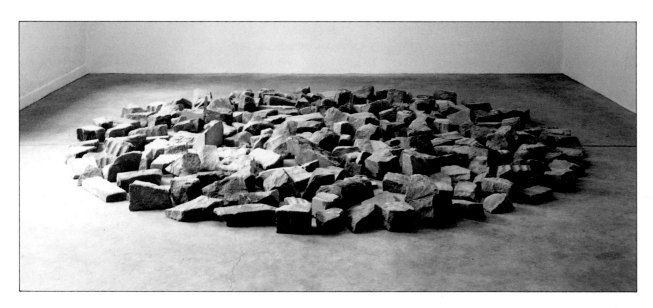

SANDSTONE CIRCLE

BASEL 1977

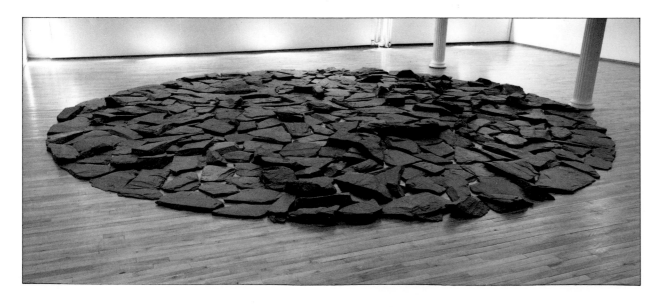

RED SLATE CIRCLE

NEW YORK 1980

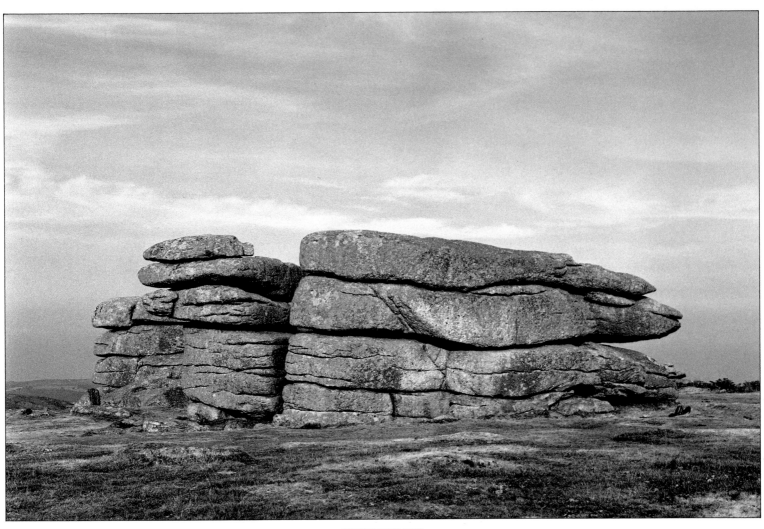

COMBESTONE TOR

A HUNDRED TORS IN A HUNDRED HOURS

A 114 MILE WALK ON DARTMOOR

YES TOR	WINTER TOR	GREAT MIS TOR	HUNTER'S TOR	FOX TOR
BLACK TOR	EAST MILL TOR	CONIES DOWN TOR	RAVEN'S TOR	SOUTH HESSARY TOR
SHELSTONE TOR	OKE TOR	LYDFORD TOR	HOUND TOR	KING'S TOR
SOURTON TOR	STEEPERTON TOR	BEARDOWN TOR	HONEYBAG TOR	VIXEN TOR
GREAT LINKS TOR	HOUND TOR	LITTAFORD TOR	CHINKWELL TOR	FEATHER TOR
BRAT TOR	WILD TOR	LONGFORD TOR	BELL TOR	HECKWOOD TOR
DOE TOR	WATERN TOR	HIGHER WHITE TOR	HOLWELL TOR	PEW TOR
GER TOR	RIVAL TOR	CROW TOR	HAYTOR	INGRA TOR
NAT TOR	KESTOR ROCK	ROUGH TOR	SADDLE TOR	LEEDEN TOR
HARE TOR	THORNWORTHY TOR	DEVIL'S TOR	RIPPON TOR	HART TOR
SHARP TOR	SITTAFORD TOR	FLAT TOR	TOP TOR	BLACK TOR
CHAT TOR	FUR TOR	LOWER WHITE TOR	PIL TOR	SHARPITOR
GREEN TOR	LYNCH TOR	HARTLAND TOR	HOLLOW TOR	LEATHER TOR
KITTY TOR	BAGGA TOR	STANNON TOR	WIND TOR	DOWN TOR
LINTS TOR	WHITE TOR	BIRCH TOR	CORNDON TOR	COMBESHEAD TOR
DINGER TOR	ROOS TOR	HOOKNEY TOR	YAR TOR	CALVESLAKE TOR
WEST MILL TOR	COX TOR	HAMELDOWN TOR	COMBESTONE TOR	HARTOR TOR
ROWTOR	GREAT STAPLE TOR	KING TOR	HUCCABY TOR	GUTTER TOR
BELSTONE TOR	MIDDLE STAPLE TOR	SHAPLEY TOR	LAUGHTER TOR	HEN TOR
HIGHER TOR	LITTLE MIS TOR	EASDON TOR	BELLEVER TOR	GREAT TROWLESWORTHY TOR

DEVON ENGLAND 1976

A 24 HOUR WALK

80½ MILES

AN EASTWARD WALK FROM MONTPELIER, BRISTOL, TO HARDWICK HOUSE NEAR PANGBOURNE.

ENGLAND 1977

A FIVE DAY WALK

FIRST DAY TEN MILES
SECOND DAY TWENTY MILES
THIRD DAY THIRTY MILES
FOURTH DAY FORTY MILES
FIFTH DAY FIFTY MILES

TOTNES TO BRISTOL BY ROADS AND LANES
ENGLAND 1980

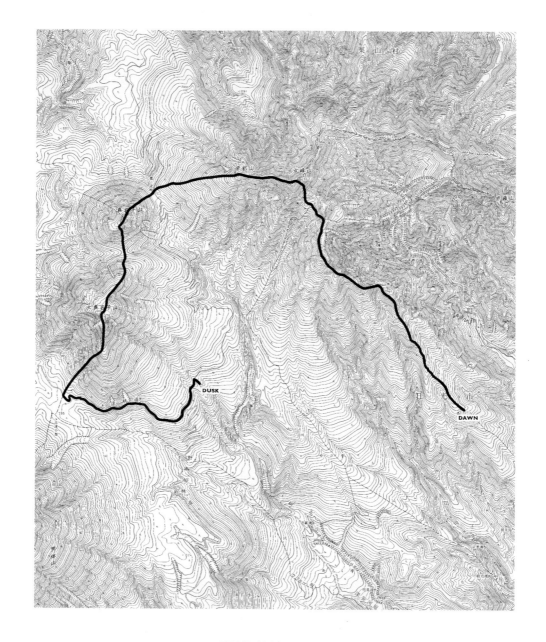

FOUR MOUNTAINS

四つの山

女峰山	8078 FT.
帝釈山	8000 FT.
小真名山	7617 FT.
大真名山	7790 FT.

1976

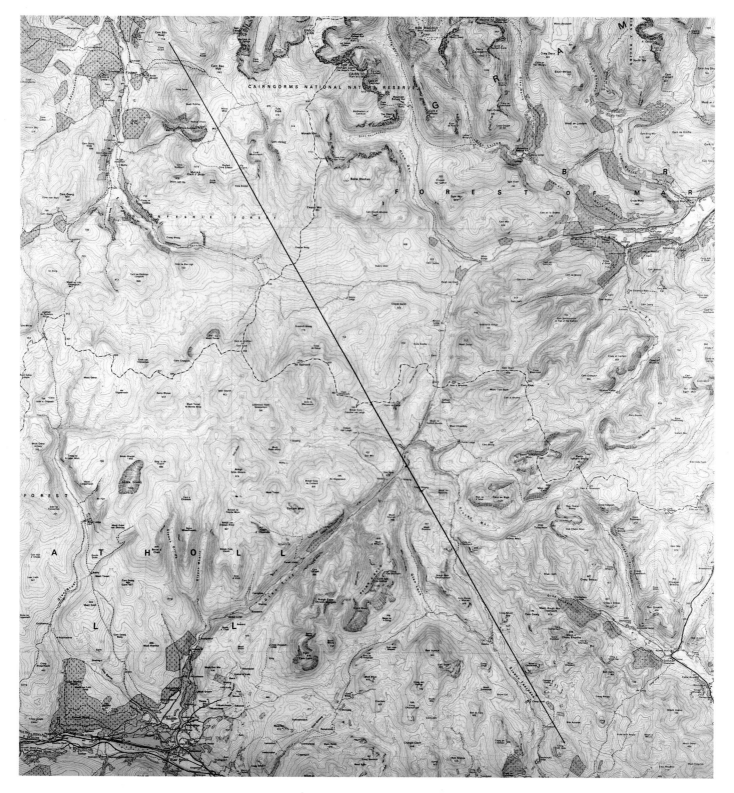

23³/₄ MILES

AS THE CROW FLIES

A ONE DAY SOUTHWARD WALK IN THE HIGHLANDS

SCOTLAND 1979

Dartmoor

Dartmoor, in south Devon, is a broken granite tableland more than 300 square miles in extent. The mean elevation is about 1200 feet, but many of the hills are higher, up to more than 1900 feet, and are crowned with granite masses known as tors. The ground is mainly covered with heather, bracken, grass and other low-lying plants; it is intersected by many streams, in all directions, seeping through bogland or rushing down the rocks. This place, to Richard Long, is above all an area of ground surface – which is not to deny that it has presence and atmosphere.

Over the years he has continued to work on the prototype 'abstract' landscape of Dartmoor. That is because the ground of Dartmoor has no particular features, therefore permitting everything. Or maybe it is better to say, it has no single commanding feature as some of the other landscapes have: the passes of Ladakh, the rocks of Western Ireland, the lava plain in Bolivia, Mount Everest in Nepal. It is, above all, a type of ground or surface, neither very high nor very low, nowhere divided by deep gorges, with spare vegetation, rocks and tors, streams and bogs, as well as remnants of ancient human habitation like footpaths, cairns, clapper-bridges, old claypits, scattered stone circles (foundations for prehistoric huts). Another important aspect of Dartmoor (which sets the area off from places like Bolivia or Ladakh) is that most of these elements, even small and insignificant ones, have proper names coined in the long history of the place.

This latter aspect for instance enabled Richard Long to make, in the dry summer of 1976, one of his largest works there, *A Hundred Tors in a Hundred Hours. A 114 mile walk on Dartmoor.* It is a typically constructed work which could be planned because, on the map, all the tors are named so that a route could be worked out which allowed reaching a hundred tors in a hundred hours. From that constructed itinerary resulted the length of 114 miles. If one follows the walk on the map – which, incidentally, is not part of the 'presentational' form of the piece, which consists of title, the names of all the tors and a photograph of one of them – one can imagine the rhythm of the walk, which was a hundred hours from beginning to end, including the hundred tors as well as camping in the normal way. The work was about the overall symmetry of time and places; the actual walking was easily adapted to that.

Pace of walking itself is the 'subject' of an earlier Dartmoor piece, *A Walk of Four Hours and Four Circles.* Four concentric circles were drawn on the map. The object was to walk each of the circles in exactly one hour. The inner circle was walked first, very slowly, then the others with increasing speed and precise adaptation of pace. In that way one becomes extremely conscious of speed as well as time: the control is almost exclusively on the physical activity of walking – even though the piece is strictly formal when seen on the map – and one realizes that it was that strict construction which made possible the distinction between four different speeds of walking. In the early days he thought that each work should be exclusive to the place of its making; this probably was a theoretical point about purity, the place being spiritually relative to the form and character of the piece. As usual in art, practice overtakes theory all the time. Afterwards Richard Long continued to work on Dartmoor and in the West of England in general, because it was convenient but also, maybe, because he felt that the steadily increasing practical knowledge he would gather, for example, about Dartmoor, would help him to devise new works.

A bit to the south, in the summer of 1970 he started a walk by night along a line of the existing grid of squares on the map: *For Six Consecutive Nights I Walked by Compass. From east to west, the line drawn on the map. The time taken was recorded at the end of each walk.* This work too was very much about walking, but in darkness, over unfamiliar ground, by compass. Sight was modified and primary perception took the form of hearing. The

first walk took 5 hours 22 minutes. He completed the last one, knowing the way much better, in just over 4 hours. To the north of this line and parallel to it, he walked, in March 1971, a straight line to the length of 1 hour at normal walking pace: 'Then marked the distance on the map. On each of the following days I walked along the same line and the times taken are given.' Each day he went more slowly, the walk extending into the night and eventually through the night into the next day: 4 hours, 8 hours, 16 hours, 32 hours. The piece was distributed as a mailer from the Konrad Fischer Gallery, Düsseldorf, which carried also the following text: *The sculpture becomes slower and slower, from day to day, day to night, day night day, motionless.* In that it involves changing pace, the work relates to *A Walk of Four Hours and Four Circles*, which was a piece about acceleration of pace as well as about changing perception. The execution of the line sculpture walked on consecutive days also included growing familiarity with the ground and the surrounding landscape; as the walk slows down, perception grows. The walker has his eyes wide open all the time.

The relation between pace and perception is a central aspect of Richard Long's art – it is what makes the walks much more than formal exercises. Walking is also a means to acquire much more intimate knowledge about a place than one would arrive at by just *looking*. Walking is, in many ways, an intensification of perception. For instance, another Dartmoor walk, *Eight Walks*, is almost like a systematic quartering of an area a little over 3 miles square which is crossed over eight times, four times north to south, four times west to east, following the lines of the existing grid of the Ordnance Survey map over an equal distance. The time taken for each walk, between 60 and 70 minutes, is a precise reflection and transference, into time, of the particular differences of each line of ground, at constant walking pace. Recently he made a piece, partly in the same area, with a similar content but different in form: *A Seven Day Circle of Ground. Seven days walking within an imaginary circle 5 1/2 miles wide* – each day starting out from the centre, where his tent was pitched, and walking about at random. The piece is a circular textwork. It gives the positions of midday and, scattered in between, the names of various geographical points. It is virtually the antithesis of the *Eight Walks* which is formally strict and very planned. The later work is freer; the form of the

walking is left out, only the juxtaposition of time (seven days) and the area of the circle is there to indicate the perceptual density of the sculpture.

As *Eight Walks* used, as pattern, the abstract grid of cartography, and as the roads of the *Cerne Abbas* work follow social and historical human patterns, the work called *Dartmoor Riverbeds* (1978) has the natural pattern of streams going down towards the sea. Choosing the high area of Dartmoor which contains the sources of streams flowing in all directions, he made the work as *A four day walk along all the riverbeds within a circle on Dartmoor.* Wearing waders, he used the riverbeds as footpaths. Following the water really involved following the lie of the land: he was adding to his experience on Dartmoor, which he had, up to that point, gathered by walking his own abstractly conceived lines and circles.

The next year he crossed Dartmoor from south to north: *A Straight Northward Walk Across Dartmoor 1979* – a line on the map but not walked, this time, with a compass but by orientation towards a known point ahead – a truly visual work, looking ahead towards the horizon. Subsequently it was presented as an upward line of words naming things seen, headed towards or passed. This type of perception is typical of a linear walk, I would assume, and is intrinsically different from the perception of landscape in walking a circle, when the attention (through concentration upon the circular form to follow) is more directed towards the ground.

In a recent Dartmoor work, done after coming back from Lappland and the cold wind so characteristic of that walk, he introduced a new method of notation: little arrows that denote the changes in the wind's direction while walking a straight line. *Wind Line. A straight ten mile northward walk on Dartmoor, 1985* is an exciting piece because it shows, once more, how the experience, or the 'technique' of walking, as an art form, can encompass a wide range of sensations. Moreover, Richard Long has here found a way to deal with wind as a walker's companion. Classical painting or photography can show only the effect of wind: bent trees, high waves or the drifting snow in the Lappland work *Arctic Spindrift*. In *Wind Line* the changing arrows are the direct translation of the wind itself: its changeability projected against the rigid straight line of the walk – a translation without other intermediary imagery, superbly concrete and precise. *Wind Line* also

shows that no work of Richard Long's is ever purely formal. Formal structure is always functional, involving the gathering and transmission of observations and experiences relative to the place and idea of the walk. Sometimes the formal structure, when concise and definite, as for instance in *Ten Mile Walk* or *Eight Walks,* leaves details unrecorded. In other instances, especially in the word-pieces (which in the last years have multiplied) he has found the means to be copious in the description of details. *One Hour* is such a richly detailed work, a circle of moments. The *Eight Walks* were structurally and for-mally explicit lines of time. *One Hour* is a circle of observations finding their way into words. Together they put across, in the form of a circular close-up, the rich texture of the walk. Many of the observations are directed towards the ground: grass, heather, slabs, rock, skull, droppings. There are observations of colour, blue, brownish, yellowish; of sound, sounds underfoot, sounds of the body, breath, panting; of water moving; of the conditions of the terrain, bank, pool, downhill, slant, slope; of weather, wind, sunlight. The richness is all there, in the circle of words.

Words and Maps

The first word-work was direct, clear, precise and enigmatic: *Richard Long March 12-22 1969 A Walking Tour in the Berneroberland.* It was made for a famous exhibition of what was then called 'Conceptual Art'. The exhibition, in the Kunsthalle, Bern, was organized by Harald Szeemann and was titled *When Attitudes Become Form.* It also had a subtitle: 'Live in your head'. The presentation of the work was dry and simply descriptive: nothing but a notice on paper attached to the gallery wall. Yet it is typical that the very first of what later was to become a series of works constructed with words is so direct and light in its form. Like the *Line Made by Walking* and the straight *Ten Mile Walk*, this first word-piece, a prosaic description of unspecified walking in the area around Bern (making the work in the landscape where the exhibition was going to take place), shows no inclination towards artistic complication of form. It is – and this suited the innovative character of the exhibition – almost defiant and polemical in its simplicity. It is perfect in its phrasing, leaving, for all the sparseness of information, no doubt as to what the work is about.

Phrasing, of course, is one of the things which lie at the heart of Richard Long's work, whether it is with words only, or in relation to a photograph or a map – where actually the image is never autonomous in respect to the description or title. The image of a line put together of stones becomes more concrete or more physical when the title is read at the same time: *A Line in Iceland.* The title gives the photograph an atmosphere and, more important, a scale. One has, after all, some idea about Iceland, even never having been there. Iceland, one knows, is different from Australia or Spain. Thus the photograph showing *A Line in Australia* is seen in a different frame of mind. Apart from the fact that the stones are visibly different, resulting from different geological histories, the works differ in feeling because of the identification of their locale. The photographs are as much images of work

as they are images of place. They are directly related also to the history of the earth itself. The types of rock tell us something about that. Once, going up a mountain in Africa with the idea of making a circle of stones, Richard Long found that there were no stones lying around because there was no ice on that mountain to break up the slabs of rock. There were, however, regular lightning storms in which the tall standing cacti growing there were hit and scorched. So he made a circle with pieces of scorched cactus: *Circle in Africa.*

After the first word-piece in Switzerland, it took a number of years, until 1977, before he made word-pieces again, but then they were to become a full genre in his work. Also they rapidly became more complicated (like his walks after the *Ten Mile Walk* on Exmoor) as he started to work on them more consciously, developing and differentiating their form and content and purpose. The first word-piece of the new generation is called *Four Walks.* It is rather a large piece, combining four walks, each time between significant topographical points in three different countries: Ireland, England and Wales – giving the piece a grand, epic quality; from mountain top to river source, from moor to seashore, from lake to forest. Reading the piece, one understands the reason for its being in words. Words, compared to maps and photographs, are very easy to handle. They are precise. They are the most common form of human communication. They are found, just as stones are found along the way. They have no particular scale of their own and they are all physically similar. The words of the name 'Sherwood Forest' are materially no different from those of the name 'Chesil Beach', each consisting of a number of letters. Their meaning is however different, and that difference is precise. They are not interchangeable. By comparison with this material similarity, photographs of those places, or maps of them, are clearly distinct from each other but no nearer to reality, and maybe less comprehensive. It is

almost impossible to take a photograph that contains, as the name does, the whole of Sherwood Forest. To construct in photographs a singular, homogeneous piece consisting of four physically different walks in completely different areas would need at least eight photographs – four times as many as a work like, for instance *Windmill Hill to Coalbrookdale*. That walk, of 1979, is a walk between two precise points of historical significance. The hill is the earliest sign of human habitation in England, the bridge over the Severn at Coalbrookdale is the first monument of the Industrial Revolution that would effectively and abruptly change the face of the English landscape as it had existed, changing only very slowly, since the time of the Windmill Hill civilization. Photographically, it seems, the *Four Walks* could never have been presented so concisely as *Windmill Hill to Coalbrookdale*: their grand scale needed words.

Maps present different but similar problems. If it is to be more than just an illustration, a map has to show a particular route marked on it. That, obviously, was not the content of *Four Walks*, in which the actual itinerary is secondary to their starting and finishing points. *Four Walks* had no common point as had another photographic piece, *The Crossing Place of 2 Somerset Walks*. That walk was made with a completely different idea in mind, that of establishing, by using roads, a centre of the county of Somerset. The two walks project a cross, going southward and eastward, from border to border – measuring the county, so to speak (much as the Isle of Wight was measured in six walks up and down). The obvious photograph, totally covering the intention and design and idea of the walk, was that of the crossing point.

These comparisons indicate that *Four Walks*, though superficially similar to many other pieces, is unique in its marking of topographical points, in between which the walking, over a certain number of miles, was done. A walk of this form and scale can be presented only in words; or rather words are the single perfect form to describe the walk. All the works of Richard Long have a balanced and calculated relation between the idea and the form of their presentation. In fact, the choice of medium may already point to a certain kind of work which in another medium would be impossible or at least cumbersome – and so be at variance with the basic principle in Richard Long's aesthetic, which is logical practicality.

In a text published a few years ago he wrote that he liked 'common means given the simple twist of art' or 'sensibility without technique'. The twentieth-century artist has always liked to present himself in that state of grace. I can see, from going through the work over and over again, that Richard Long is an artist who relies, more than most, on instinct, on good feelings about a place or a situation. So, trying to understand a work's structure by first isolating its elements may seem to violate the wholeness of that work, which is always all the works rolled into one. But experiences, of whatever kind, are floating, formless – the artwork gives them form and meaning and beauty. The actual work (words, a circle of stones, a photograph) is different from the sensibility that produced it because it is a construction: words, photoprinting, typography, stones, signs, watermarks, colours, mud, wood, sticks, driftwood, footprints: all *arranged*, somehow, according to rules, procedures, preferences, models and also instinct. My writing is not about the sensibility, which I can only surmise; my writing is about the arranging, the *arrangement* of details. Therefore I read and reconstruct.

It seems to be the intention of many word-pieces to bring together and to group natural stimuli in a variety and density which are beyond the reach of photography. A most notable example is the beautiful *Early Morning Senses Island Walk*, made on the Isles of Scilly in 1982 and presented as five vertical lines of words corresponding with the five senses: vision, touch, hearing, smell and taste: sun, hard path, gulls, fresh air, blackberry. The richness comes out best when the words are read both vertically and horizontally, or even criss-cross. One then discovers that some phenomena are experienced by more than one sense. The sun is seen but also felt as warmth. The sea is smelt, then tasted (salt water), but also seen (dazzling foam) and heard (distant surf roar, breakers). One bird, the lark, is heard, but the shag and the wren are seen. The butterfly, whose flight is silent, is seen, whereas the bee is always first heard, then eventually seen. Some things cannot be seen, like fresh air, which is smelt, or like crunching which is heard. Other things, like the lighthouse, cannot be heard or smelt but can be seen. Boulders are touched when one climbs over them; when doing so, one hears water lapping between them. A word-piece like *Early Morning Senses Island Walk* is extremely free-

ranging in its expression, yet by adhering to the classic division of perception through the five senses it also has a strange formality which makes it perfectly rounded and complete.

All the word-pieces have a form, more or less tight, but none of them has a narrative syntax as in poetry. They are visual art using words; they are, like the map-pieces, rather dry in their formulation. That is, they do not syntactically construct an atmosphere, as poetry does, although a few of them come close: the *Senses Walk* is suggestively atmospheric, if only by the inclusion, in the title, of the words 'early morning'. Another piece that is more atmospheric than most is *Full Moon Circle of Ground:* a rather sturdy work compared to the breezy lightness of the *Senses Walk,* words weighing on the paper like stones, rough-cut because the pale bluish light of the full moon eliminates from nature not only the finer details but also colour. So, if we have in *One Hour,* the other circle on Dartmoor, a finely tuned perception capturing details and shades (brownish, spider, haze, moth), the *Full Moon Circle* has a completely different metre. Also – and that too is part of one's experience of the work – *One Hour* follows the fine, thin edge of the circle as the words follow each other rhythmically and melodiously, minute after minute; the *Full Moon Circle* has a surface but only a rough perimeter of eight stones. The words are on their own, their disposition irregular. Instead of a melody, as in *One Hour,* they have a heavy, steady but occasionally interrupted beat: rock . . . rock . . . reeds, stone, rock . . . stone, gorse . . . stream . . . stone . . . grass, reeds. One is an hour, the other a night. The intensity of perception, and of walking itself, obviously changes with the direction taken, and this becomes part of the quality of the work.

Time, in Richard Long's work, is a consciously employed element. Just as he has made works using set, abstract distances, *A Ten Mile Walk, A 100 Mile Walk,* so there are works specifically about time: *A 24 Hour Walk, A Day's Walk on Honshu,* or *On Midsummer's Day. A westward walk from Stonehenge at sunrise to Glastonbury by sunset, forty five miles following the day.* In this way, time functions as a formal element, a method of giving an identifiable form to an activity like walking in a landscape, which, in its perceptual complexity, cannot really be entirely recorded. Imposing a form on time is like giving a form to water, as when he applied the length of the River Avon, a fixed measure, to the moving water of the River Severn – or it is like giving shape to the rhythm of walking, 10 miles, 20 miles, 24 hours. Also, a stone thrown into water, as he did in Mexico, fixes a moment in time, just as a work like *Throwing a Stone round MacGillycuddy's Reeks,* in which he walked in short stages after a stone thrown forward, is, instead of a continuous walk, an accumulation of moments.

Duration, like walking pace, relates to perception, to feeling. The quickest works he ever made took only an instant: throwing water against rocks, or *Muddy Water Falls,* throwing muddy water against the gallery wall to leave splashed shapes. They are, not counting the time of preparation, impulsive works, made without reflection or perception during their making – and in that they are the opposite of Richard Long's longest work, *A Thousand Miles, A Thousand Hours,* which he himself described in a note as about the 'geometry of time and distance'. He went on: 'Also the geometry of the walk itself which was a clockwise spiral walk in England on roads and lanes, beginning at Bootle near Liverpool and ending at No Man's Heath in the Midlands. The whole of central England was the site of this work, but despite its length the walk was not hard, it was rhythmical. Twenty-four miles each day, day after day. On the longer walks the day-to-day rhythm of the walk is very peaceful and enjoyable. The routine of camping, campfires, wayside stops, the simplicity of just walking each day and just having that to do and to be in a new fresh place to sleep every night.'

This work is different from shorter works, and most of all from works like *Muddy Water Falls,* in that it is relaxed and therefore it can take account of the world. *Muddy Water Falls* is a series of intense, abstract moments; *A Thousand Miles, A Thousand Hours* moves through a large geographical area, looking around, being part of the life and traffic of the roads and of the towns and villages passed through. Being a spiral, the work occasionally passes, at a distance, places where the walker has passed before. The work is the accumulation of many sensations and memories: it is like time itself. And as the world is more and more covered by Richard Long's forms, as time goes on, so his work in its totality becomes more and more an accumulation of time, of moments, hours, days, nights, weeks. Slowly the work begins to equal his life.

Other pieces, similar in notation to *Four Walks,* are extremely concise, bare even, in that they cut out all scenery. Consider, for instance, *Granite Stepping Stone Circle* and *Granite Line.* Here again the precise phrasing of what was the form and character of the walk gives an indication of content – as complete as possible. *Granite Line* has, somehow, a double form. The description of the title reads: *Scattered along a straight 9 mile line 223 stones placed on Dartmoor.* One may ask: how can that become visible? By photography?

There is a comparable work which uses a photograph. It is *A Line of 164 Stones. A Walk of 164 Miles. A walk across Ireland, placing a nearby stone on the road at every mile along the way.* The accompanying photograph shows, in close-up, a stone lying at the roadside. Also visible is a short stretch of road ahead. Here the photograph does not show a specific place, a particular stone: it is a generic image, almost a visual footnote underlining the title, showing the system of the walk. That is appropriate because the walk and the distribution of the stones is completely regular, like the ticking of a clock: 164 miles equalling 164 stones placed at the precise and repeated interval of one mile. The one photograph is enough. *A Line of 164 Stones* is a large work divided into 164 elements that are light and simple and effective. There is a considerable total displacement of stones; yet the work is, beyond the photograph, invisible.

Now, compared to *A Line of 164 Stones,* the work *Granite Line* is equally precise, except that it cannot be precisely measured, because there are two lines involved: a straight line, 9 miles long, made by walking and a second line made of scattered stones. The line walked is solid, but invisible. The line of stones is, as the title says, visible but scattered, meaning unequal distances between the stones. The second line might here and there deviate from the first straight line. The word 'scattered' is vague: maybe clear in itself but not precisely measurable. It would therefore be impossible to photograph the line of scattered stones: given the likely uneven condition of the terrain and the relative distance from stone to stone as well as the small size of each stone (not exceeding the weight one person could carry), a photograph taken along the ground from one stone to the next would certainly not show the next stone. Photography could not visualize the continuity of the stone line. *Granite Line,* then, is an absolute word-piece – just as, to continue my quest for fundamental principles as they appear in the practice of the work, *Countless Stones,* presented as a book, is an absolute photo-work.

Its subtitle is: *A 21 day footpath walk. Central Nepal 1983;* it contains seventy-five photographs of the footpath directly in front of the walker (views looking forward, in sequence). In a note Richard Long commented: 'The idea (to record some of the countless stones I touched along my walk) came on the third day of the walk, 3 days of looking for every footfall on the tortuous path, and the feeling that while being surrounded by spectacular distant views, walking was very much about watching and concentrating on the path ahead. So the work came from the circumstances of the walk and commenced at the time of the idea. . . . The work is also about the universality of footpaths, like walking itself. Footpaths of stepping stones are very similar be they on Ben Nevis or Nepal or in the Andes. Stones are stones.'

Yet, even if Richard Long is laconic about the work, in the book another element has slipped in – that of love for this path. Unlike the stones carried and placed in *Granite Line,* these are not only deposited by nature but also adjusted by man. They have been there since time immemorial. One walks over them and sees them – which is precisely the photographic structure of the book.

Word-pieces have their own potential of generating walks that otherwise would not be presentable in a satisfying way. This goes, too, for walks with a certain intricate form or construction. Take, for instance, the walk in which each day the distance to be walked is longer: *A Five Day Walk:* first day ten miles, second day twenty miles, third day thirty miles, and so on. This work, dealing with duration per day and exertion (neither easy nor difficult), freshness or tiredness, can only be referred to in words.

The technique of the word-pieces has thus extended his idiom or repertoire. I will discuss one last example: *Three Moors Three Circles,* with a description: *A 108 mile walk from Bodmin Moor, to Dartmoor, to Exmoor, walking around three circles along the way. Liskeard to Porlock.* The walk itself was fairly long. The exact route is not given, except that it includes the three moors. The sense of the work is not the form of the walk in general but its 'interruption' by three distinct forms: the circles. (It is a companion-piece to *Straight Miles and Meandering*

Miles, carried out in the same area of south-west England.) The circles themselves are rather small: one mile round on Bodmin Moor, two miles round on Dartmoor, three miles round on Exmoor. On maps these circles would be visually insignificant; printed in words, as they are, concentrically on the page and thus intensifying their circularity and giving a direct idea of their relative size, they present a powerful image. The three word-circles are precise enlargements of each other, as the actual walked circles were. Underneath is the title in red, then the description of the whole walk; visually the three circles are literally *embedded* in the work as a whole. That visual image exactly conveys the structure of the real walk.

Some of the works just discussed were again made on Dartmoor. The size of Dartmoor and the scale of some of these works (and there are still a fair number of other Dartmoor pieces which have not been mentioned) are such that some of these forms laid down on the ground actually overlap, cross or intersect each other. The longest and most extensive Dartmoor walk, *A Hundred Tors in a Hundred Hours,* passes through all the other pieces. Dartmoor, therefore, is not just a densely used prototypical ground, it is also a close-up of what will result if one takes Long's works, up to now, in their totality. The ground is covered, on Dartmoor and increasingly in other more frequented areas – Ireland, south-west England in general, the Highlands of Scotland and possibly also the Everest area in Nepal – with his personal, human forms, cutting through the regular patterns of geography and cartography: a truly intense, wide-ranging, complex and also poetic form of human reconnaissance of the earth he walks on. 'To carry out new walks and ideas,' he commented, 'within the space of England it was necessary to intersect and overlap. So now the country is criss-crossed with different works, enabling me to perceive the same place (England) at different times, from different directions and from artistically different points of view.'

Dartmoor and the West Country are native ground, the places he knows best and where many of the forms are developed and discovered – much as Rembrandt, throughout his life, used himself and his immediate family as again and again in his drawings he explored forms, expressions, postures and gestures. Mingled with these, with Dartmoor and the other familiar landscapes, are distant, possibly stranger encounters with landscape and ground. Those encounters widen the scope and enlarge the scale, also lending their breadth and magic to the works made 'at home'. The balance is between Dartmoor and Africa, Somerset and Ladakh, Wales and Lappland, Ireland and Bolivia, Scotland and Mexico. Each time the work is brought back, maybe not even consciously, from the far to the near, so that it can never degenerate into exoticism. Thus the work, as a whole, seeps outwards, spreading over the surface of the earth from the dense centre around Bristol. That is the movement of the work and the structure of its development: outward and concentric.

While the work as a whole is growing steadily, not systematically but assiduously, the journeys themselves, which produce individual works, are spontaneous and instinctive: the place carries the artist along. In a letter, he described to me as an example a visit to Ireland, three weeks in March 1974: 'From Dublin, train to Westport, hitch and bus up coast to the mountains of County Mayo where I made a 100 mile walk along a straight line. Hitched southwards down west coast, walking down a riverbed in Joyce's Country along the way. Continuing south to County Clare, walked up and over the Burren where *A Line in Ireland* was made. Continued hitch-hiking until reaching Spanish Point on the west coast, near Ennistimon. From here I started walking eastwards across the country, placing a stone at each mile along the way, until I reached Arklow on the east coast. This work was *A Line of 164 Stones. A Walk of 164 Miles.* From Arklow I took the train back to Dublin.'

Four different works were made on this trip, each of them going into a different category of the total oeuvre. That is to say, there is the unity of the individual walks, and there is the different, more abstract (even aesthetic) unity of the work as a whole.

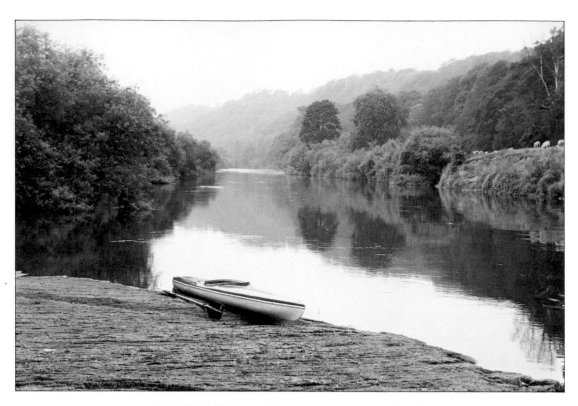

A JOURNEY OF THE SAME LENGTH AS THE RIVER AVON
AN 84 MILE CANOE JOURNEY DOWN THE RIVER SEVERN

ENGLAND 1977

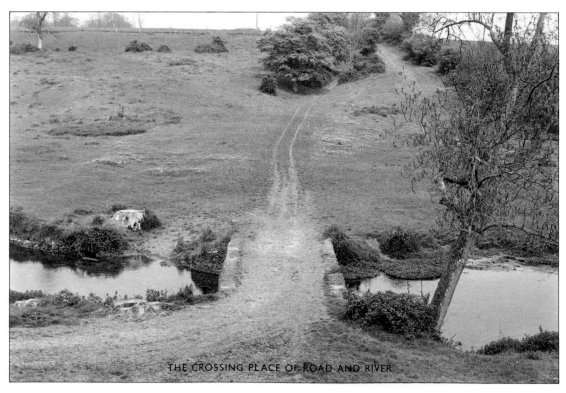

THE CROSSING PLACE OF ROAD AND RIVER

A WALK OF THE SAME LENGTH AS THE RIVER AVON
AN 84 MILE NORTHWARD WALK ALONG THE FOSS WAY ROMAN ROAD

ENGLAND 1977

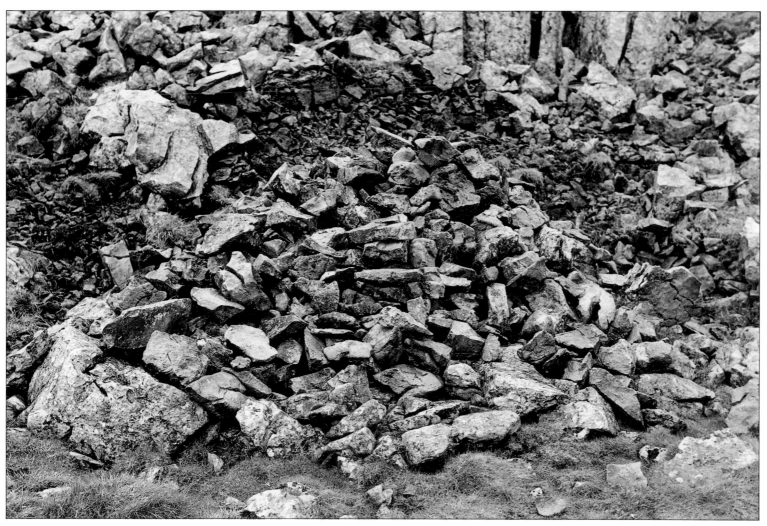

1450 STONES PLACED AT 1450 FEET ABOVE SEA LEVEL

FOOTSTONES

A 126 MILE WALK ACROSS ENGLAND FROM THE IRISH SEA COAST TO THE NORTH SEA COAST,
PLACING FIVE PILES OF STONES ALONG THE WAY.

82 STONES PLACED AT 82 FEET ABOVE SEA LEVEL

1450 STONES PLACED AT 1450 FEET ABOVE SEA LEVEL

754 STONES PLACED AT 754 FEET ABOVE SEA LEVEL

49 STONES PLACED AT 49 FEET ABOVE SEA LEVEL

351 STONES PLACED AT 351 FEET ABOVE SEA LEVEL

ENGLAND 1979

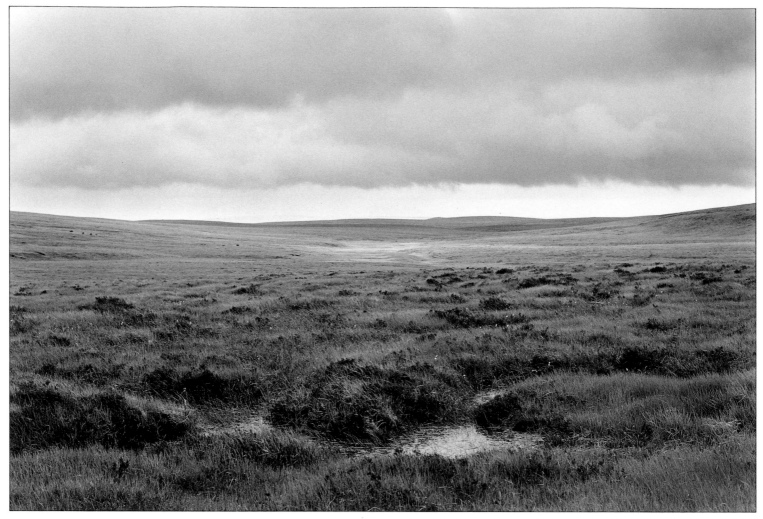

EAST DART HEAD

DART TAMAR EXE

A 3 DAY TRIANGULAR WALK BETWEEN THE SOURCES OF THE DART, TAMAR AND EXE RIVERS.

FROM EAST DART HEAD TO THE SOURCE OF THE RIVER TAMAR 34 MILES

FROM THE SOURCE OF THE RIVER TAMAR TO EXE HEAD 41 MILES

FROM EXE HEAD TO EAST DART HEAD 44 MILES

DEVON CORNWALL SOMERSET

ENGLAND 1978

AVON GORGE WATER DRAWING

BRISTOL 1983

1449 STONES AT 1449 FEET

1449 TINNER'S STONES PLACED ON DARTMOOR AT 1449 FEET ABOVE SEA LEVEL

ENGLAND 1979

SEA LEVEL WATER LINE

DEATH VALLEY CALIFORNIA 1982

¼ MILE SOUTH TO NORTH 6¾ MILES NORTH TO SOUTH 10½ MILES SOUTH TO NORTH 15 MILES NORTH TO SOUTH 9 MILES SOUTH TO NORTH 1½ MILES NORTH TO SOUTH

THE ISLE OF WIGHT AS SIX WALKS

COAST TO COAST WALKS BY ROADS AND PATHS

ENGLAND 1982

THROWING MUDDY WATER

NEW YORK 1984

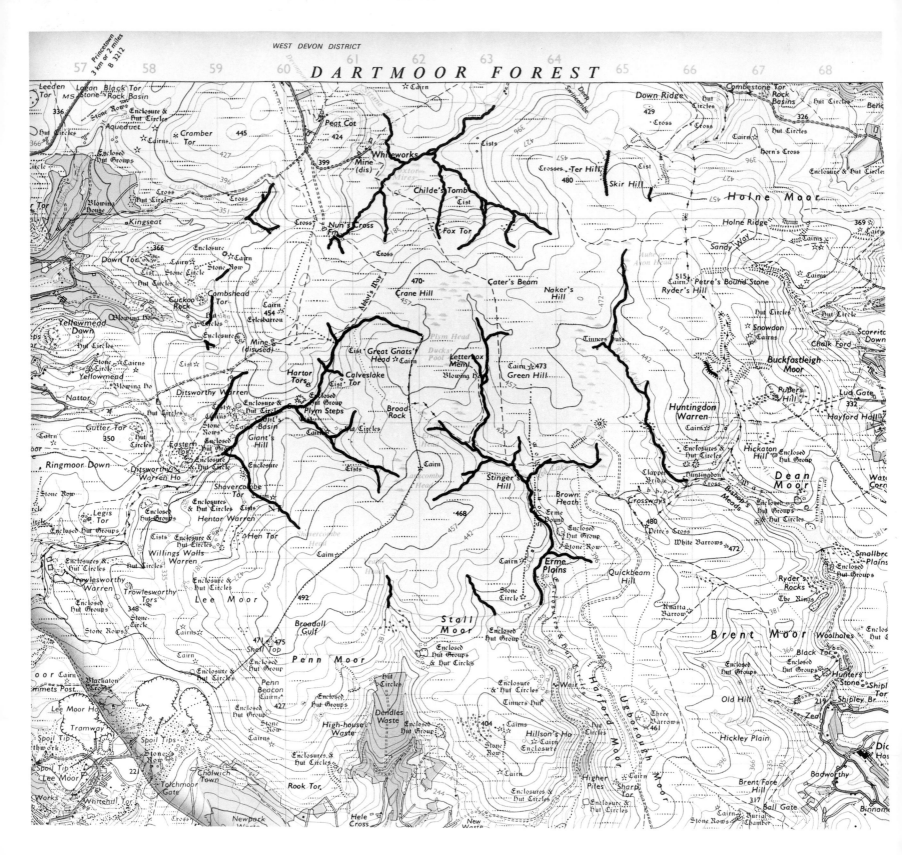

DARTMOOR RIVERBEDS

A FOUR DAY WALK ALONG ALL THE RIVERBEDS WITHIN A CIRCLE ON DARTMOOR

DEVON ENGLAND 1978

114

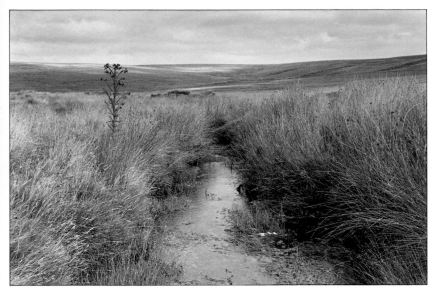
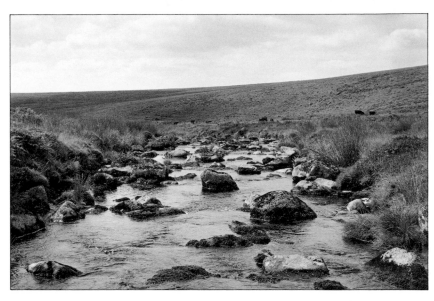
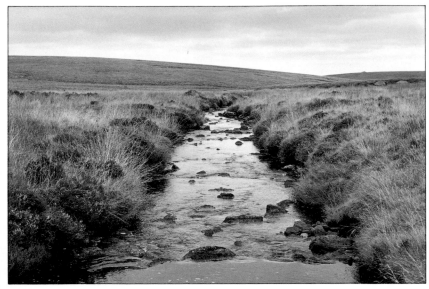
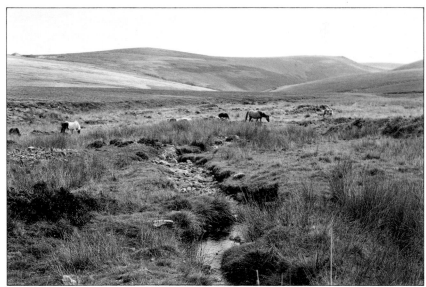
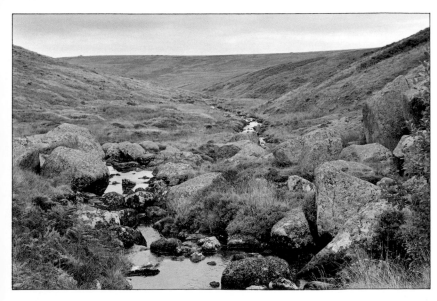
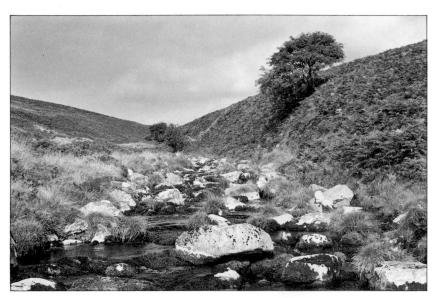

115

FOUR WALKS

FROM THE SUMMIT OF CARANTOUHIL TO THE MOUTH OF THE RIVER SHANNON 42 MILES

FROM MALHAM TARN TO SHERWOOD FOREST 106 MILES

FROM KING'S SEDGE MOOR TO CHESIL BEACH 41 MILES

FROM THE SOURCE OF THE RIVER SEVERN TO THE SUMMIT OF SNOWDON 60 MILES

IRELAND

ENGLAND

WALES

WINTER 1977

FRESH WATER SALT WATER LINE WALK

SOUTHWARDS SUTHERLAND, ROSS AND CROMARTY SCOTLAND 1980

117

WINDMILL HILL
THE WINDMILL HILL FOLK WERE THE FIRST INHABITANTS OF ENGLAND TO MAKE PERMANENT CHANGES IN THE LANDSCAPE.

WINDMILL HILL TO COALBROOKDALE

A 113 MILE WALK IN 3 DAYS FROM WINDMILL HILL TO COALBROOKDALE

WILTSHIRE TO SHROPSHIRE ENGLAND 1979

THE COALBROOKDALE IRON BRIDGE
COALBROOKDALE, ON THE RIVER SEVERN GORGE, WAS THE BIRTHPLACE OF THE INDUSTRIAL REVOLUTION.

THE CROSSING PLACE OF 2 SOMERSET WALKS

A 40 MILE SOUTHWARD WALK FROM THE AVON BORDER TO THE DORSET BORDER
A 76 MILE EASTWARD WALK FROM THE DEVON BORDER TO THE WILTSHIRE BORDER

ENGLAND 1977

AFRICAN WALK

A 5 DAY WALK OF 102 MILES ON DIRT ROADS AND BUSH PATHS IN EASTERN PROVINCE, ZAMBIA.

CENTRAL AFRICA 1978

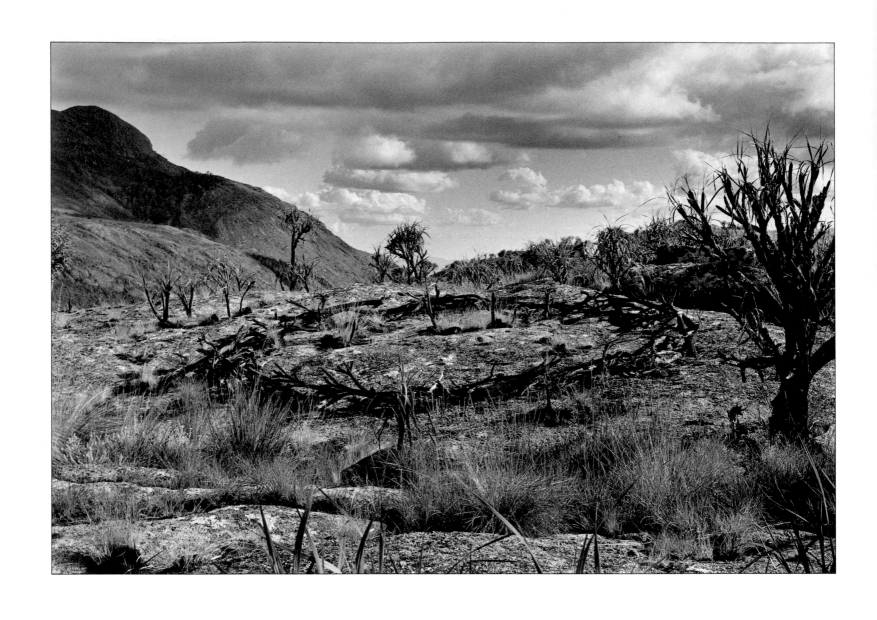

CIRCLE IN AFRICA

MULANJE MOUNTAIN MALAŴI 1978

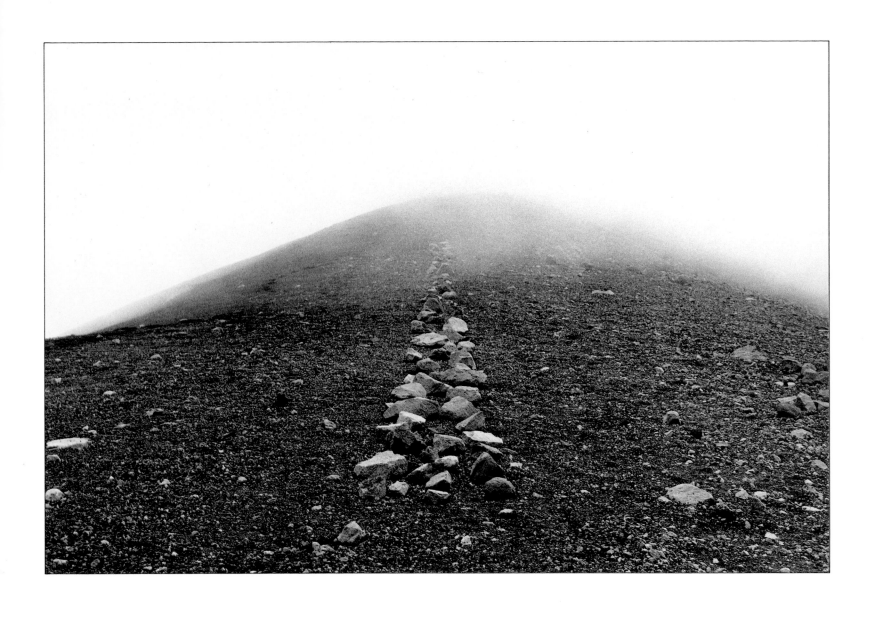

A LINE IN JAPAN

MOUNT FUJI 1979

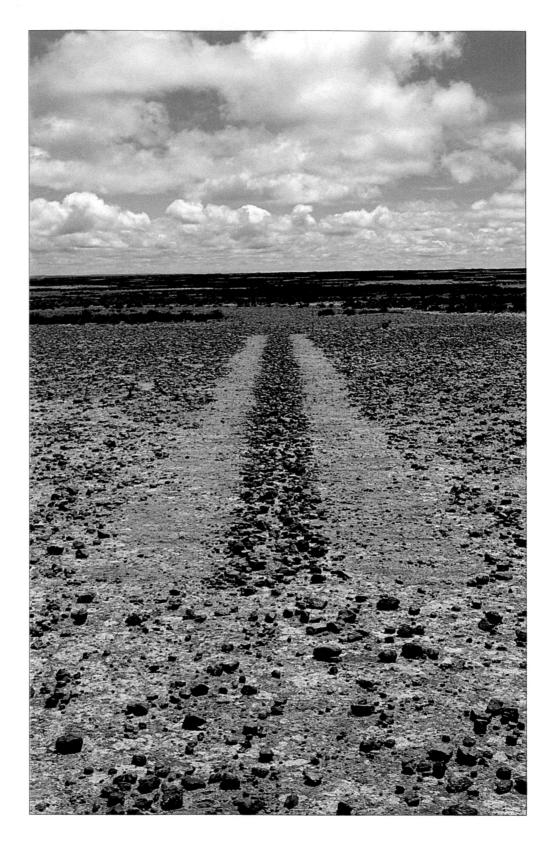

A LINE IN BOLIVIA

1981

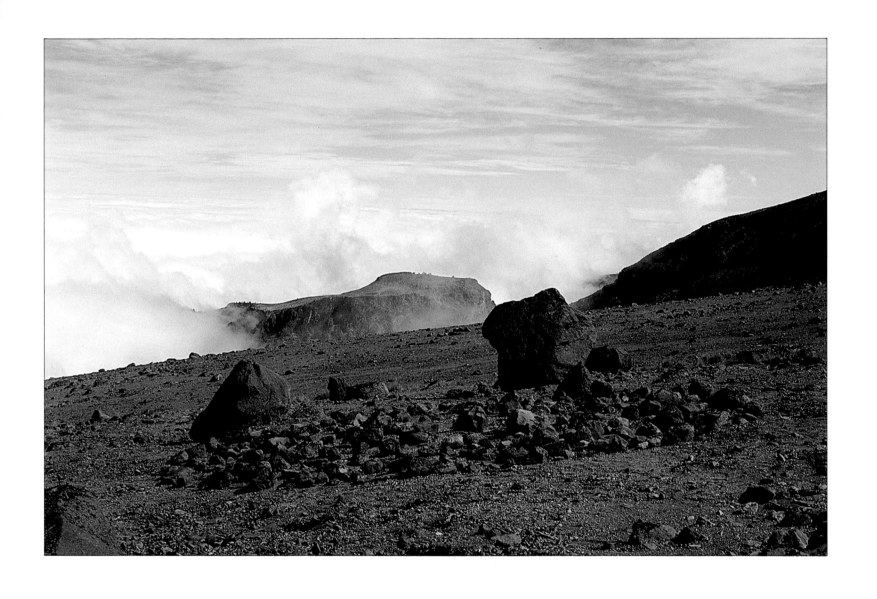

CIRCLE IN MEXICO

1979

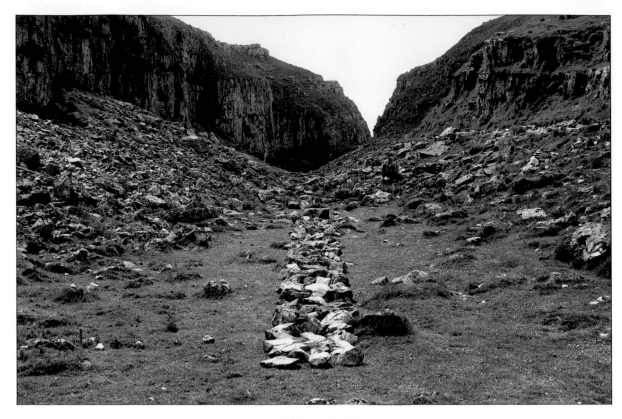

A LINE IN ENGLAND

YORKSHIRE 1977

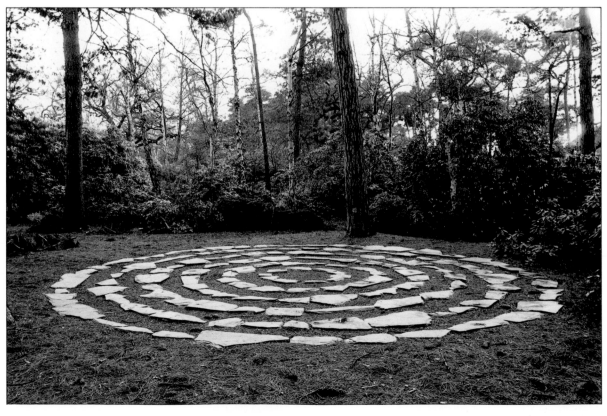

SIX STONE CIRCLES

ENGLAND 1981

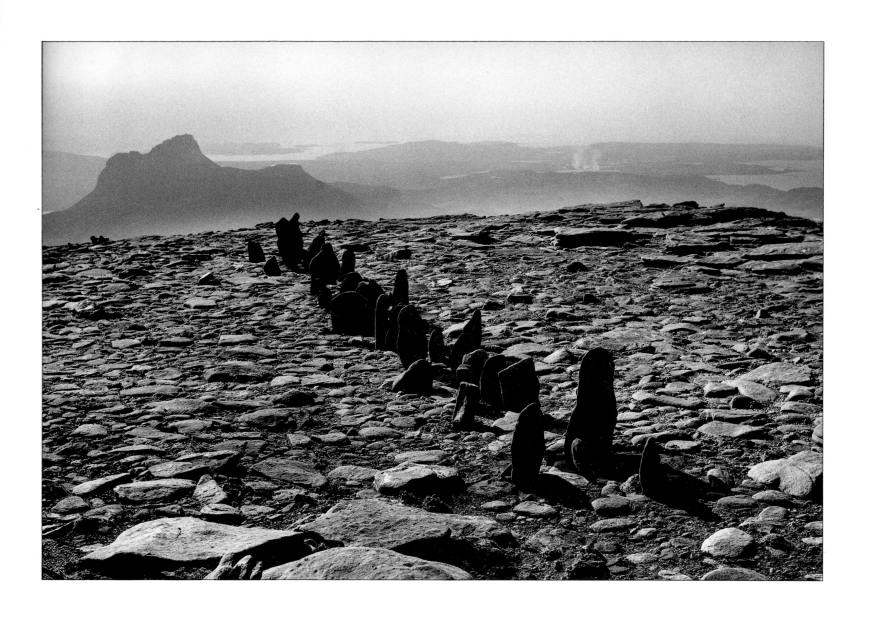

A LINE IN SCOTLAND

CUL MÓR 1981

SNOW

WARM GRAVEL

SNOW

STONES ROCKS

DUST

PINE NEEDLES

POWDER DUST

GRIT

PICO DE ORIZABA

A 5½ DAY WALK FROM TLACHICHUCA
TO THE SUMMIT AT 18855 FEET
AND BACK

MEXICO 1979

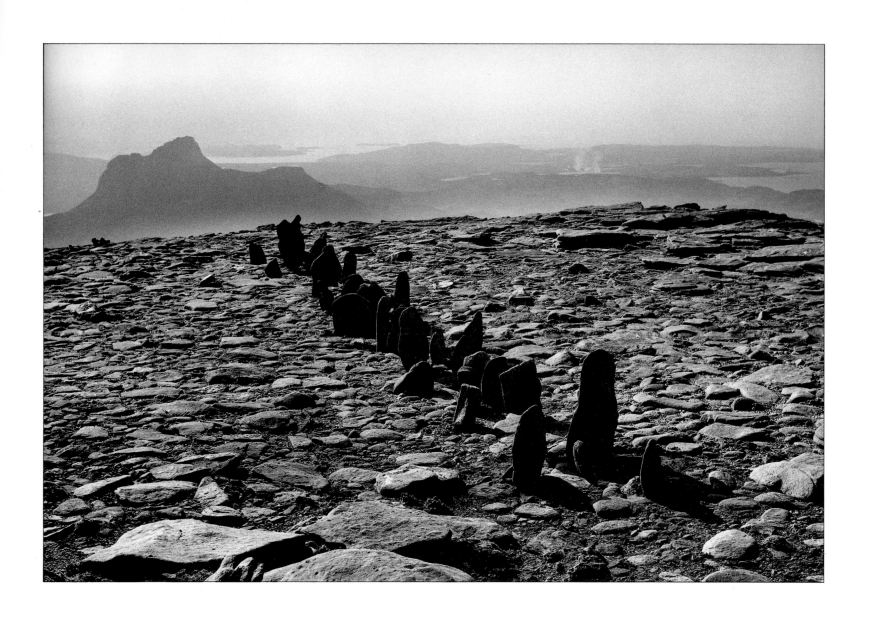

A LINE IN SCOTLAND

CUL MÓR 1981

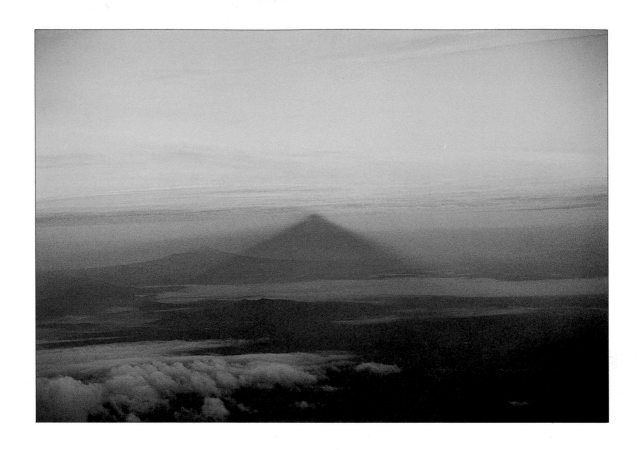

SNOW

WARM GRAVEL

SNOW

STONES ROCKS

DUST

PINE NEEDLES

POWDER DUST

GRIT

PICO DE ORIZABA

A 5½ DAY WALK FROM TLACHICHUCA
TO THE SUMMIT AT 18855 FEET
AND BACK

MEXICO 1979

THE SIERRA MADRE

A 5 DAY WALK FROM DIVISADERO DOWN INTO THE CANYON OF THE RIO URIQUE AND BACK

WALKING ON ROCK

LIGHTING FIRES ON ROCK

MARKING ROCK

SLEEPING ON STONES

THROWING STONES

PLACING STONES

MEXICO 1979

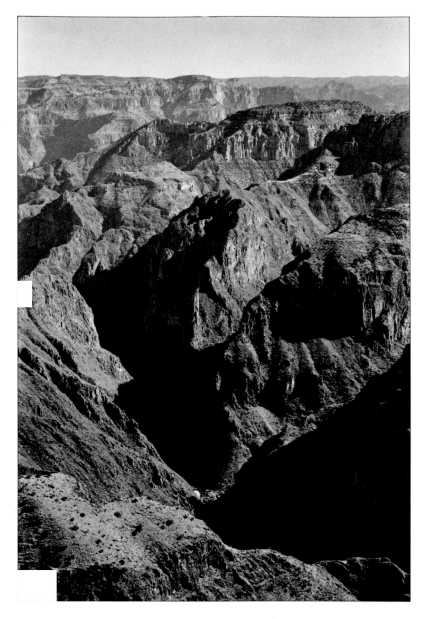

LOOKING DOWN TO THE RIO URIQUE

THROWING STONES ACROSS THE RIO URIQUE

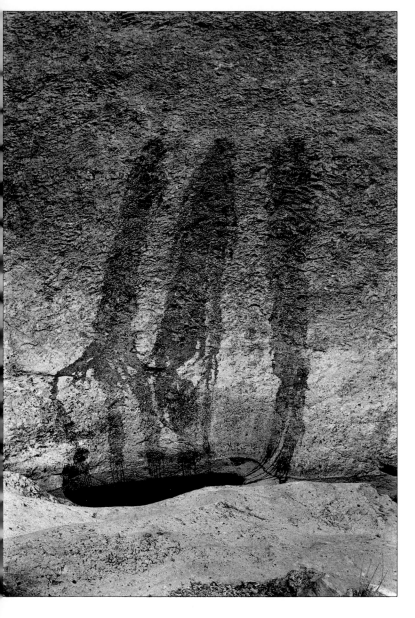

POURING WATER ON A RIVERBED

THE PATH DOWN AND UP

Stones

In the early 1970s the character (or should one say the method) of Richard Long's shows in interior spaces underwent changes, as invitations gradually became more frequent. The earliest gallery exhibitions presented works somehow directly related to the type and the place of a walk, like the Avon Gorge sticks in Düsseldorf in 1969 or the spiral *Line the Length of a Straight Walk from the Bottom to the Top of Silbury Hill*. Since then there have continued to be works related to a specific place, made by transporting materials from that place, or by actual walking on the floor of a gallery. There is, for instance, a considerable group of sculptures using River Avon driftwood (circles, lines, spirals), and Richard Long has walked a long line of River Gironde mud in the Entrepôt Lainé, Bordeaux. Recently he added wall works to his repertoire, circles made by hand with (often) River Avon mud as well as mud drawings made by throwing muddy water against the white wall.

Yet such later works are different. Forms, once discovered, settled into the life of Richard Long's work. The very first lines and circles were discoveries in themselves. After those, the work became also involved in the use and development of its own discoveries. The first line, done 'abstractly' on grass, was the starting point of an exploration of other possibilities opened up by that line: lines walked on different types of ground, lines of different materials, long lines and short lines, parallel and crossing lines, invisible lines punctuated by placing or moving stones, systems of lines. With these variations came different forms of presentation born out of the logical and the possible: a long line walked on Dartmoor would be a map-piece, a line of stones in Iceland would be a photograph. The same operation took place with the other major form, the circle; others, like the spiral or the ziggurat, originated between these two major forms. One could probably say that the line and the circle are not only forms but also backbone structures upon which (and out

of which) variations of pattern, combination, shape, scale, movement were developed. In this process of amplification and refinement, deepening and sharpening the idiom, there emerged larger categories of work which became more and more distinctly recognizable. There was the special group of Dartmoor works, then the category of the country roads and lanes of England, the category of works on the wild ground of Scotland, the Irish works, works about water and using water, the larger walks in remote landscapes, works done in mountains, works done in flat areas. Among these emerging categories was the special category of works in galleries and public museums.

What he started to do was to make sculptures that would be independent of the walks but would use similar basic forms – as it were, echoing the sculptures made during walks. As material he generally uses the materials at hand in the area where the exhibition is to be made, stones brought by local transport from quarries or mountain sites.

The first circle of stones within a walk was made in 1972 in the Andes (the same walk that produced the magnificent *Walking a Line in Peru*, crossing over a dry riverbed following aligned notches made by native Indians). It was the first large outside circle, not however the first outside work made by moving stones. In 1971 Richard Long laid out a stone sculpture in the form of a circular, curving labyrinth in Connemara, Ireland. In 1970, crossing a river in Tennessee, he aptly made a sculpture of two crossing lines just under the water's surface by shifting pebbles on the riverbed: *Reflections in the Little Pigeon River*. The sculpture mingled with the reflections of trees in the water. It is a gentle and rather intimate and delicate piece, the result of light touching, much like the pebble square, 1968, of *A Somerset Beach*. The same American trip produced *Arizona 1970*, a rectangular spiral scratched with the edge of his boots in the gravel of

a mountain slope. On the Irish trip during which the *Connemara Sculpture* came into existence, he laid out crossing lines of stones on a bed of seaweed in Bertraghboy Bay, one evening at low tide. He camped on the bank that night and when he looked out in the morning there was a cross on the water. The tide was coming in, drifting the seaweed upwards except where it was weighed down by stones. At half tide the crossing lines were visible as a smooth water surface, surrounding seaweed still not completely submerged in the water as it would be an hour or two later approaching high tide. A sculpture of chance, almost, visible for only a short time, literally drifting past. Seaweed was also used as a material for a spiral *Sculpture Left by the Tide* on a Cornish beach, also to be washed away by the tide which had deposited it. A similarly fragile and short-lived sculpture was made in the Bolivian desert during the South American trip in 1972, a rectangle made of dry plants that were lying around, probably torn off by feeding llamas and drifting like dust. The sculpture itself could at any moment be blown away in a gust of wind.

The outdoor works mentioned above were made in various places, in various materials, in a time-span of two years. They demonstrate an astonishing variety in idea and feeling and scale. The differences between them must somehow come from the feel and character of the landscape in which they originated. Sculptures situate themselves in landscapes whose features produce or, at least, suggest them: not only in their material, scale and form but also in their mood. *A Sculpture Left by the Tide* is maybe the most moving work (as *Reflections in the Little Pigeon River* is the most poetic one, or should I say the most musical one, as the sound of water was almost certainly an element in the sculpture's origin). *Sculpture Left by the Tide* introduces duration in time as part of the sculpture's existence. Material, place and time, perfectly matched, are in fact part of the same movement of the sea meeting the beach. The sea at high tide deposits drifting seaweed on the beach. The artist moves the seaweed, which is slowly dying, into the finite form of the spiral which in itself is a figure of slow movement. There the sculpture awaits the next high tide, six hours later, which will wash it away. The six-hour existence of the sculpture tells us about the eternal movement of the sea. What I want to stress is how perfectly form and material were

suited to the place: the beach. *Sculpture Left by the Tide* is a work made within the limits and conditions of the place, with no attempt to invade the place or overwhelm it with structures or materials not belonging to it.

That goes, too, for the other sculptures I mentioned. Some are curiously intimate, like *Half-Tide* or *Reflections*. Others, like the dry plants in *Bolivia 1972*, are very fragile in that the sculpture recognizes the frailty of life in that bare desert under the high sky. The rectangular spiral in Arizona is one of Richard Long's first pieces employing the truly grand scale present in the landscape. It is made by scratching because there were no stones and the gravel would leave no footprints. The *Circle in the Andes* is another sculpture recognizing scale. It is large in feeling, just as *Reflections* is intimate in scale. The latter place is an almost pastoral stream passing beneath whispering trees; the former is a high place in bare mountains. The wide, rough circle of rocks echoes the wide sweep of mountains, the wildness of the place. It looks sturdy (as the plants look fragile) but only just so.

One should add here that although his landscape sculptures are not in urban areas, they are not always remote from people. In England he added a thousand stones to a footpath cairn which itself was built by previous walkers to mark the trail, and which will continue to be added to by others. Thus his sculpture shares the work of other walkers. During a twelve-day walk in Ladakh, the Buddhist part of Kashmir and a mountainous land of footpaths, he respectfully walked lines upon the existing footpath, 'Walking within a walk, along the line of shared footprints.' In Nepal, where there are many villages throughout the valleys, he made a work by brushing the footpath to leave a dusty line clear of leaves and twigs. Remoteness does not mean the absence of other people.

I have said that the gallery pieces echo the outdoor pieces made within walks. By that I mean that they are infused with a certain feeling and experience: the artist's eye and hand making them remember the crosses and lines and circles made in a landscape. They are echoes and transformations; in a sense also formalizations. Having their own life and rationale, they do not of course contradict the exterior works. But their reality is different, which is why they exist in the first place. For Richard Long, as he has said in conversation, it is important to keep the places where he has walked and worked to

himself and anonymous. Those works were made in isolation, one to one with the place, and the spirit of work and place should not be altered by visitors. That is why it is not important whether outside works remain or change or disappear. Information about them can be transmitted through words and photography. But words, and especially photography, have the tendency to enhance distance and remoteness: what you see in a photograph is in past time and somewhere else. They are still, frozen images. The gallery sculptures, whatever their precise formal relation to exterior work, are always real; one can move around them and they feed the senses directly. Thus the gallery sculptures complement the 'memory' aspect of the exterior works transmitted in words or photographs.

In the same year as the *Circle in the Andes,* 1972, Richard Long did two interior stone circles: one at *Documenta V,* Kassel, and another one, a concentric group of *Three Circles of Stones,* for the legendary *New Art Exhibition* organized by Anne Seymour at the Hayward Gallery. I remember both pieces quite well. First one was struck by their repose, their tranquillity. Transported from the high Andes, so to speak, was not the wildness of the place but the stillness of mind which accompanied the making of the Andes sculpture. (I am not saying that the interior circles *derived* from the Andes circle: I am using the comparison as a model.) One moment looking at the massive range of mountains, the next making a circle of stones, a moment of concentration and quiet, even of isolation, like a lull in a storm. The transformation is perfect. Another thing that struck me was the care with which the stones in the Hayward were laid out. Evenly distributed, they gently touched each other forming three delicate circles, resting lightly on the floor. The Andes circle is much more uneven: the difficulty of the place prohibited refinement in distribution. It is a very rough circle. The Hayward circles, on the other hand, were refined and fitted to the formal context of the gallery, perfectly and as logically as the circle in the Andes fitted the mountains or as the seaweed spiral fitted between the tides. The Hayward circles were, in a sense, a formalization, but then only to retain or to attain that quality of being there in a very light way: chamber music rather than a full orchestra. Had the stones been bigger, rougher, they would in that situation have been overly dramatic and rhetorical.

There are many possible ways of making stone circles. Apart from size, which is mainly dictated by the size of the given space, one can differentiate in the choice of stones (type, colour, shape, size, weight), in the form (circle, ring, line, spiral, cross) or in the specific way of placing and joining the stones. This type of variation, internal to the actual construction of the sculpture, has since the Hayward circles become the central idea in the development of these works. Even if their development and conception, from exhibition to exhibition, has in the course of time become a relatively independent process, it is never completely cut off from the making of sculptures within the span of a walk – for the simple reason that walks were always taking place concurrently and that, in both categories, the same operations were being carried out: picking up stones, carrying them and placing them, joining them together to form a pattern. When you do that one week beneath the Everest Icefall, or in Australia, and two weeks later in a gallery in London or Düsseldorf, there must be a mental and physical relation between the two.

I want to look at the series of stone lines Richard Long has been making, while walking, in various places since 1974. As always, the construction and character of these lines is related to the condition of the terrain and the type of stone found on the site. It is my contention that the situation found at a place where he arrived, suggesting the type of construction (often the only possible one), directly informed the type of construction used for interior lines or circles (sometimes it might be the other way around). This follows from the fact that Richard Long's work is always practical: that is, forms and variations of form suggest themselves in ongoing practice. He is not the type of artist who sits down to calculate intellectually in how many ways he can join stones together into a line or a circle.

The first major stone line was made in Ireland in 1974. The terrain was a plateau densely covered with rather flat stones. Therefore the only way to articulate a line was to heighten it from the surrounding ground. Thus he built *A Line In Ireland* which looks like a narrow ridge or a dorsal spine. In the Himalayas, on the Everest Icefall a year later, he found stones in different colours or with different coloured sides. There he made a line of predominantly white stones leaving the surrounding area pre-

dominantly greyish blue, elegantly reflecting the contrast between the snow-capped horizon and the dark blue sky. In Yorkshire in 1977 he found a rather narrow valley in between cliff-like mountains. The *Line in England*, made there of greyish limestone, is dense and narrow, echoing the place. Also in 1977, in the Australian outback, he made a rough line of red stones, put together roughly – that is, without the sophistication of the Yorkshire stone line. The *Line in Japan*, 1979, on the slope of Mount Fuji, is slender and open, with stones not really touching, light like Japanese calligraphy. In 1981 he made four different lines in Bolivia. *A Line and Tracks in Bolivia* is not quite a stone line but a line made by walking over a terrain strewn with small stones. Walking through it he kicked the stones away, thus uncovering a line of ground. The line was crossed by tracks made in the same way by passing animals. In another place, not far from the first one, he again found the ground densely, evenly but not completely covered with small stones. He moved stones from right and left towards the centre, making in the centre a dense straight line of stones – which was consequently accompanied on either side by a line of uncovered rock. Also in Bolivia he made a line, fairly wide, of widely spaced stones in a place where few stones were available so that he had to economize. In another place he *kicked* the stones into place, thereby creating a line rather more unevenly spaced and irregular than the previous one. In 1981, on Cul Mór in Scotland, the long mountain-top stones were too big and too heavy to move around, so he made a line of a single row of stones heaved into a vertical position. (On this occasion he replaced the stones before leaving the mountain.) Again, in California in 1982, the stones were too heavy to be lifted, so he rolled them aside to make a line of ground between stones: the negative of a stone line. And finally, in Iceland in 1982, the stones were light and rounded, so the line came together perfectly.

There are places (in Iceland, Switzerland, Japan, Ladakh, Wales, Aran Islands, Scotland, Nepal, Spain) where it may be impracticable to move stones into either a line or a circle. But when of suitable shape, they can be heaved upwards into a standing position – often grouped in a roughly circular form. These works, *Standing Stones*, mark the place of such stones. 'On some walks', the artist wrote in a letter, 'there is the pleasure, from day to day, to never know the sleeping place of the coming night and, never having slept there, to never see that place again. Similarly with a sculpture: to find some stones by chance, use them, and walk on, and never see them again.'

Stones selected in making the stone lines were not chosen for their individuality. What I have called the formalization of the interior works, compared to the exterior works, consists precisely in how the individual stones are regarded – that is, as individuals. There is a fascinating word-piece, *Full Moon Circle of Ground*, which provides a kind of negative close-up of how, in the interior sculptures, stones are handled. The work mentions, in a circle of words, observations of ground or rather the ground's features, each of them seen individually: stone, rock, gorse, rock, stone, and so on. The visual structure of the words on the paper is such that each thing seen acquires an absolute individuality and individual presence.

Something similar happens in the interior works when Richard Long puts stones together, for example in a circle. Each stone is individual. Each stone is considered, as to size and shape, before it is put down. This precision in placing and joining is, among other things, expressed in the instructions he writes as part of the certificate of an interior sculpture. As the sculptures made in galleries will be sold and change location, he himself is not able to put them into place and control them all the time. The instructions tell the new owner what rules to observe when setting out a sculpture in a place different from where it was made by the artist. A typical instruction would read (I refer to *Slate Circle*, London 1979, of which the diameter, 6 m 60 cm, as well as the number of stones, 214 pieces of Welsh slate, appears in the hand-drawn and written, signed, dated, red-monogrammed certificate that goes along with it): 'First, the perimeter of the circle is marked out lightly on the floor (e.g. in pencil). The circle is then filled in stone by stone in a haphazard pattern. Each stone is placed on its longest, flattest, most stable side, not touching another stone. The stones are chosen at random. There is an even density of stones throughout the sculpture, and a fairly even distribution of sizes and lengths amongst the stones. All the stones should be used.'

To demonstrate the slight variations that occur in the instructions, variations that refer to the way of joining the stones, I quote another one, this one referring to the *Helsinki Circle:* 'First, the inner and outer perimeters are

drawn very lightly on the floor (e.g. in pencil). The space between the circles is filled in stone by stone in a haphazard pattern. The stones are chosen at random, although with a fairly even distribution of the largest ones amongst them. Each stone is placed flat on its most stable side, touching but not overlapping adjacent stones. The stones are closely spaced, but not fitted together. There is an even density of stones throughout. Both edges of the sculpture are jagged. There are some extra stones to make selection for the last spaces easier. The precise number of stones in the sculpture can vary (e.g. by 2 or 3), according to the particular selections and placements. The extra stones can be mixed with the rest when the sculpture is in storage.'

There are these differences in the instructions because, for one thing, different sculptures use different stones. The long pieces of slate could never make the pattern created by the flat, squarish or triangular stones in the Helsinki sculpture – not, at least, in the density required by the sculpture. The flat, closely spaced stones in the Helsinki work, 'touching but not overlapping', make a ring, very flat on the ground, which works as a refined, melodious pattern, a calligraphy of stones. The *Slate Circle* is much rougher, working with more robust gestures. The surface is uneven, it is like a surface cut and slashed, and the long, sharply edged stones also make for an interchange of light and shadow that is almost absent in the Helsinki work.

By now he is an expert on stones, knowing them so well that these differences in look, in the way a stone sculpture presents itself (light, rough, dense, spare, colourful . . .), can be orchestrated while making the work, just as a painter mingles and composes colours. (Richard Long emphasizes that he always, in all circumstances, inside and outside, chooses the stones he likes the look of. However, the stones of the exterior works are used in the landscape where they belong, while the stones for gallery sculptures come from local quarries – for reasons of logic and convenience. They are the quarry's detritus, offcuts or stones cut or sawn for other purposes. The pieces of flint, for example, are leftovers from chalk-quarrying. Stones are never especially cut.)

This precise, calculated handling of stones, this premeditation, is what I mean by formalization in the interior sculptures. Just as diverse landscapes and grounds, and the circumstances of a walk, result in outdoor pieces with radically different characters – so it is with stones in the interior pieces. Early interior pieces still tried to adapt consciously to the space, to use the floor as their landscape; the later ones have become much more autonomous. Resting in themselves, they barely seem to notice the space they are in; the space dissolves around them.

Of course the overall size of the sculpture is decided in relation to the space, but in a very practical fashion: in general the sculptures are as large as they can be, leaving however enough room about them to enable the visitor to walk comfortably around them. A squarish room would call for a circle, a long room would accommodate a line.

The types of stone he uses produce sculpture of great originality and visual and physical diversity – as we have already seen in the enormous difference between the massive, heavy 1979 *Slate Circle*, a ground of rock ploughed open, and the light-footed, calligraphic *Helsinki Circle*, an arabesque of stone. In fact, here one encounters variations in expression which relate them somehow to the perception of ground during walks – as we can observe them, for instance, in certain word-pieces. The delicacy of the *Helsinki Circle*, as a pattern of shapes, of darker intervals between the stones, and of edges like etched or scratched lines, is very similar to the sensitive and attentive observation of ground in the circular walk on Dartmoor, *One Hour*. The rhythm of the words, as they follow the perimeter of the circle (*reeds, gurgle, swish, reflection, skyline, belch, tor, wind, downhill, loping, sunlight, rock, crunching . . .*), has the same soft sound as the pattern of joined stones. The stones, or rather the always different shapes of the stones, follow and touch each other as the words do in *One Hour* – articulating that the shape of each stone is as distinct as the sound and meaning of each single word. The *Slate Circle*, heavier and more abrupt in its rugged surface, has an affinity of feeling with the *Full Moon Circle of Ground* which is equally broken up – much less fluent in its articulation than *One Hour*.

I do not want to push these comparisons too far; it is not that the *Helsinki Circle*, for instance, is the equivalent of *One Hour*. There are, however, in Richard Long's work, certain ways – and they definitely do transcend physical and formal categories – in which elements are joined. I am talking about the very foundation of sculpture or art in general: if a stone is put on the ground, what

stone do you use, and how exactly is it put on the ground; and how, and in what relation to the previous one, is the next stone put on the ground? Or if you walk the ground, what do you see, how do you see it (at what distance, for instance) and what do you see next? Here, at that basic level, is where the first decisions are made, giving the direction to all that follows. In Richard Long's work, the way in which elements join and touch or not quite touch, reflects many feelings or moods ranging from very intimate and tender to rough and blunt. So when I talk about *One Hour* and the *Helsinki Circle* I am talking about affinities in mood or feeling: the sentiment about its elements that the works transmit. It has nothing to do with forms. I might compare the *Helsinki Circle* just as well with the *Early Morning Senses Walk*, which is not a circle, because of its musing, drifting quality. *One Hour* can be compared, for the compactness in its modulation, with the *Elterwater Stone Ring:* a ring of pointed stones with the surface going up and down like a miniature mountain range. They can also be compared for the variation in 'distance' implied in the sequence of words: *pool* (close) *reeds* (closer) *gurgle* (very close) *swish* (very close) *reflection* (less close) *skyline* (distant). These seem similar to the rise and fall of the pointed stones. All this suggests that at the centre of Richard Long's aesthetic are these figures of speech, tones of voice, different kinds of music, and it also seems that they are consciously present in his mind as something he can use.

Not only well-defined sculptures or word-pieces (works that are easier to see in close-up) but also longer walks can be seen from this vantage point. For instance, compare *With the River Towards the Sea. A walk down a riverbed in Joyce's Country, County Galway,* with *A Hundred Mile Walk along a Line in County Mayo, Ireland.* In each of these works the Irish landscape and ground are observed and used in a completely different way. The walk down the riverbed, following the lie of the land as the water finds it, curving around all natural obstacles, is a very gentle use of the surface of the earth: it is joining in what is already there. The *Hundred Mile Walk* consisted in walking on a straight line, of unspecified length, up and down until a total of 100 miles were walked. Compared to the probing flow of a river, that line is hard and decisive – a form laid on the land in a totally abstract way, not concerned with path but with distance. The river walk belongs to that river only: the *Hundred Mile Walk* is an idea which can be executed elsewhere – differing in time according to the type of ground. In fact, it is a work to be made in different landscapes on different grounds. Up till now he has made it in Ireland, on a mountain slope in Japan, in the Australian desert and on the Canadian prairie ('a sea of grass'), and, as a circular walk, on Dartmoor.

In the exterior works one of the most basic conditions is the type and character of the ground which carries the sculpture (or the walk) from below; the expression of the interior sculptures lies rather in their surface. Thus, the London *Flint Line* of 1983 is dense and hard in effect, because of the flint, whereas the Eindhoven *Chalk Line*, formally similar, is also dense but soft. Another work, *Stone Rows* (1977), is slender and delicate, as if drawn by a pencil – but another *Stone Line* (London 1980) looks toughly linear, with strong contrasts in light and dark. A Basel *Red Stone Circle* is rugged, dense, rough rock – whereas a *Stone Circle* made in Denmark, 1980, was much more open, gentle in effect, like water rippling.

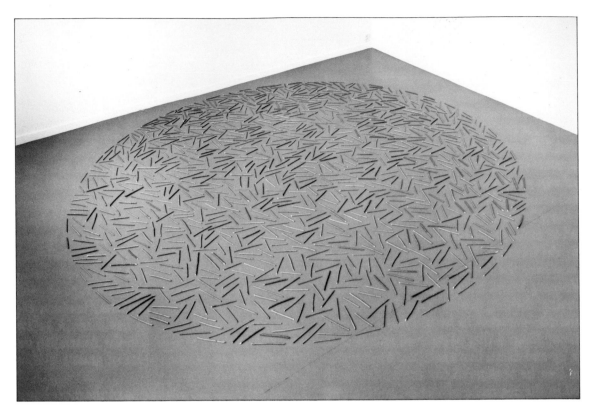

STICK CIRCLE

AMSTERDAM 1980

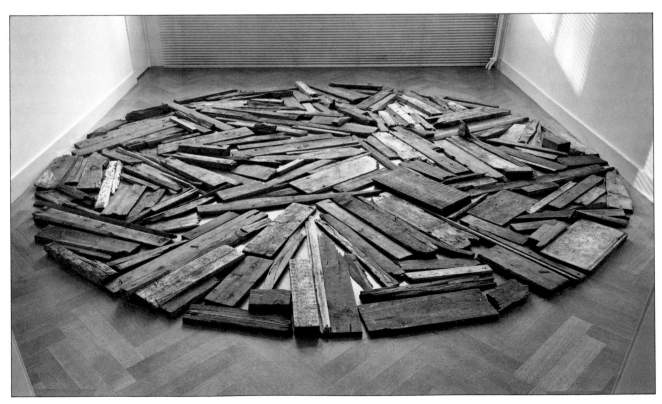

RIVER AVON DRIFTWOOD CIRCLE

AMSTERDAM 1978

stone do you use, and how exactly is it put on the ground; and how, and in what relation to the previous one, is the next stone put on the ground? Or if you walk the ground, what do you see, how do you see it (at what distance, for instance) and what do you see next? Here, at that basic level, is where the first decisions are made, giving the direction to all that follows. In Richard Long's work, the way in which elements join and touch or not quite touch, reflects many feelings or moods ranging from very intimate and tender to rough and blunt. So when I talk about *One Hour* and the *Helsinki Circle* I am talking about affinities in mood or feeling: the sentiment about its elements that the works transmit. It has nothing to do with forms. I might compare the *Helsinki Circle* just as well with the *Early Morning Senses Walk*, which is not a circle, because of its musing, drifting quality. *One Hour* can be compared, for the compactness in its modulation, with the *Elterwater Stone Ring:* a ring of pointed stones with the surface going up and down like a miniature mountain range. They can also be compared for the variation in 'distance' implied in the sequence of words: *pool* (close) *reeds* (closer) *gurgle* (very close) *swish* (very close) *reflection* (less close) *skyline* (distant). These seem similar to the rise and fall of the pointed stones. All this suggests that at the centre of Richard Long's aesthetic are these figures of speech, tones of voice, different kinds of music, and it also seems that they are consciously present in his mind as something he can use.

Not only well-defined sculptures or word-pieces (works that are easier to see in close-up) but also longer walks can be seen from this vantage point. For instance, compare *With the River Towards the Sea. A walk down a riverbed in Joyce's Country, County Galway,* with *A*

Hundred Mile Walk along a Line in County Mayo, Ireland. In each of these works the Irish landscape and ground are observed and used in a completely different way. The walk down the riverbed, following the lie of the land as the water finds it, curving around all natural obstacles, is a very gentle use of the surface of the earth: it is joining in what is already there. The *Hundred Mile Walk* consisted in walking on a straight line, of unspecified length, up and down until a total of 100 miles were walked. Compared to the probing flow of a river, that line is hard and decisive – a form laid on the land in a totally abstract way, not concerned with path but with distance. The river walk belongs to that river only: the *Hundred Mile Walk* is an idea which can be executed elsewhere – differing in time according to the type of ground. In fact, it is a work to be made in different landscapes on different grounds. Up till now he has made it in Ireland, on a mountain slope in Japan, in the Australian desert and on the Canadian prairie ('a sea of grass'), and, as a circular walk, on Dartmoor.

In the exterior works one of the most basic conditions is the type and character of the ground which carries the sculpture (or the walk) from below; the expression of the interior sculptures lies rather in their surface. Thus, the London *Flint Line* of 1983 is dense and hard in effect, because of the flint, whereas the Eindhoven *Chalk Line,* formally similar, is also dense but soft. Another work, *Stone Rows* (1977), is slender and delicate, as if drawn by a pencil – but another *Stone Line* (London 1980) looks toughly linear, with strong contrasts in light and dark. A Basel *Red Stone Circle* is rugged, dense, rough rock – whereas a *Stone Circle* made in Denmark, 1980, was much more open, gentle in effect, like water rippling.

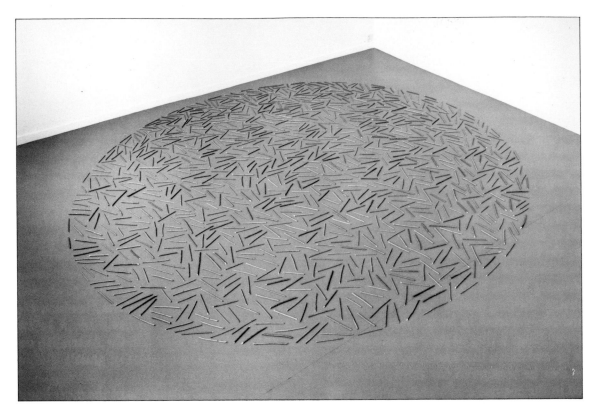

STICK CIRCLE

AMSTERDAM 1980

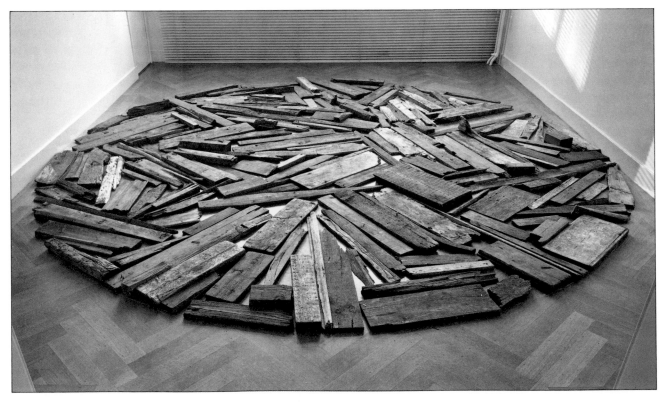

RIVER AVON DRIFTWOOD CIRCLE

AMSTERDAM 1978

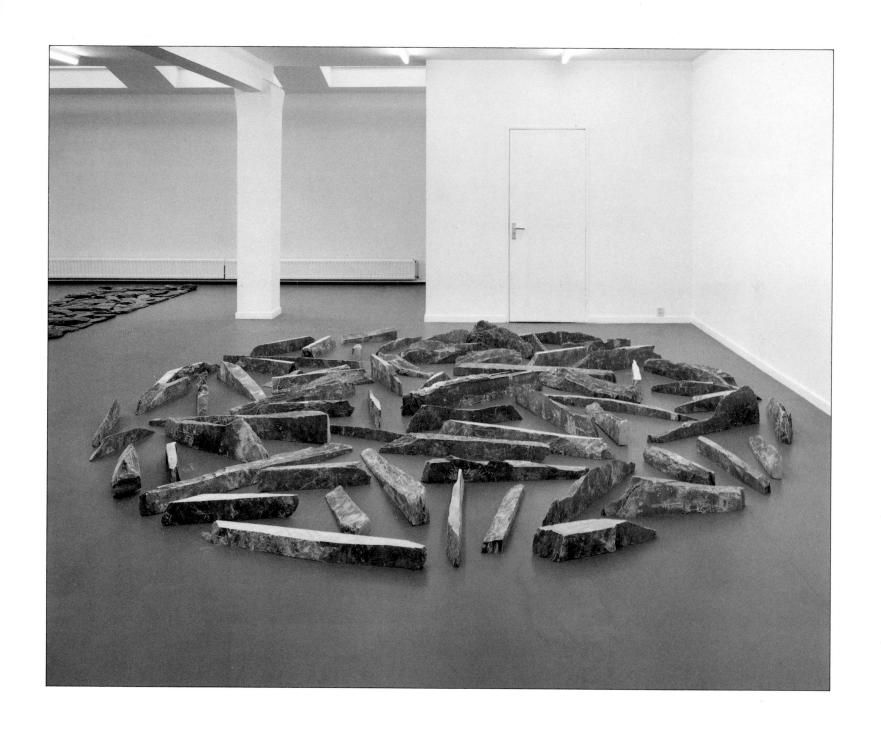

SLATE CIRCLE

AMSTERDAM 1980

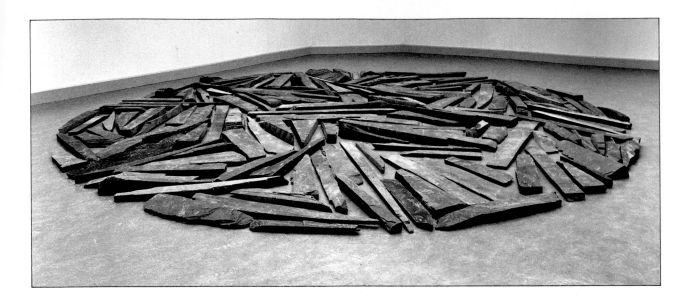

SLATE CIRCLE

EINDHOVEN 1979

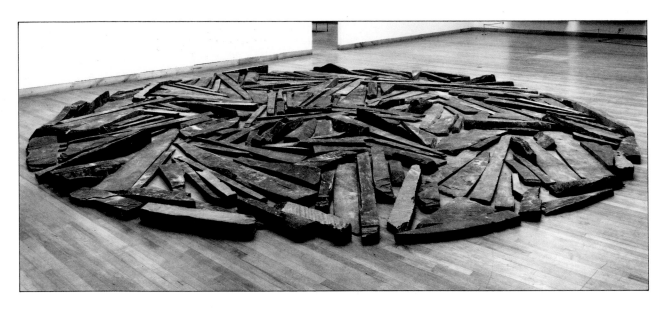

SLATE CIRCLE

LONDON 1979

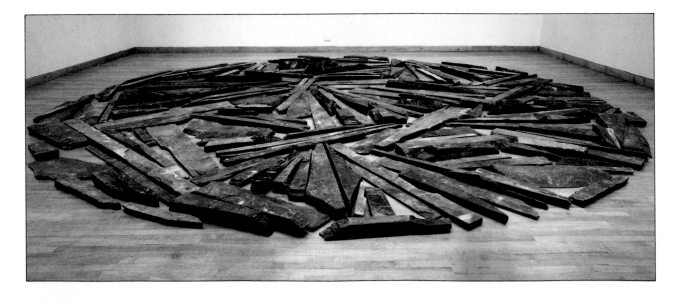

THE SAME WORK MADE AT ANOTHER TIME

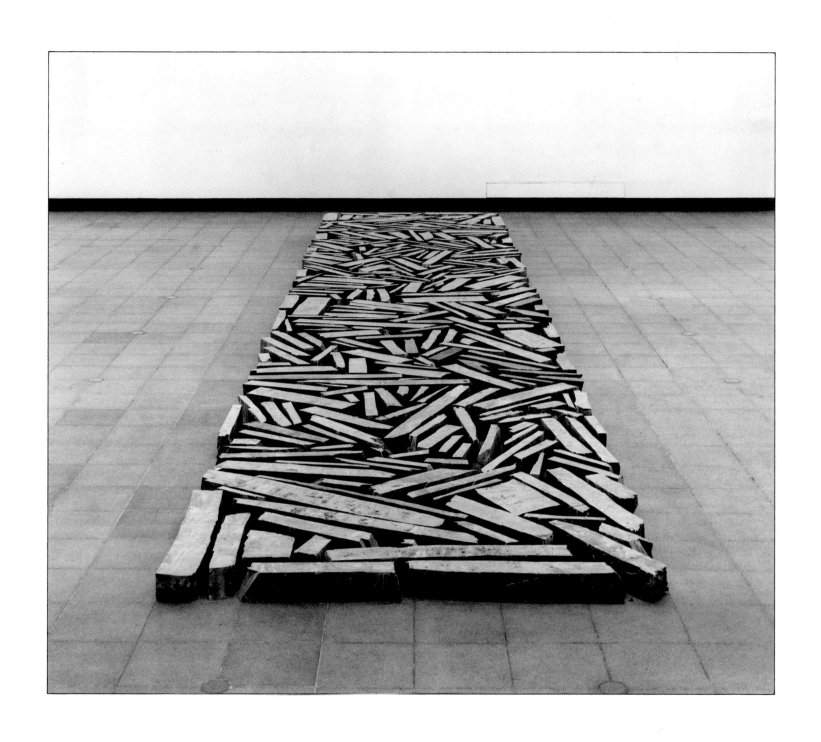

STONE LINE

LONDON 1980

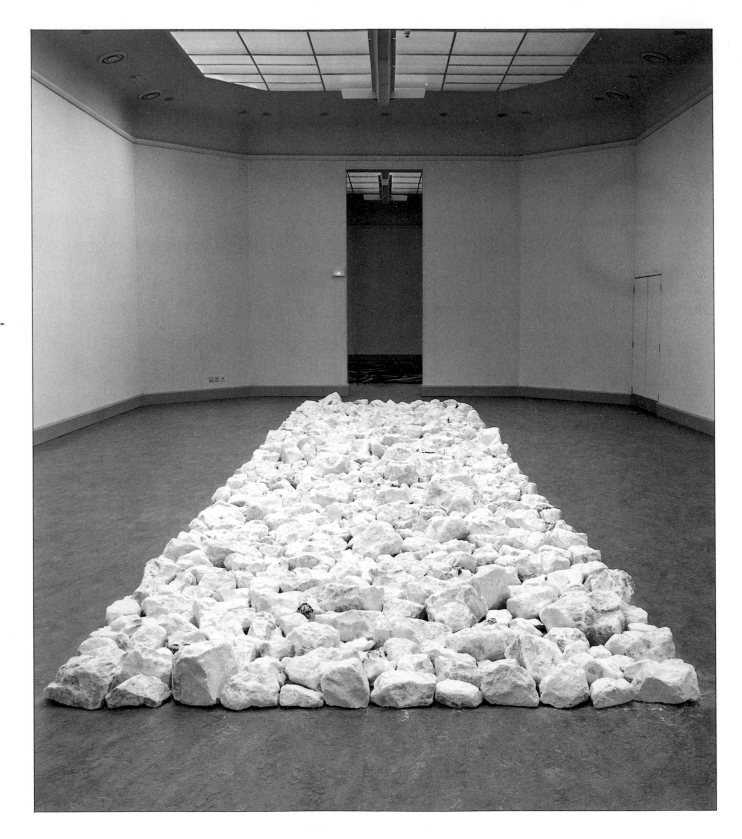

CHALK LINE

EINDHOVEN 1979

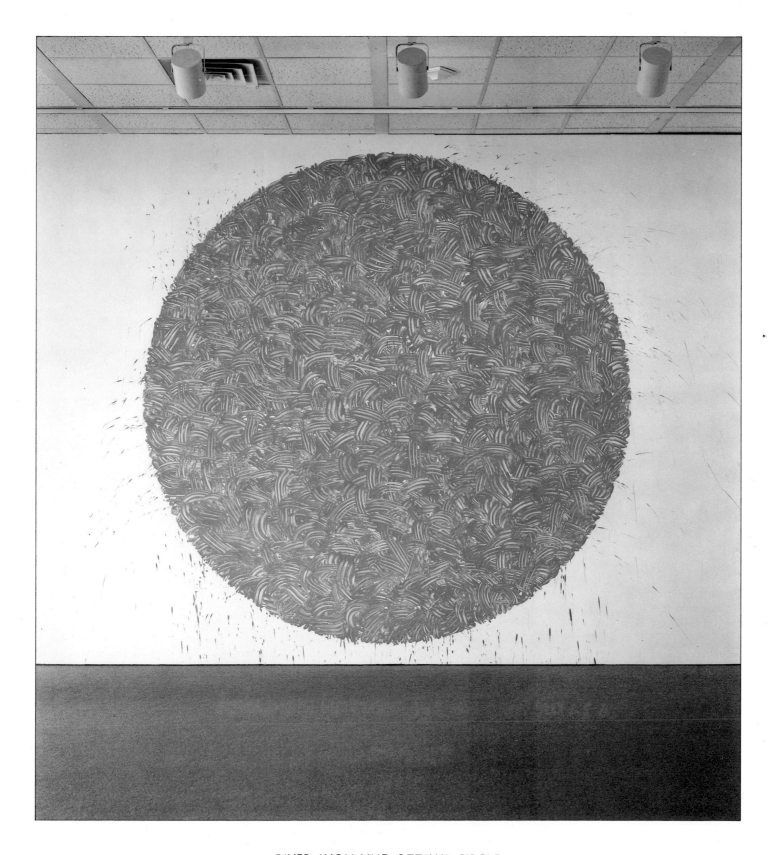

RIVER AVON MUD OTTAWA CIRCLE

1983

SLOW GROUND

DAM

IN THE CLOUDS

UNDER THE CLOUDS

BY MEALL AN UILLT CHREAGAICH

MAOL AN T-SEILICH

WHITE GRAVEL

BY A'MHARCONAICH

HEADWIND

PEAT

SECOND NIGHT

IN THE CLOUDS

SIDEWIND

UP BRUTHACH CHIULAM

WEATHER ROUNDED GRANITE

FIRST NIGHT

BEINN DEARG

ALLT A'CHAMA CHOIRE

HIGHEST PLACE

AM MEADAR

SLEET

RED STONES

WADING

DEER

LOWEST PLACE

WHITE OWL

BURNT HEATHER

A 2½ DAY WALK IN THE SCOTTISH HIGHLANDS

CLOCKWISE

1979

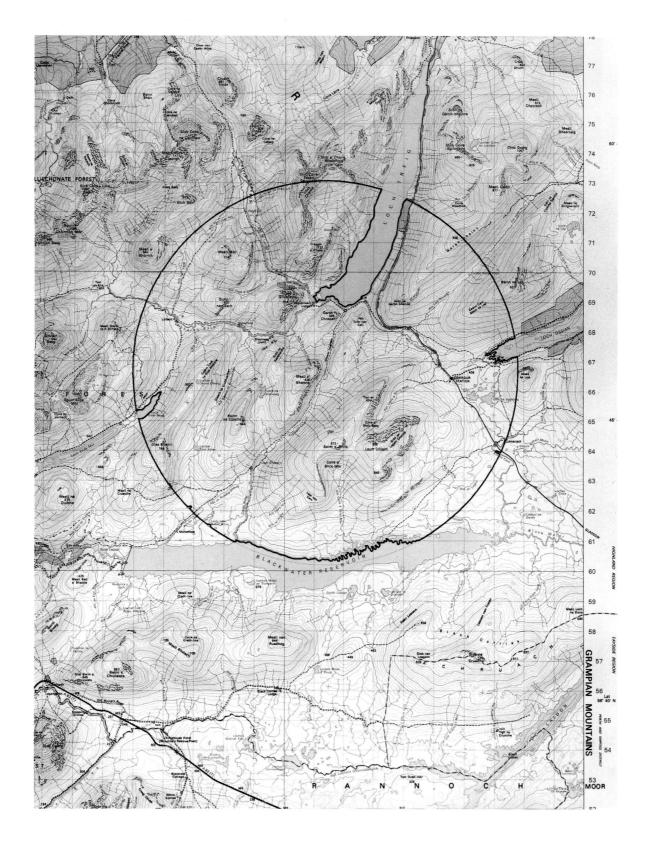

LOW WATER CIRCLE WALK

A 2 DAY WALK AROUND AND INSIDE A CIRCLE IN THE HIGHLANDS

SCOTLAND SUMMER 1980

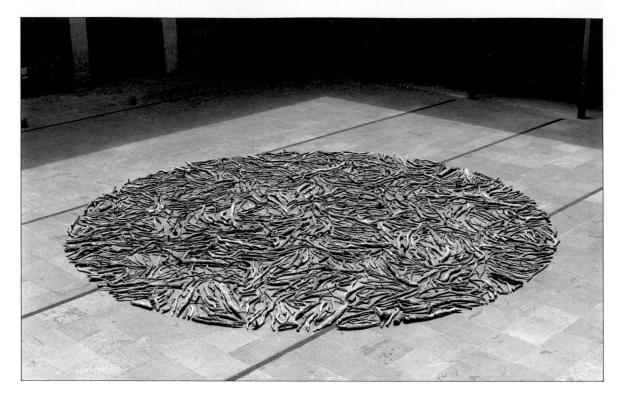

BUSHWOOD CIRCLE

MELBOURNE 1977

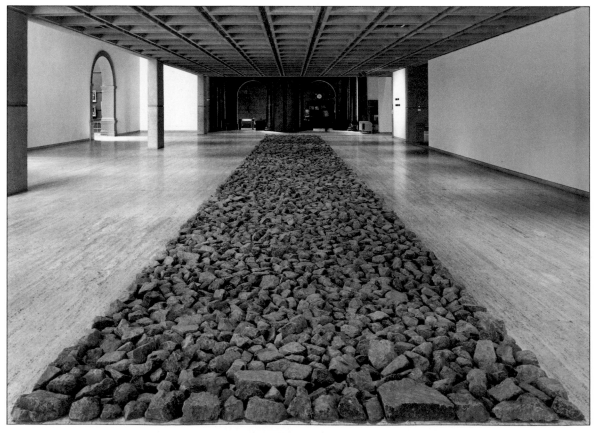

STONE LINE

SYDNEY 1977

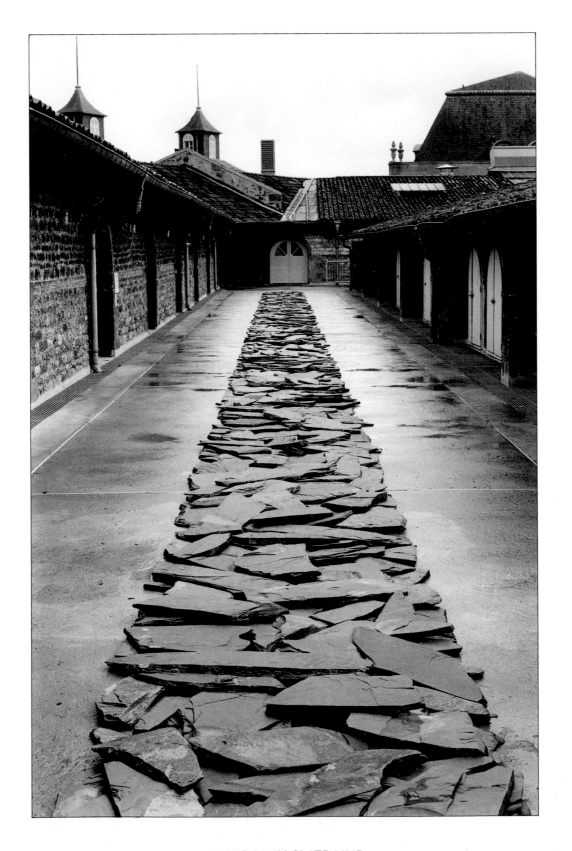

BORDEAUX SLATE LINE

1985

RAILWAY LINE
A PAIR OF BUZZARDS
THISTLES
IRISHMAN'S WALL
WHITEHORSE HILL
STATTS HOUSE
WINNEY'S DOWN
EAST DART RIVER
SANDY HOLE PASS
A DEAD SHEEP
BROAD DOWN
SHEEP BONES
COTTON GRASS
CLAPPER BRIDGE
MIDDAY
GORSE
GRANITE BOULDERS
SECOND FOX
SMALL WOOD
WEST DART RIVER
NAKER'S HILL
FOX
OLD CHINA CLAY WORKINGS
RED LAKE
PONIES
FIRST SUN
CAIRN
BRACKEN
STONE ROW

A STRAIGHT NORTHWARD WALK ACROSS DARTMOOR

ENGLAND 1979

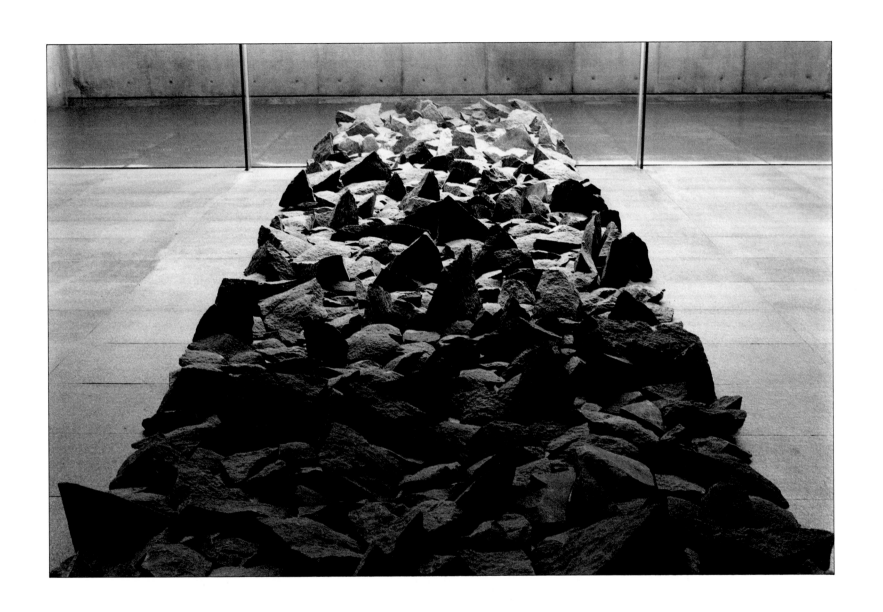

TOKYO STONE LINE

1983

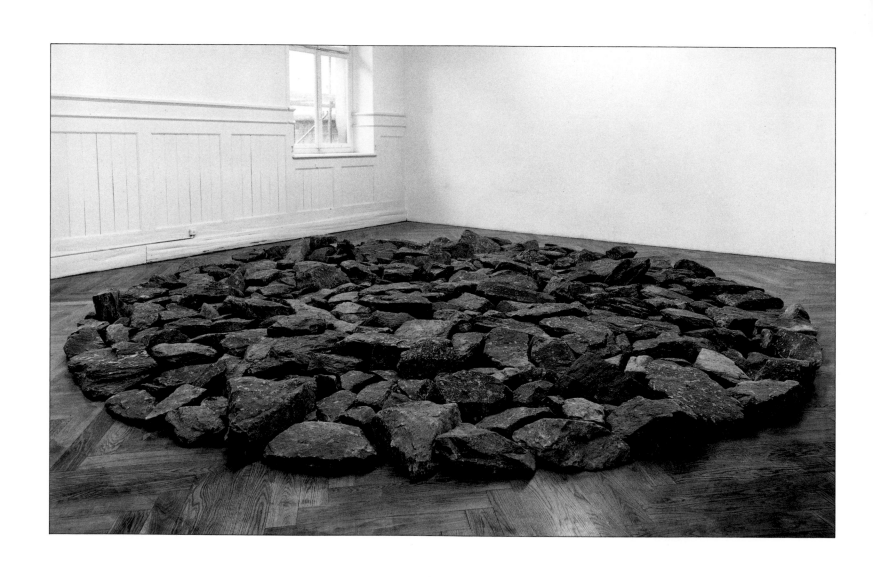

RED STONE CIRCLE

BASEL 1979

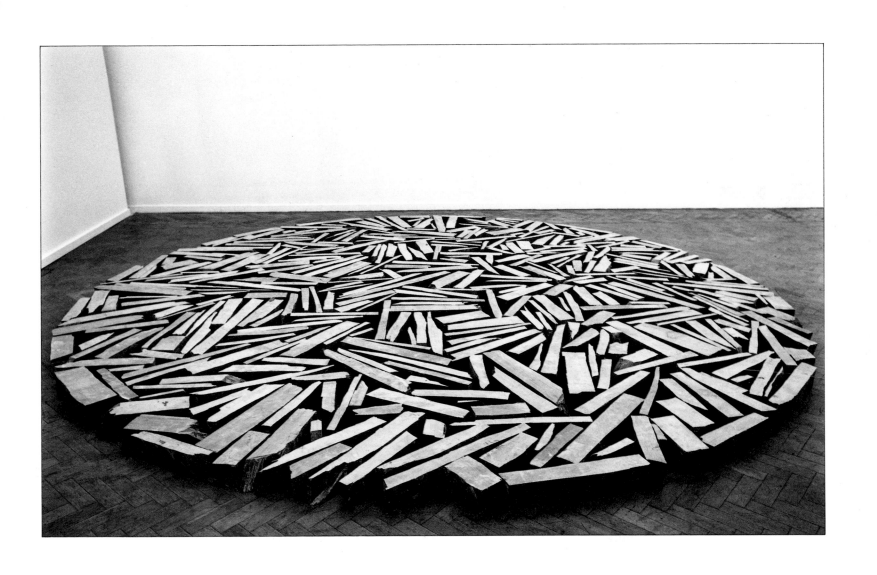

WHITECHAPEL SLATE CIRCLE

LONDON 1981

A FOUR DAY WALK

A LINE OF GROUND 94 MILES LONG

ROAD STONY TRACK ROAD GRASS FIELD
ROAD BARE ROCK LANE ROAD STONY PATH
HEATHER BURNT MOOR STONY PATH ROAD
ROUGH GRASSLAND RIVERBED SHEEPTRACKS EARTH WALL
ROUGH GRASSLAND GRASS FIELDS BRAMBLES GRASS FIELD
ROAD WOODLAND PATH ROAD DUSTY LANE
ROAD GRASS FIELDS EARTH PATH ROAD
SAND BEACH CLIFF PATH ROAD ROCKS
CLIFF PATH SAND DUNES SAND PATH EARTH PATH
ROAD OLD RAILWAY TRACK MUD FLATS SEA WALL
MUD FLATS ROAD RIVERBANK ROAD

ENGLAND 1980

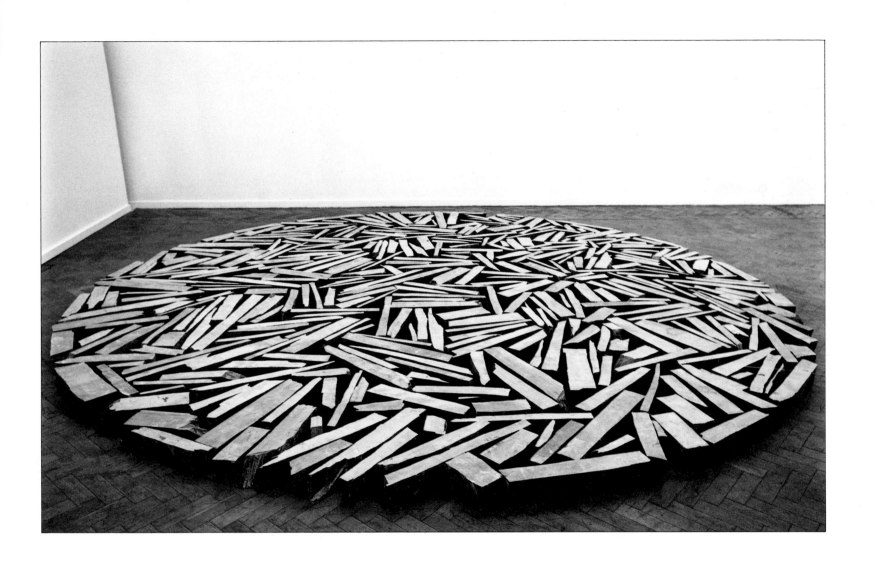

WHITECHAPEL SLATE CIRCLE

LONDON 1981

A FOUR DAY WALK

A LINE OF GROUND 94 MILES LONG

ROAD STONY TRACK ROAD GRASS FIELD
ROAD BARE ROCK LANE ROAD STONY PATH
HEATHER BURNT MOOR STONY PATH ROAD
ROUGH GRASSLAND RIVERBED SHEEPTRACKS EARTH WALL
ROUGH GRASSLAND GRASS FIELDS BRAMBLES GRASS FIELD
ROAD WOODLAND PATH ROAD DUSTY LANE
ROAD GRASS FIELDS EARTH PATH ROAD
SAND BEACH CLIFF PATH ROAD ROCKS
CLIFF PATH SAND DUNES SAND PATH EARTH PATH
ROAD OLD RAILWAY TRACK MUD FLATS SEA WALL
MUD FLATS ROAD RIVERBANK ROAD

ENGLAND 1980

A 118 MILE WALK UNDER THE SKY

CLOUD RAIN RAIN AND SUN CLOUD DRIZZLE RAIN SUN
CLOUD SUN CLOUD THUNDER CLOUD HAIL RAIN SUN
CLOUD SUN CLOUD SUN CLOUD SUN CLOUD
SUN CLOUD SUN CLOUD RAIN STARS SUN
HAZE SUN CLOUD SUN CLOUD SUN CLOUD
SUN CLOUD SUN CLOUD SUN CLOUD SUN
HAZE CLOUD SUN CLOUD SUN CLOUD SUN
CLOUD RAIN AND SUN RAIN CLOUD SUN HAZE CLOUD
SUN CLOUD SUN CLOUD SUN CLOUD SUN
CLOUD SUN CLOUD SUN CLOUD SUN CLOUD
SUN CLOUD SUN AND RAIN CLOUD SUN CLOUD SUN

ENGLAND AUTUMN 1980

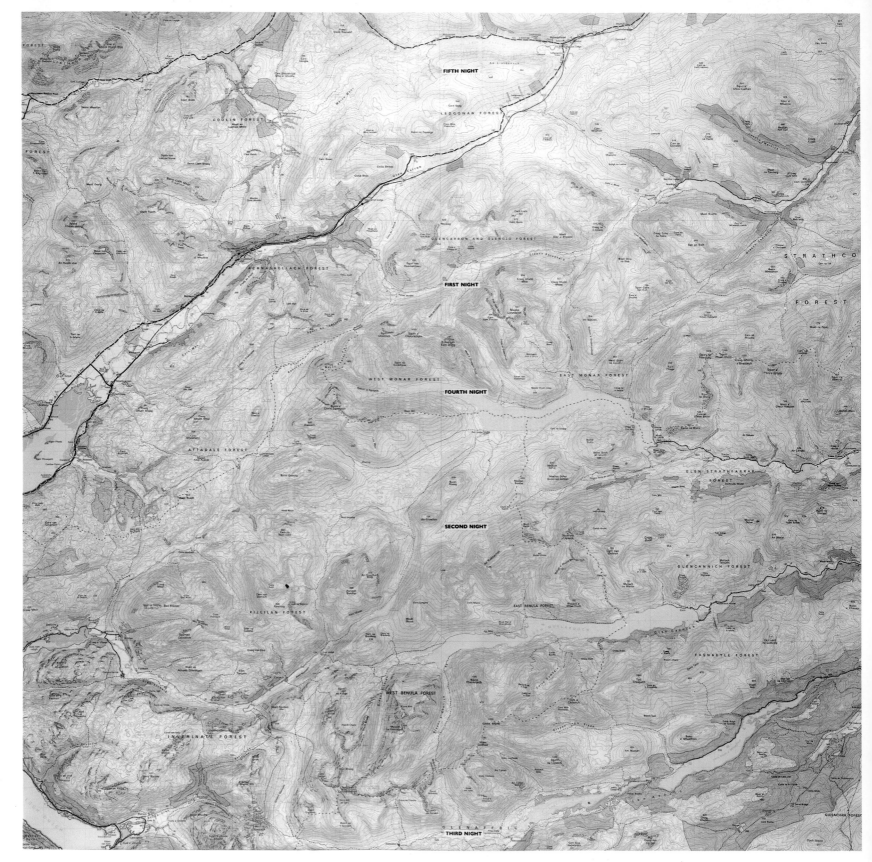

FIFTH NIGHT

FIRST NIGHT

FOURTH NIGHT

SECOND NIGHT

THIRD NIGHT

A LINE OF NIGHTS

A 106 MILE MEANDERING WALK IN NORTH-WEST SCOTLAND 1981

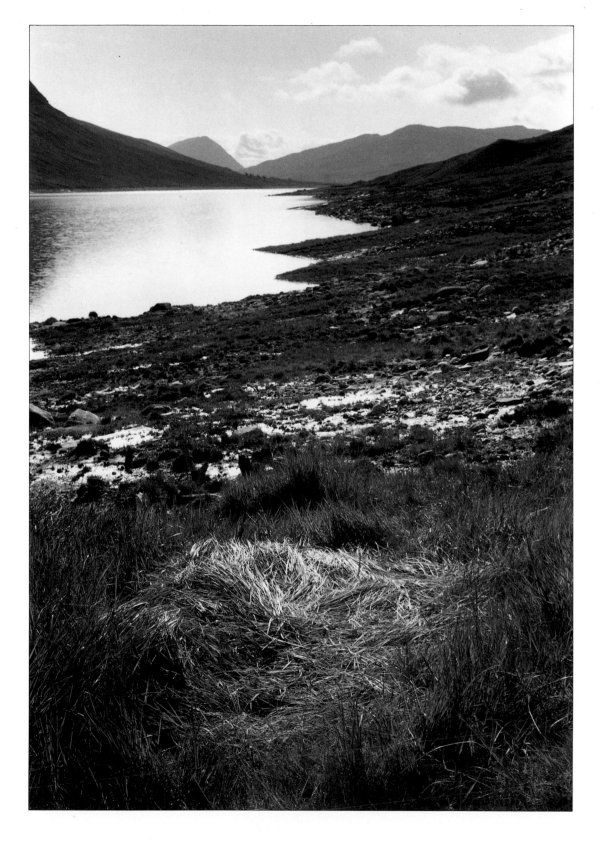

FOURTH NIGHT MORNING

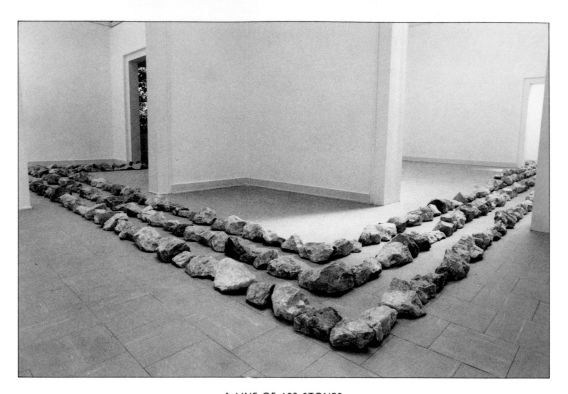

A LINE OF 682 STONES

THE BRITISH PAVILION
XXXVII VENICE BIENNALE 1976

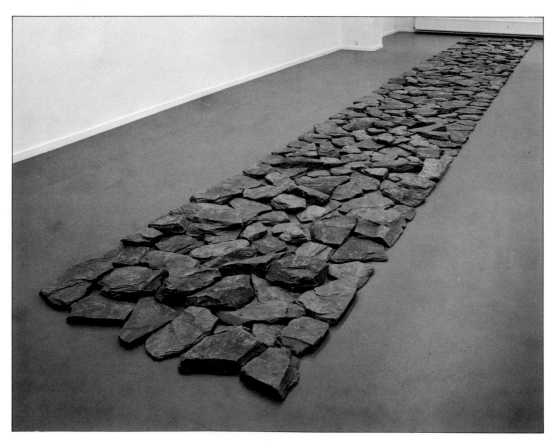

SLATE LINE

AMSTERDAM 1980

STONE STEPS DAYS

FIRST DAY A STONE MOVED ONE STEP WEST
SECOND DAY THE STONE MOVED TWO STEPS NORTH
THIRD DAY THE STONE MOVED THREE STEPS EAST
FOURTH DAY THE STONE MOVED FOUR STEPS SOUTH
FIFTH DAY THE STONE MOVED FIVE STEPS WEST
SIXTH DAY THE STONE MOVED SIX STEPS NORTH
SEVENTH DAY THE STONE MOVED SEVEN STEPS EAST

LONGSTONE HILL

SOMERSET ENGLAND 1985

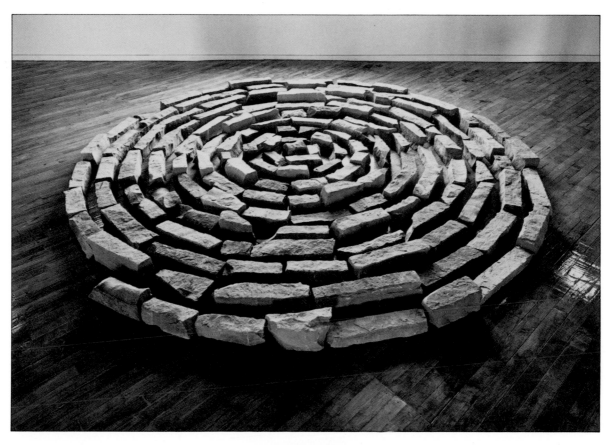

SANDSTONE SPIRAL

TORONTO 1983

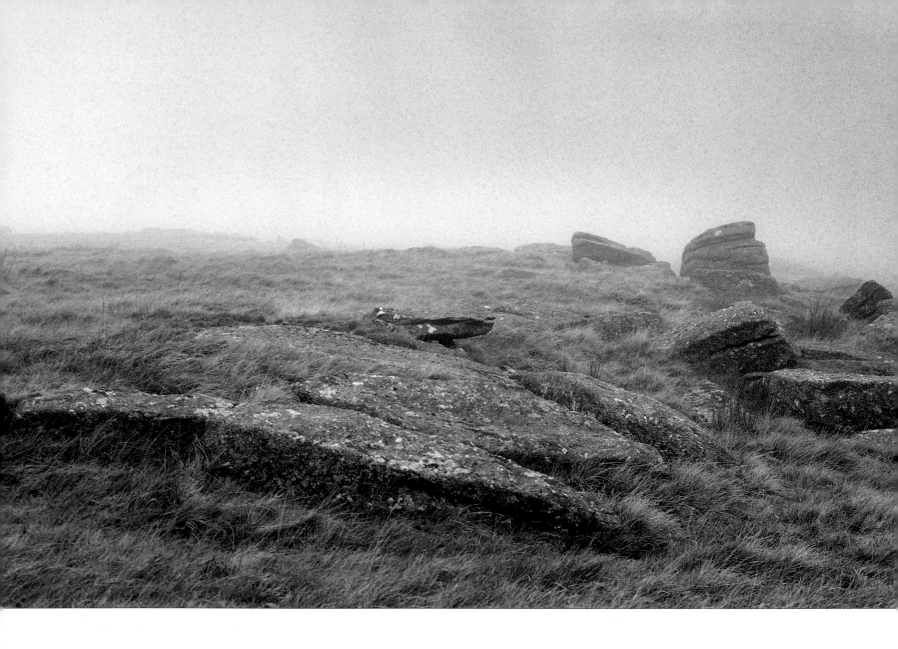

GRANITE STEPPING-STONE CIRCLE

A 5 MILE CIRCULAR WALK ON DARTMOOR
PASSING OVER 409 ROCK SLABS AND BOULDERS

ENGLAND 1980

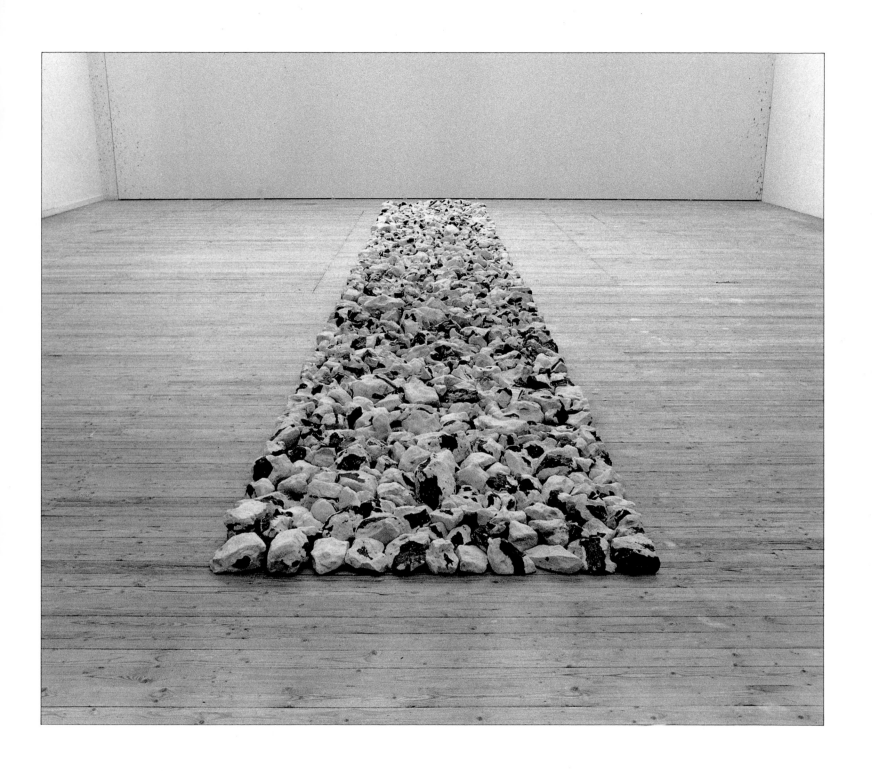

MAGPIE LINE

FLINT

MALMÖ 1985

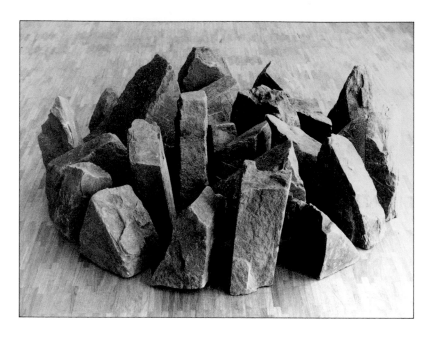

CIRCLE OF STANDING SANDSTONES

DÜSSELDORF 1983

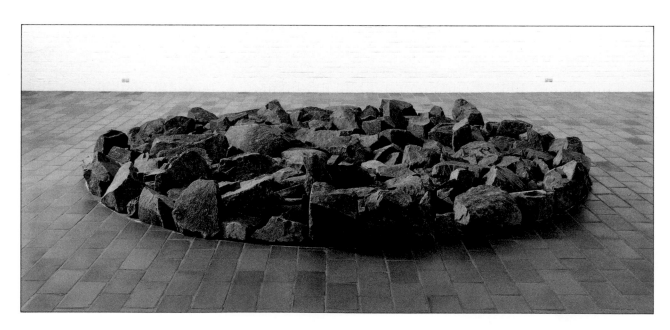

STONE CIRCLE

HUMLEBAEK 1980

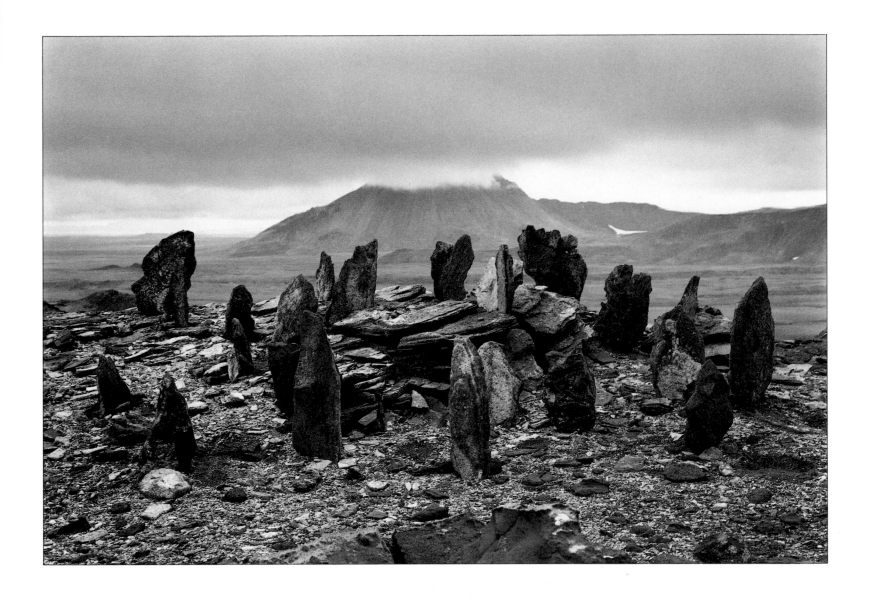

TOUCHSTONES SHELTER FROM THE STORM

A FIVE DAY WALK IN ICELAND

SUMMER 1982

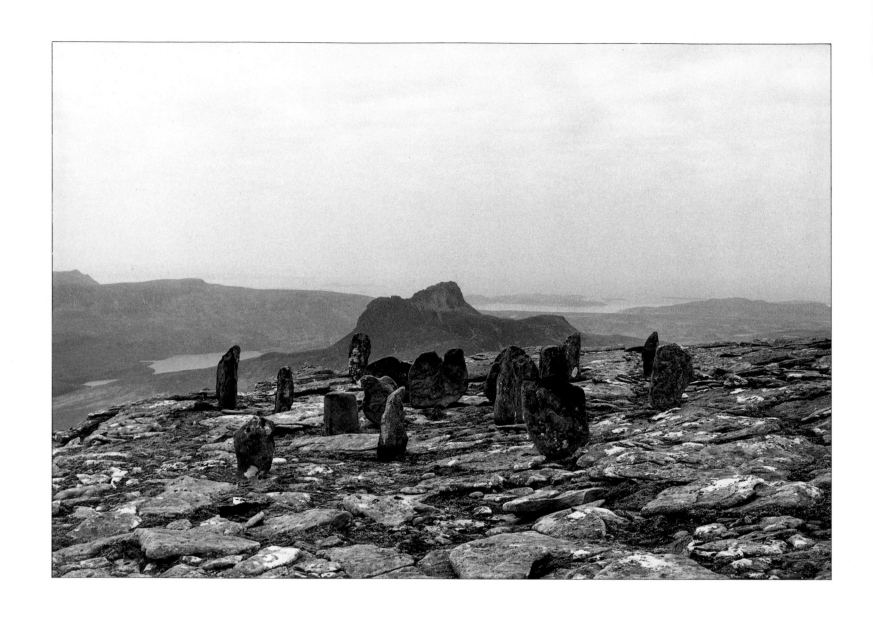

STONES AND STAC POLLAIDH

SCOTLAND 1981

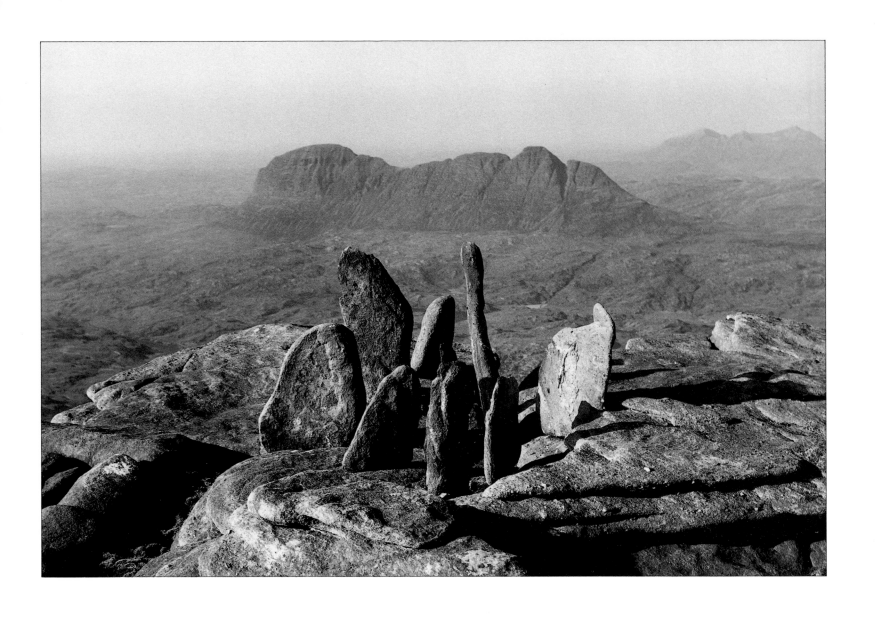

STONES AND SUILVEN

GRANITE LINE

SCATTERED ALONG A STRAIGHT 9 MILE LINE
223 STONES PLACED ON DARTMOOR

ENGLAND 1980

A LINE OF GROUND 226 MILES LONG

ROAD COAL TIP ROAD ROMAN MOUNTAIN ROAD ROAD
WOODLAND RIVERBED ROAD STONY TRACK ROAD
MUD TRACK ROAD GRASS LANE ROAD PEBBLE RIDGE
ROAD BARE ROCK LANE ROAD SLURRY ROAD

A 7 DAY WALK
WALES 1980

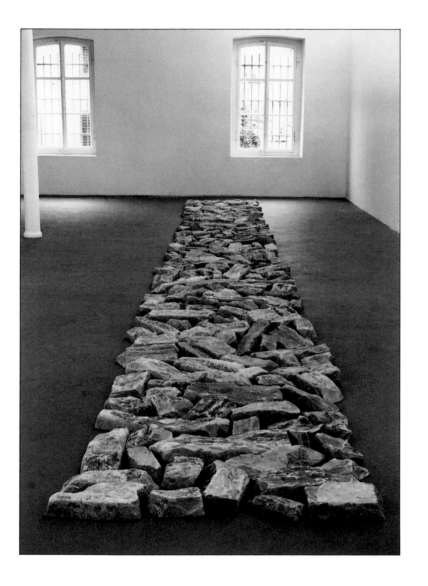

STONE LINE

ZÜRICH 1981

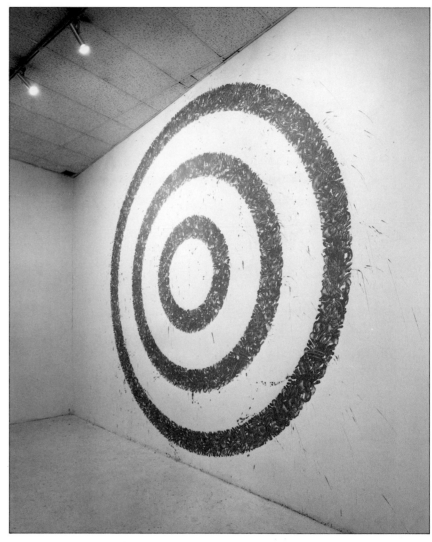

RIVER AVON MUD CIRCLES

PARIS 1982

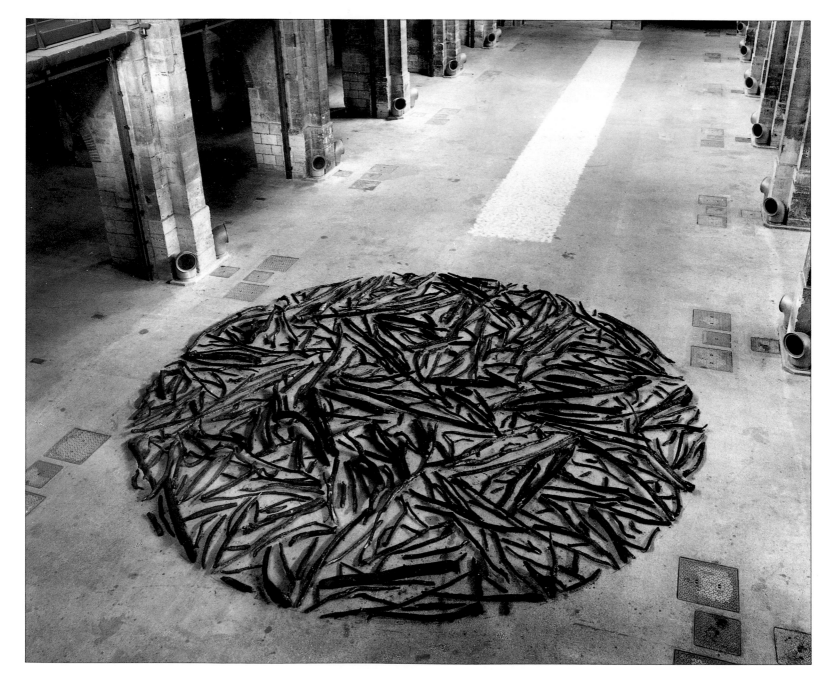

LIGHTNING FIRE WOOD CIRCLE

BORDEAUX 1981

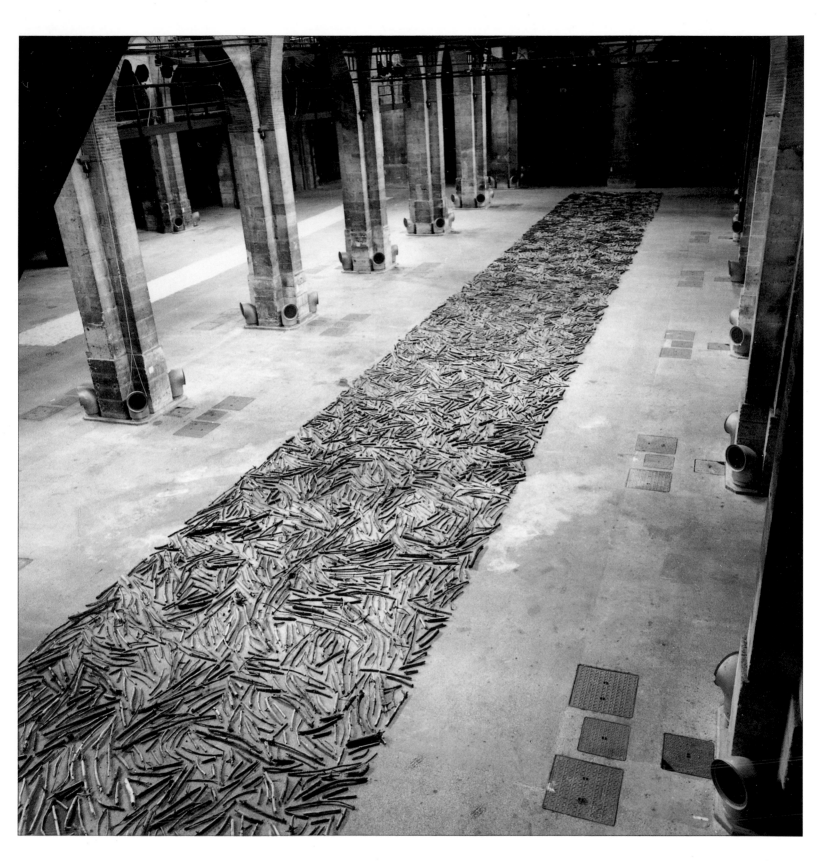

FORÊT DU PORGE LINE

BORDEAUX 1981

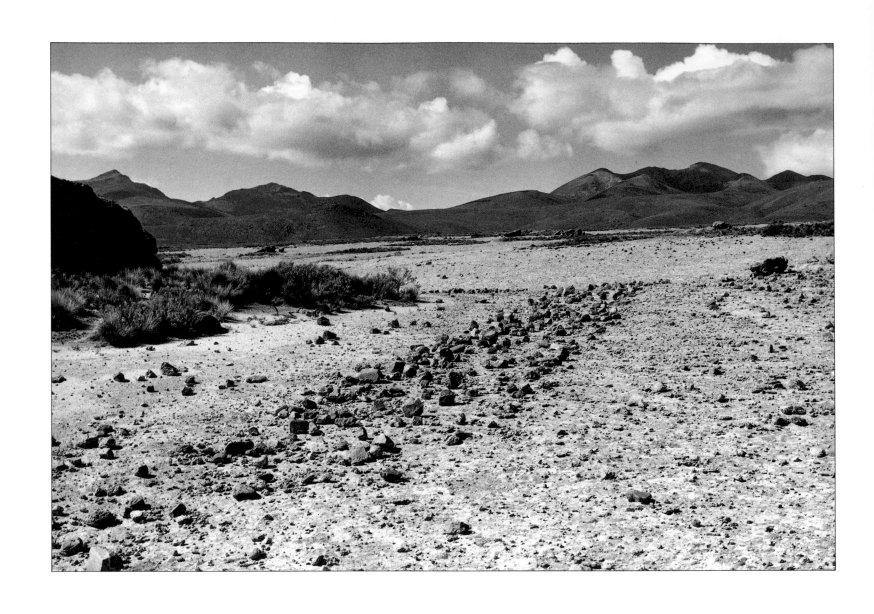

A LINE IN BOLIVIA

KICKED STONES

1981

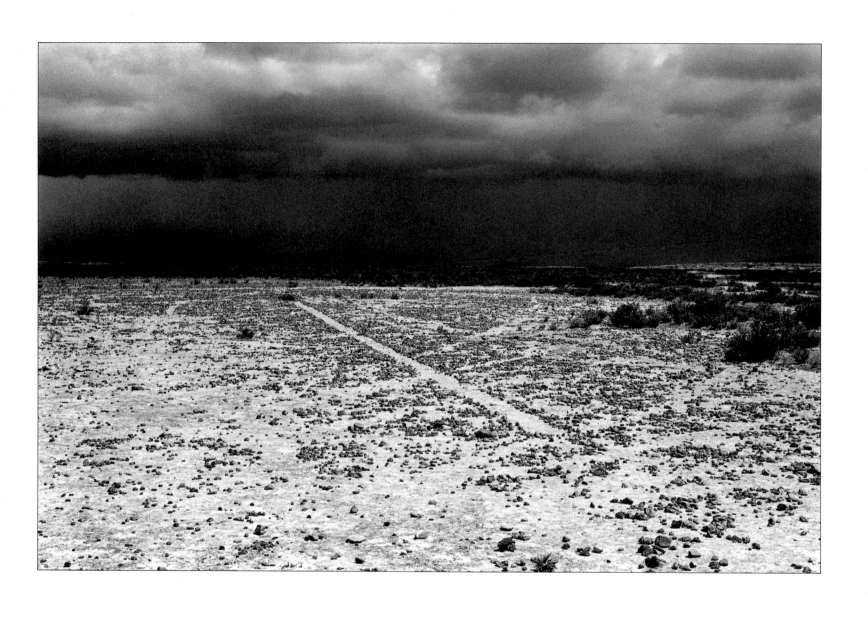

A LINE, TRACKS AND A STORM IN BOLIVIA

1981

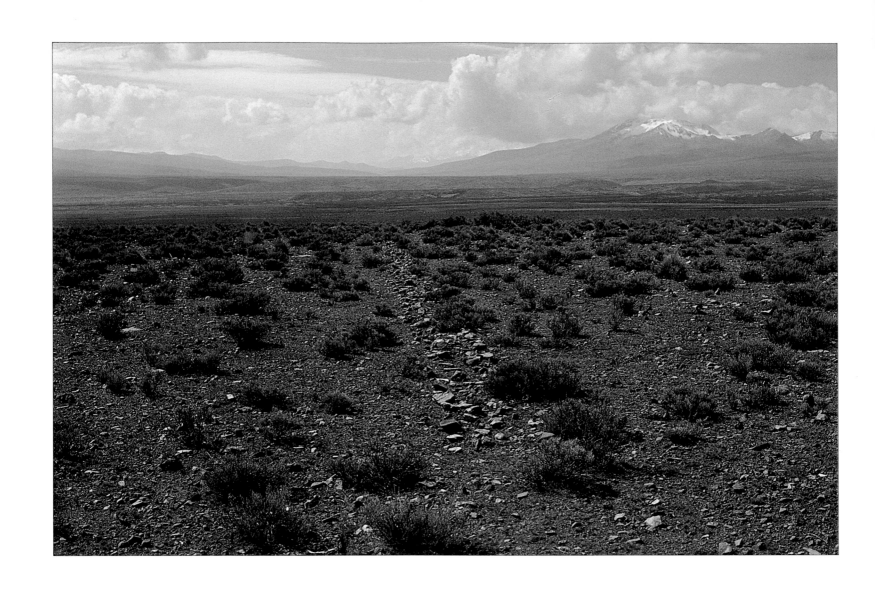

BLOWING IN THE WIND

BOLIVIA 1981

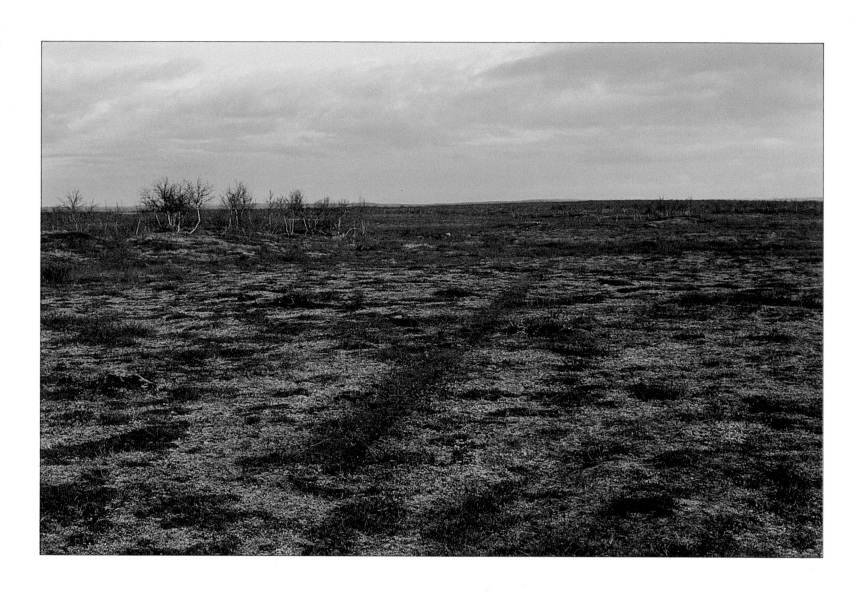

WALKING A LINE IN LAPPLAND

FINLAND 1983

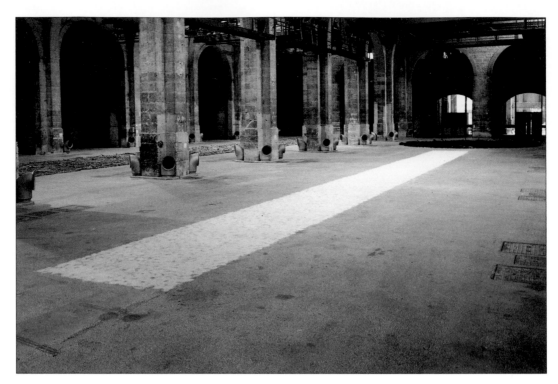

WALKING A LINE IN BORDEAUX

1981

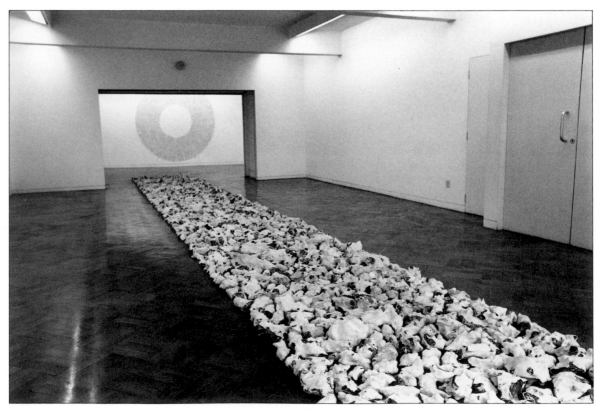

FLINT LINE

LONDON 1983

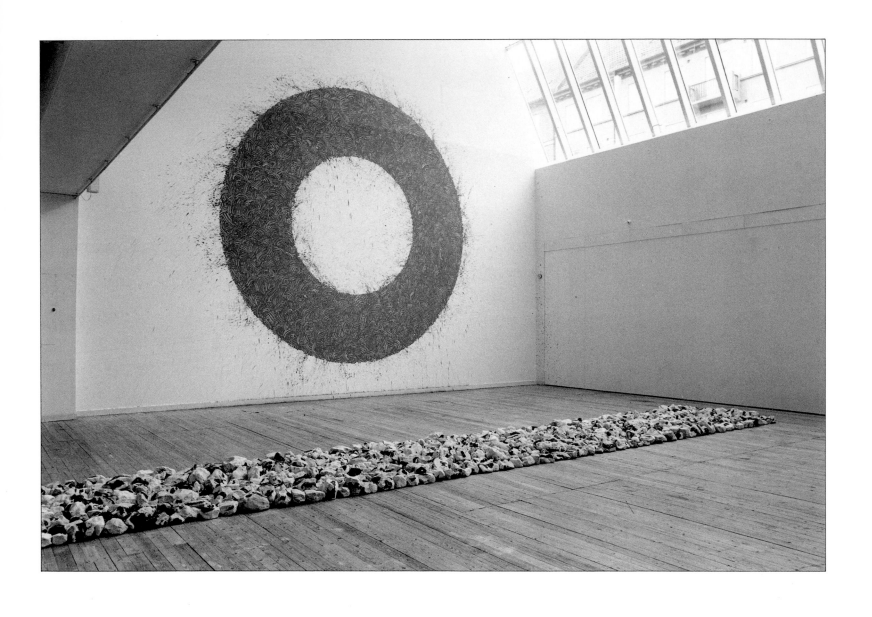

MAGPIE LINE AND RIVER AVON MUD CIRCLE

MALMÖ 1985

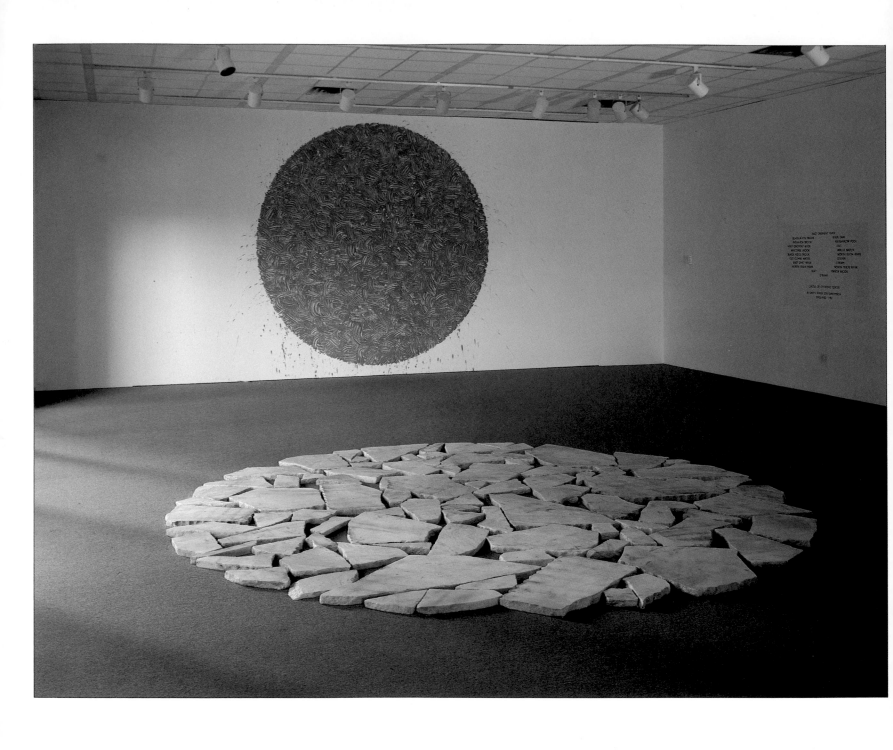

WHITE MARBLE CIRCLE AND RIVER AVON MUD OTTAWA CIRCLE

OTTAWA 1983

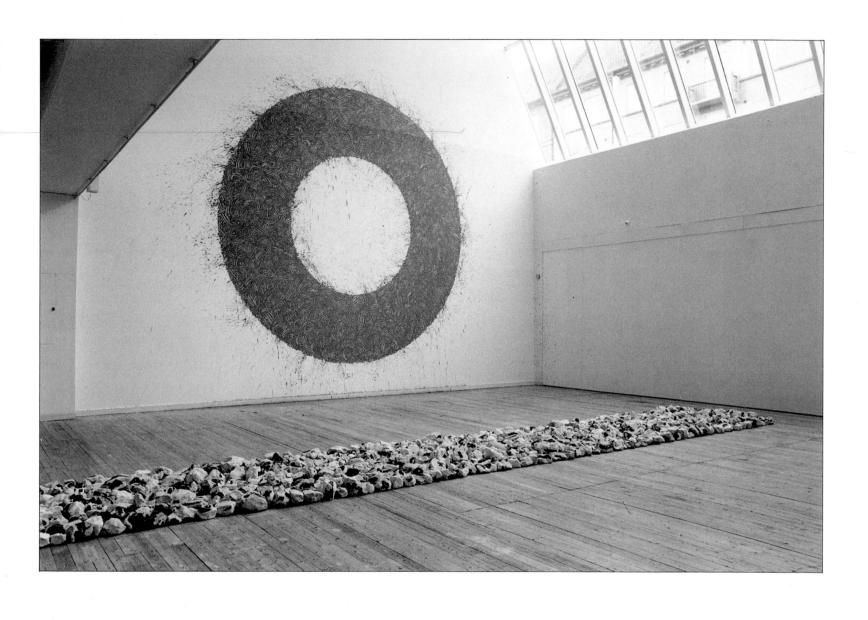

MAGPIE LINE AND RIVER AVON MUD CIRCLE

MALMÖ 1985

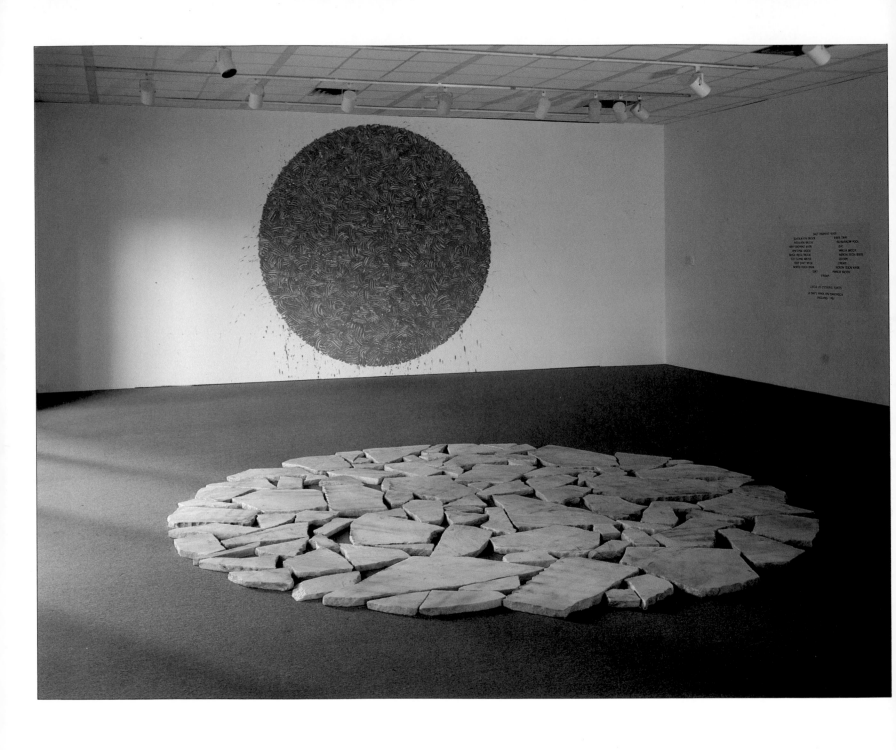

WHITE MARBLE CIRCLE AND RIVER AVON MUD OTTAWA CIRCLE

OTTAWA 1983

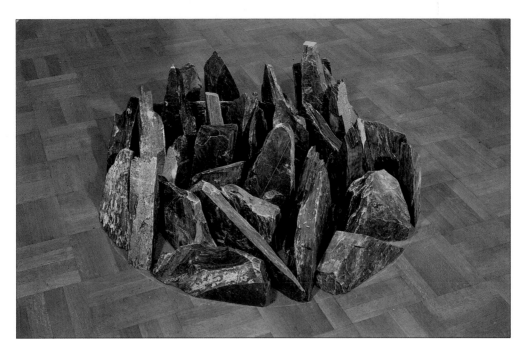

STANDING STONE CIRCLE

LONDON 1982

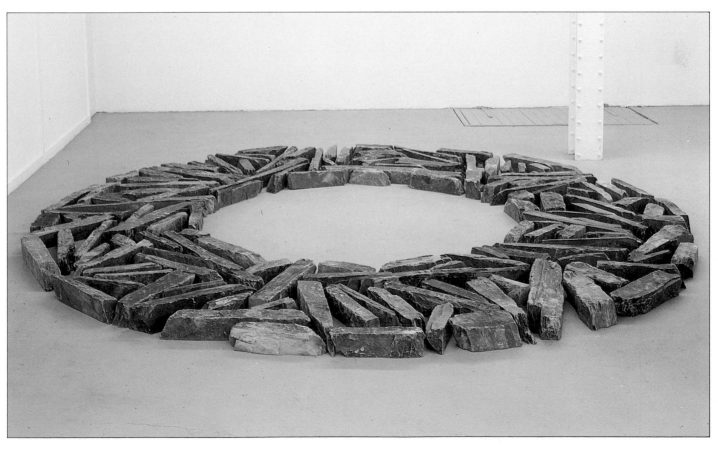

CORNISH SLATE RING

PARIS 1984

175

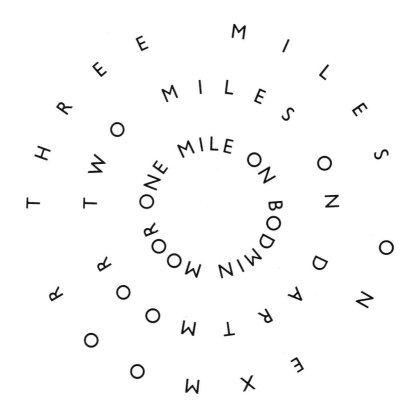

THREE MOORS THREE CIRCLES

A 108 MILE WALK FROM BODMIN MOOR, TO DARTMOOR, TO EXMOOR,
WALKING AROUND THREE CIRCLES ALONG THE WAY

LISKEARD TO PORLOCK ENGLAND 1982

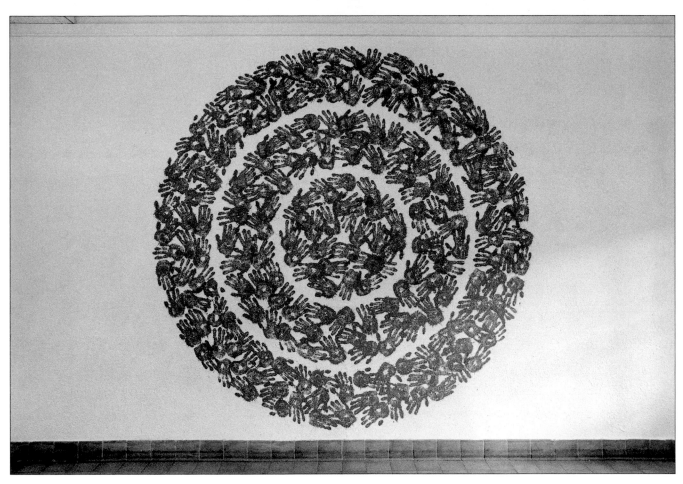

KILKENNY CIRCLES

1984

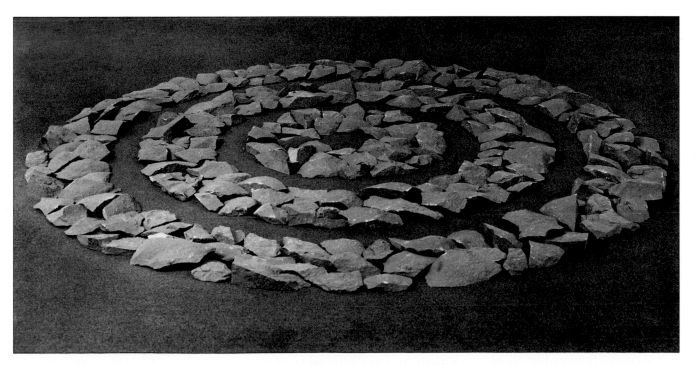

NAPOLI CIRCLES

1984

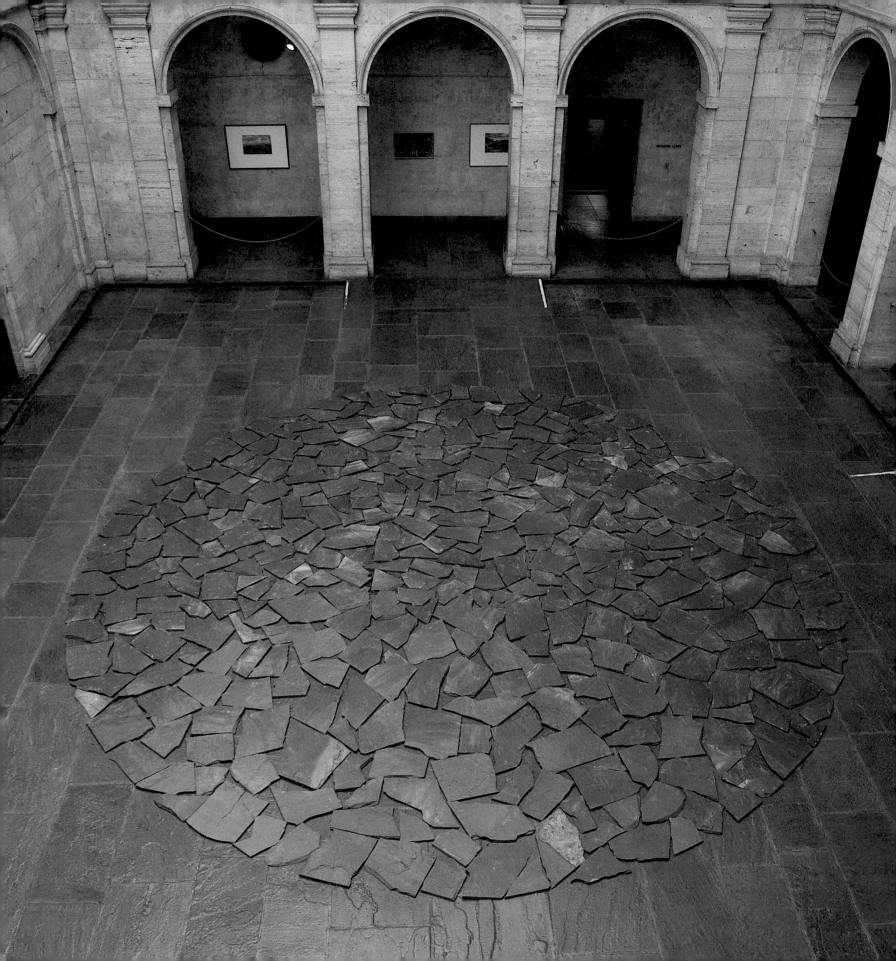

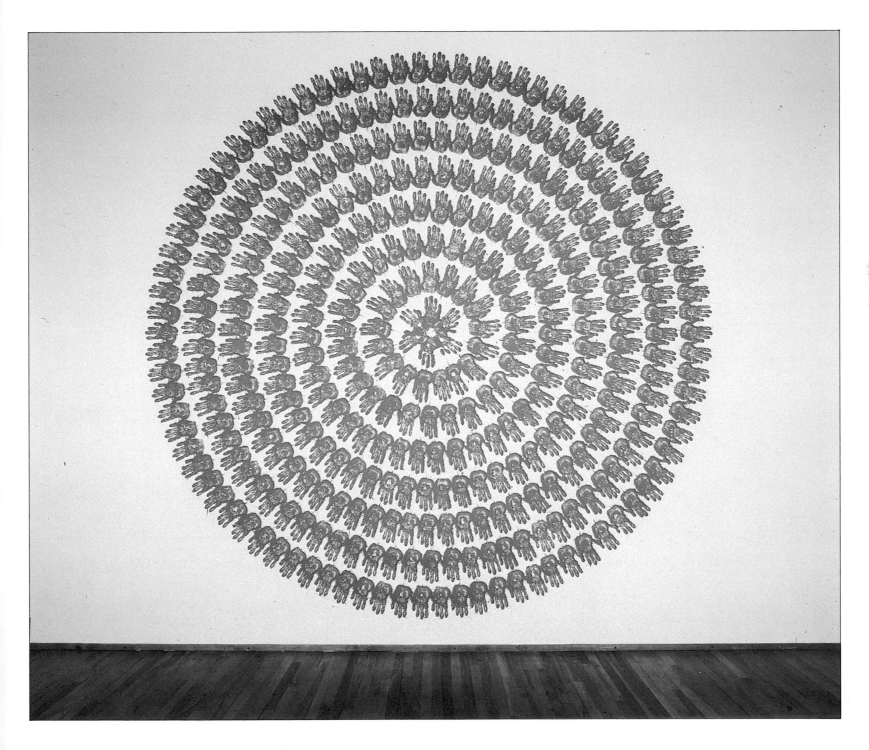

MUD HAND CIRCLES

NEW YORK 1984

RED SLATE CIRCLE

BOSTON 1980

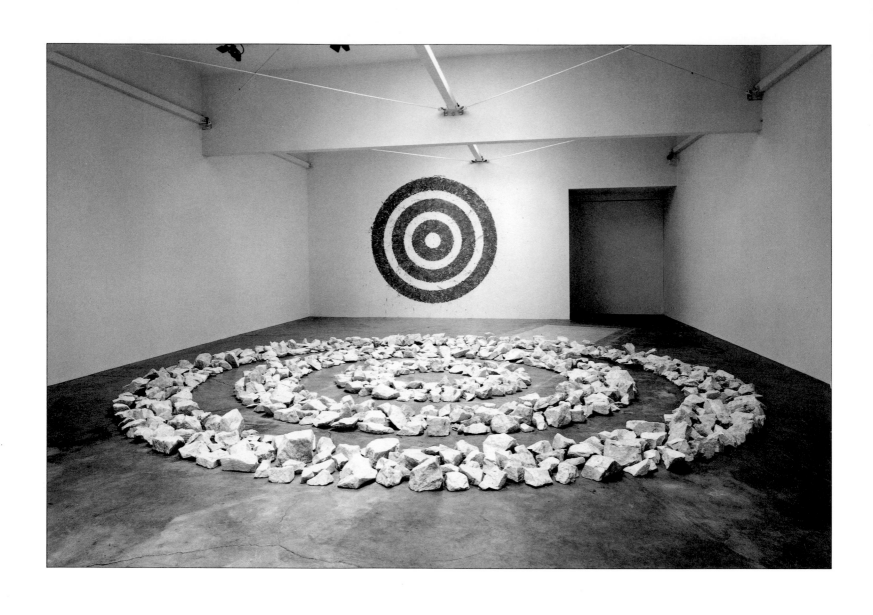

LITTLE TEJUNGA CANYON STONE CIRCLES

LOS ANGELES 1982

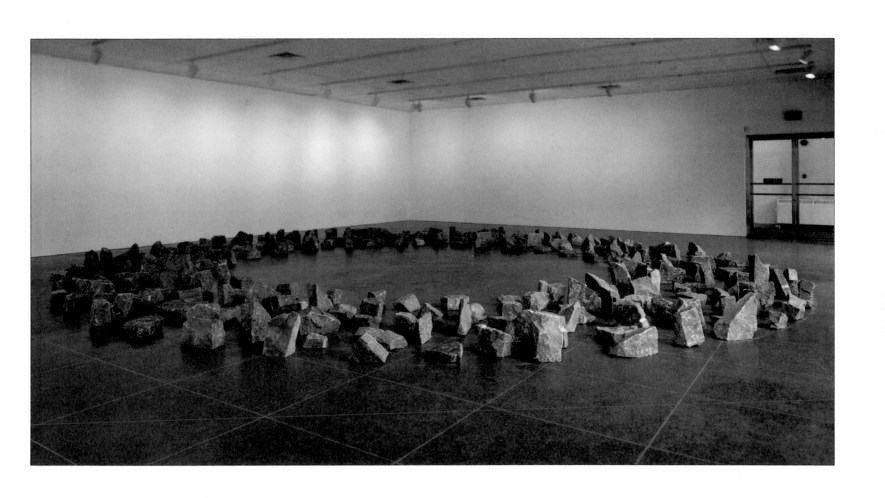

RING OF STONES

OTTAWA 1982

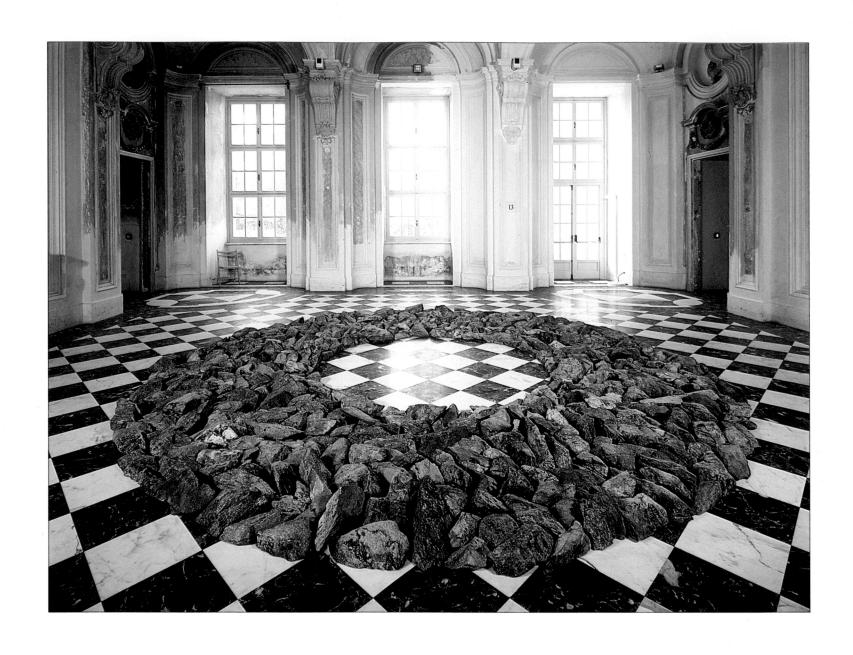

PIEMONTE STONE RING

TURIN 1984

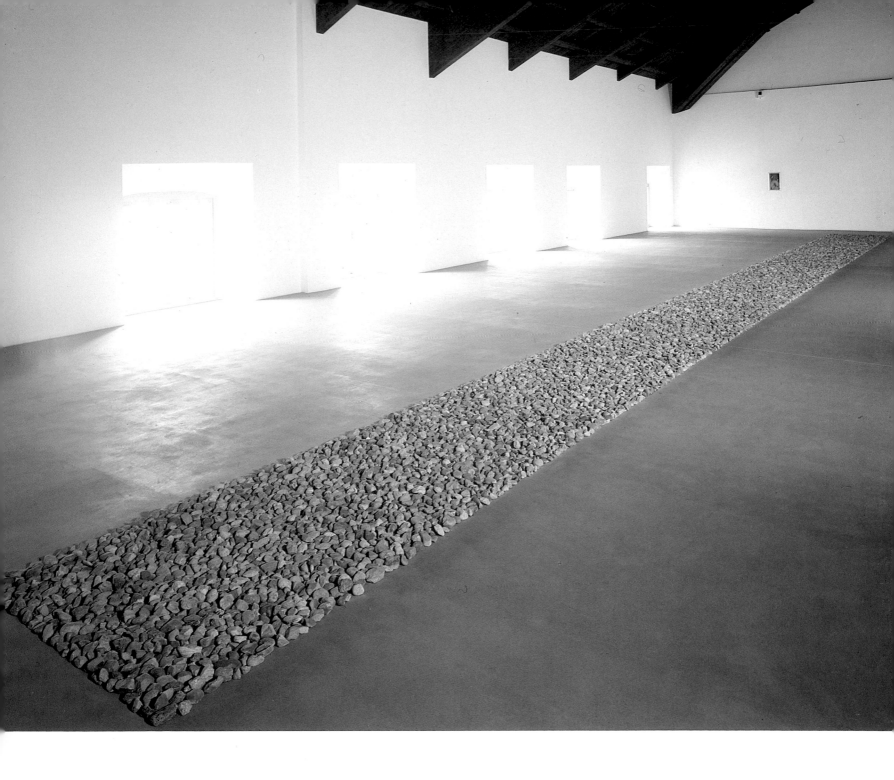

LINE OF LAKE STONES

TURIN 1984

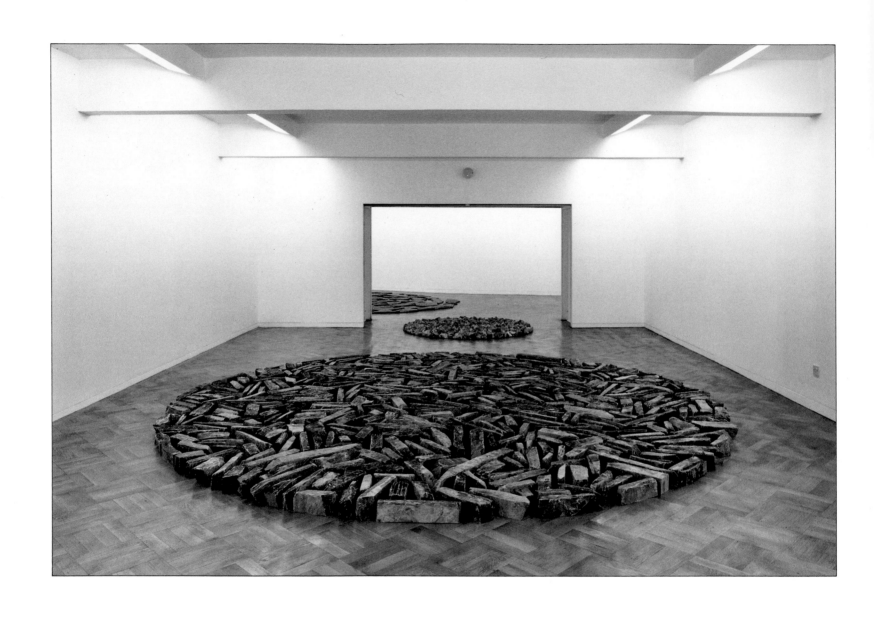

DELABOLE SLATE CIRCLE

LONDON 1981

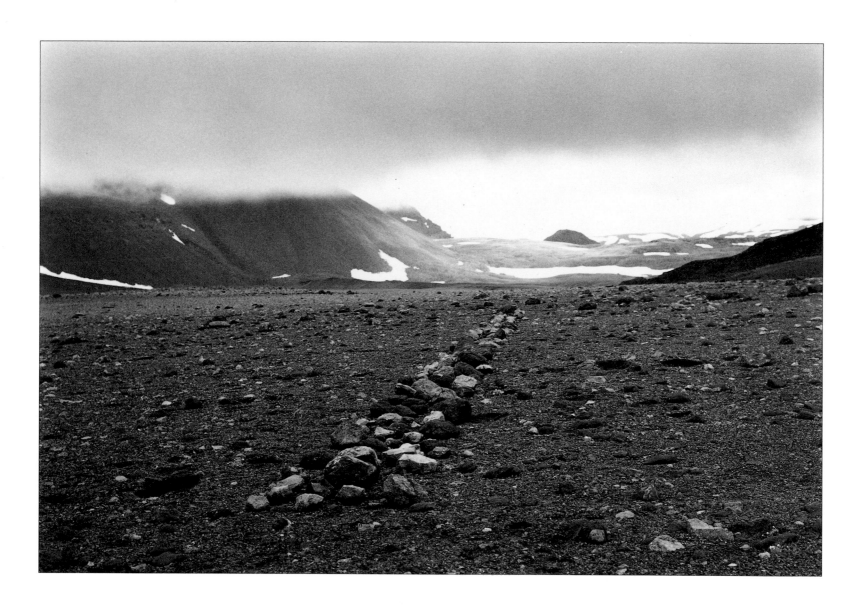

A LINE IN ICELAND

1982

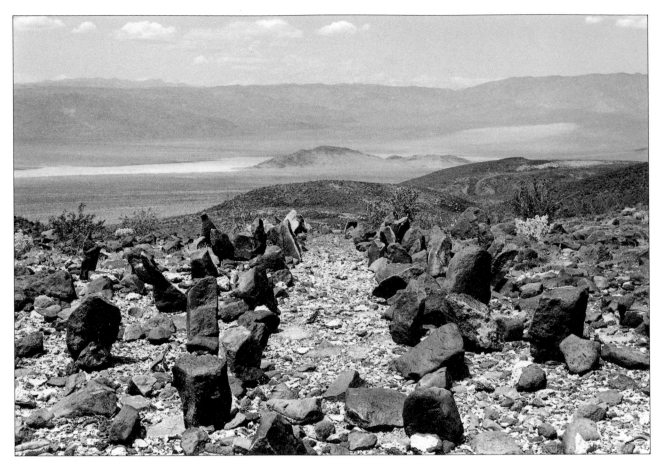

A LINE IN CALIFORNIA

1982

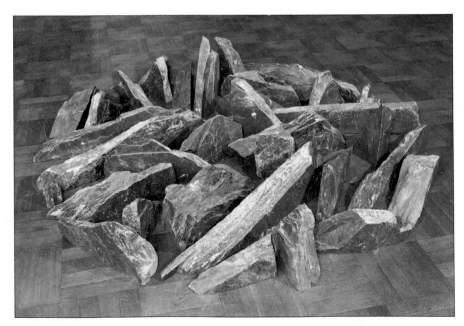

CORNWALL SLATE CIRCLE

1982

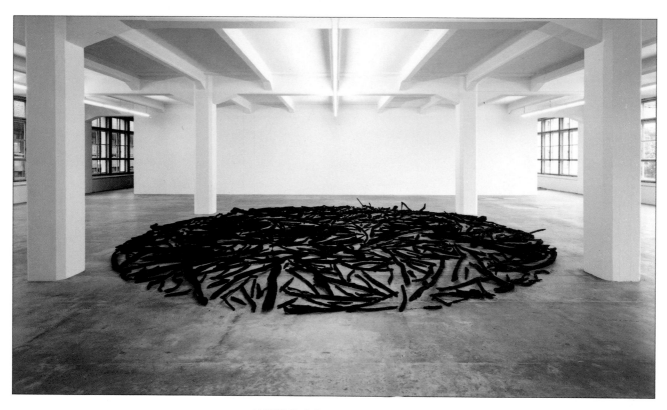

LIGHTNING FIRE WOOD CIRCLE

SCHAFFHAUSEN 1982

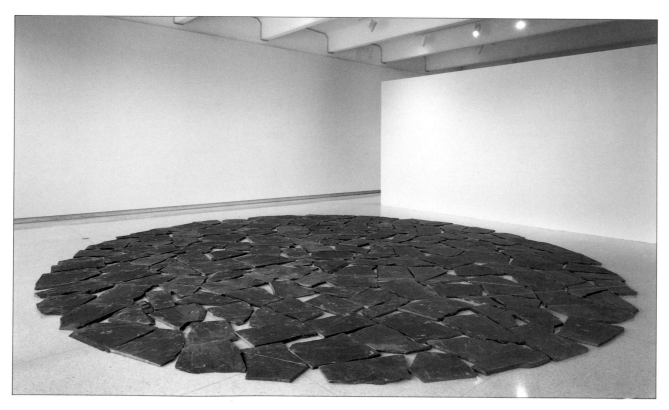

MINNEAPOLIS CIRCLE

1982

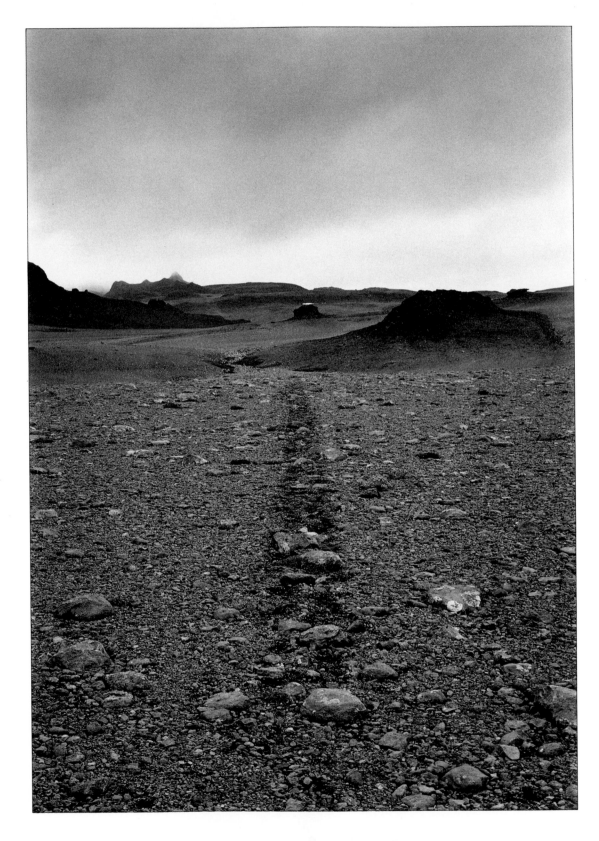

WALKING A LINE IN ICELAND

1982

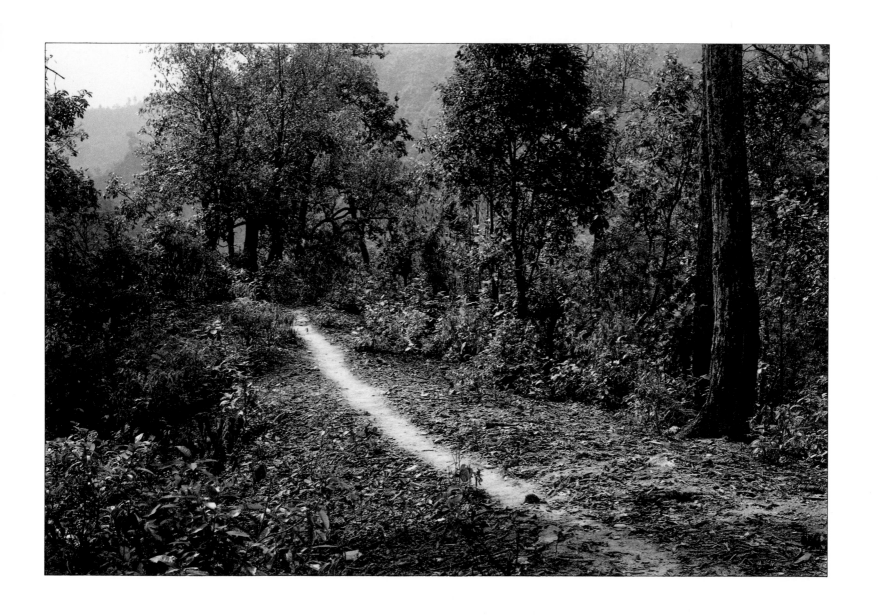

BRUSHED PATH A LINE IN NEPAL

1983

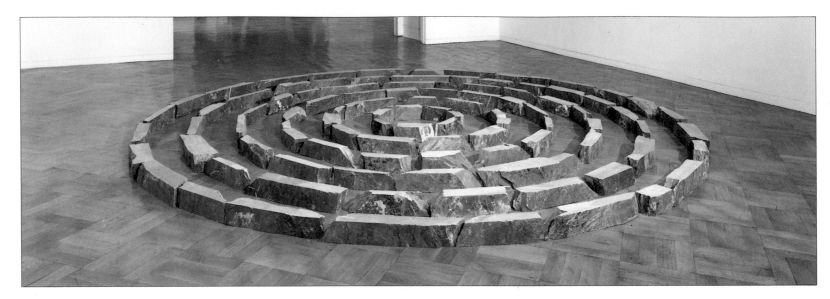

SIX SLATE CIRCLES

LONDON 1982

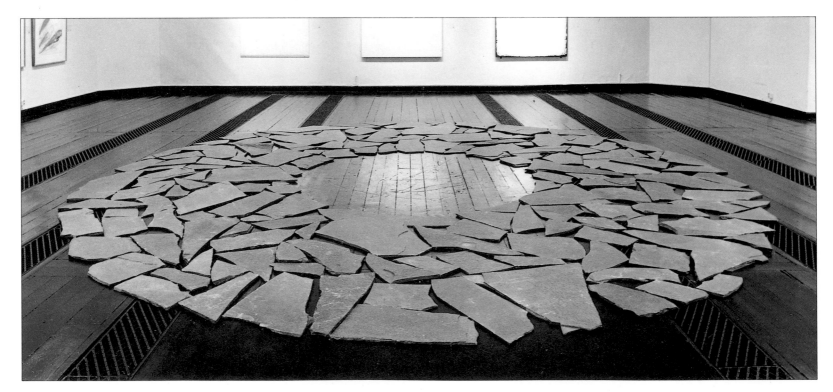

HELSINKI CIRCLE

1983

190

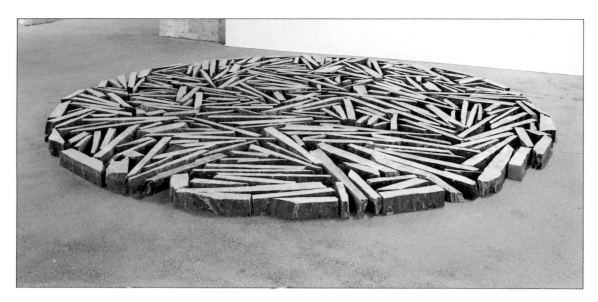

CORNWALL SLATE CIRCLE

BORDEAUX 1981

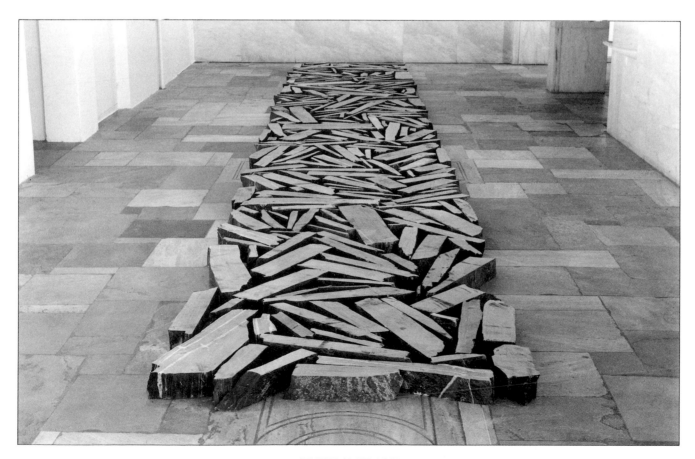

ATHENS SLATE LINE

1984

SUN	HARD PATH	GULLS	FRESH AIR	BLACKBERRY
HORIZON	WET EARTH	CRUNCHING	EARTH LANE	LICHEN
LIGHTHOUSE	CHILLNESS	DISTANT SURF ROAR	HEATHER	SALT WATER
SHAG	GRANITE	BEE	SEA	STONE
DRIFTWOOD	HEATHER	PADDING	DEAD FISH	
RABBIT	TURF	LARK		
BUTTERFLIES	BRAMBLES	BREAKERS		
NET	BOULDERS	LOBSTER BOAT		
SEAL	WET GRASS	MOOING		
WREN	ROOTS	GOOD MORNING		
PEBBLE MAZE	WARMTH	LAPPING		
DAZZLING FOAM	COBWEB	SWISH		
TALL HEDGE	HARD PATH	COW CHEWING		
		GENERATOR		

EARLY MORNING SENSES ISLAND WALK

ST. AGNES, ISLES OF SCILLY ENGLAND 1982

HEAVIER SLOWER SHORTER
LIGHTER FASTER LONGER

A FOUR DAY WALK IN ENGLAND
PICKING A STONE UP EACH DAY AND CARRYING IT.
A FOUR DAY WALK IN WALES
SETTING DOWN ONE OF THE STONES EACH DAY.

1982

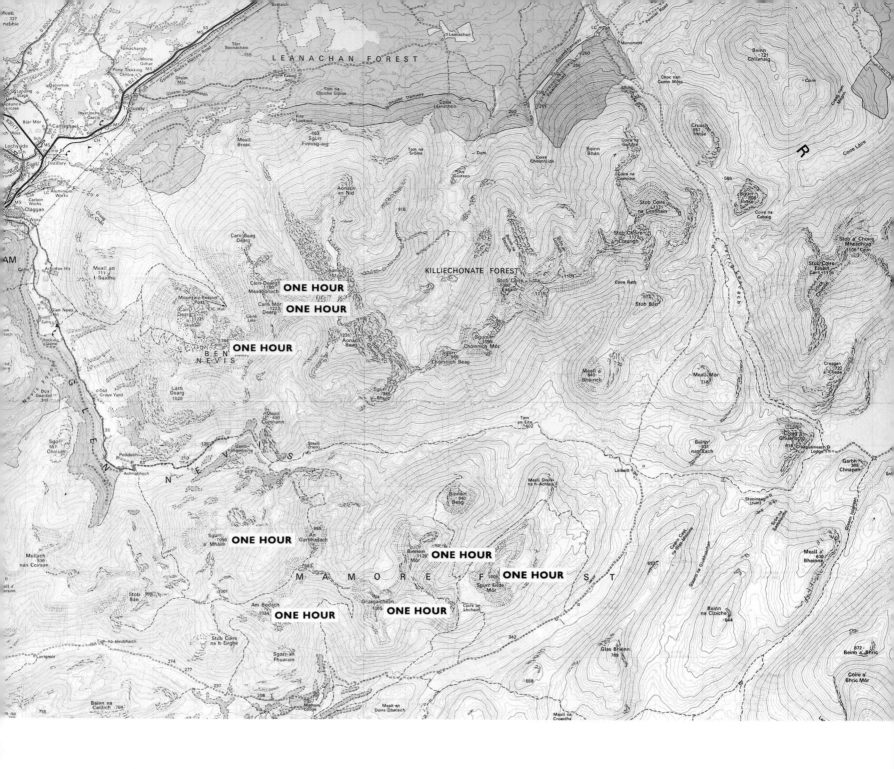

TWELVE HOURS TWELVE SUMMITS

ONE HOUR AT EACH SUMMIT ALONG A 5 DAY WESTWARD WALK IN THE HIGHLANDS

SCOTLAND 1983

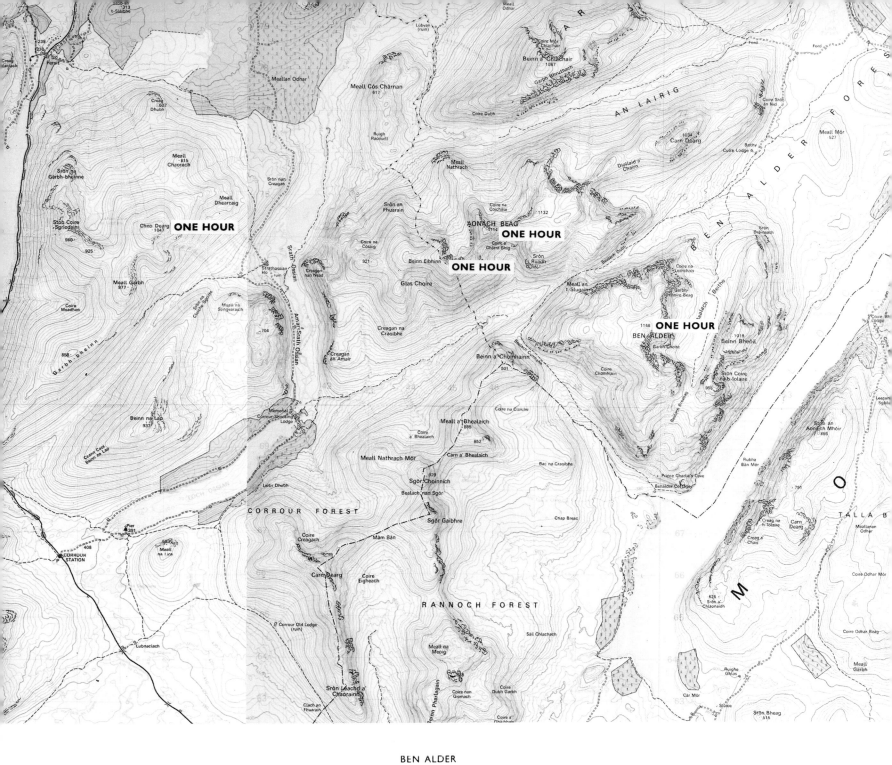

BEN ALDER
AONACH BEAG
BEINN EIBHINN
CHNO DEARG
SGURR EILDE MÓR
BINNEIN MÓR
NA GRUAGAICHEAN
AM BODACH
SGURR A'MHÀIM
CARN MÓR DEARG
CARN DEARG MEADHONACH
BEN NEVIS

LIGHT CLOUD

DARK CLOUD

SWIFT

LIGHT CLOUD

HILLSIDE

SWIFT

SCRUB

BUSH

SCRUB

BUSH

SCRUB

GORSE

TURF

STONE

TURF

STONES

TURF

STONE LINE

TURF

SHEEP DROPPINGS

RUCKSACK

TURF

STONE

GRASS CLUMP

TURF

GORSE

TREES

FIELD

TREES

FIELD

TREES

RIVER

MISTY LEVELS

LIGHT CLOUD

DARK CLOUD

PLANE OF VISION

THE MENDIPS ENGLAND 1982

FULL MOON CIRCLE OF GROUND

DARTMOOR 1983

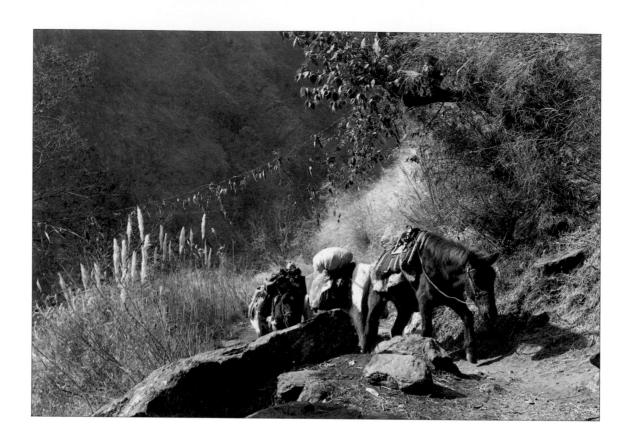

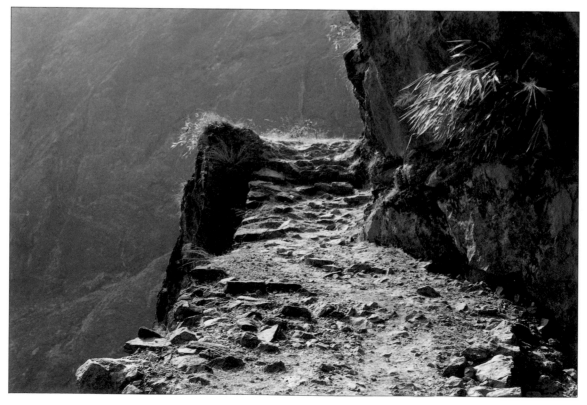

COUNTLESS STONES

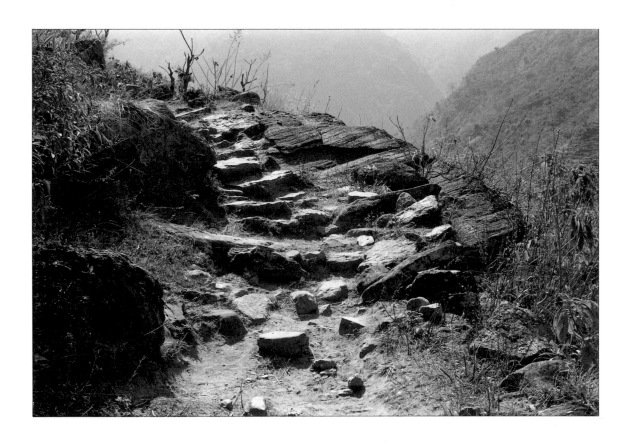

A 21 DAY FOOTPATH WALK

CENTRAL NEPAL 1983

NEPAL 1983

WALKING WITH THE RIVER'S ROAR

GREAT HIMALAYAN TIME A LINE OF MOMENTS

MY FATHER STARLIT SNOW

HUMAN TIME FROZEN BOOTS

BREAKING TRAIL CIRCLES OF A GREAT BIRD

COUNTLESS STONES HAPPY ALERT BALANCED

PATHS OF SHARED FOOTMARKS ATOMIC SILENCE

SLEEPING BY THE RIVER'S ROAR

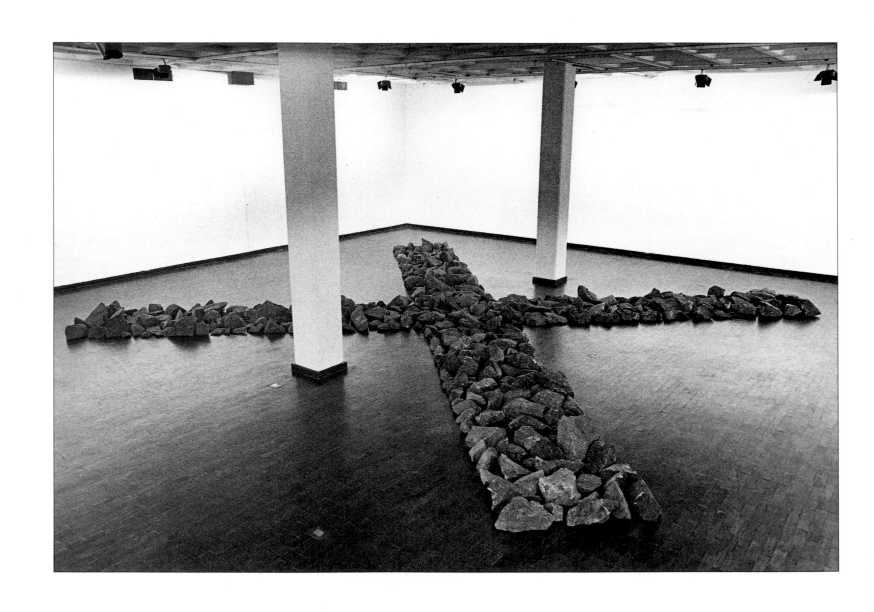

A CROSSING PLACE

BRISTOL 1983

 GRAVEL
 BOULDER
 STONES
 SAPLING
 ROCKS
 TREES
 CLOUD
 SKY
BOULDERS SEA TERN SEA ROCK ISLAND SKY SUN SKY ROCK ISLAND SEA SEAWEED BOULDERS BOULDER
 CLOUD
 SKY
 CLOUD
 TREES
 SCREE
 TREES
 STONES
 GRASS

 ITALY ENGLAND PLANES OF VISION

 1983

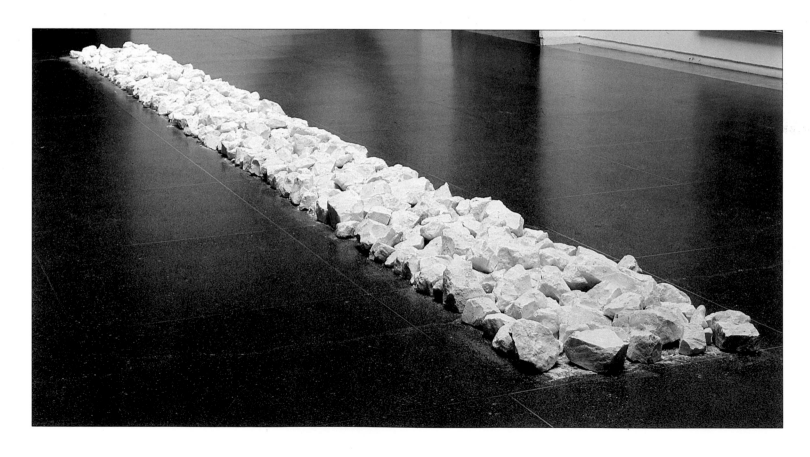

CHALK LINE

LONDON 1984

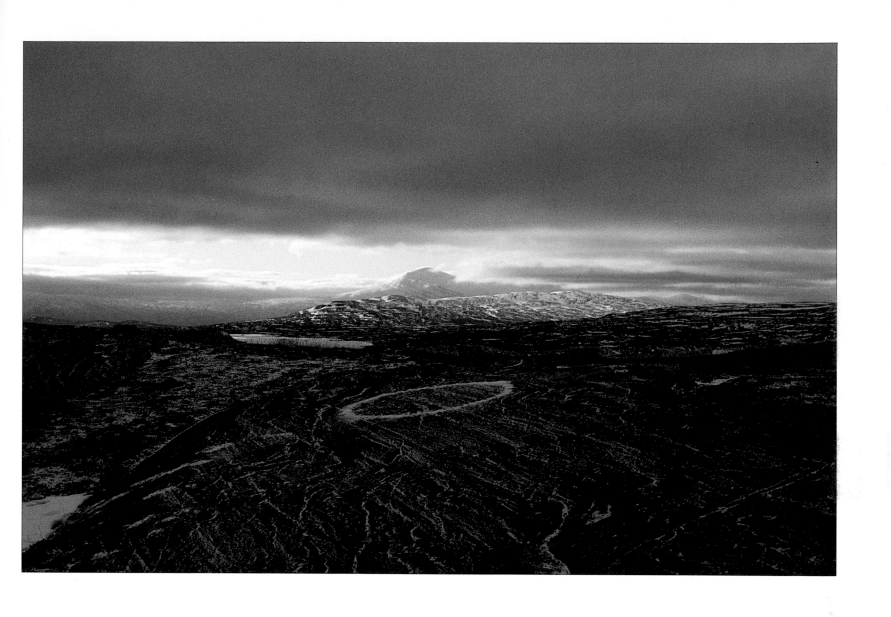

MOUNTAIN LAKE POWDER SNOW

LAPPLAND 1985

A MOVED LINE

PICKING UP CARRYING PLACING
ONE THING TO ANOTHER
ALONG A STRAIGHT 22 MILE WALK

MOSS TO WOOL
WOOL TO ROOT
ROOT TO PEAT
PEAT TO SHEEP'S HORN
SHEEP'S HORN TO STONE
STONE TO LICHEN
LICHEN TO TOADSTOOL
TOADSTOOL TO BONE
BONE TO FEATHER
FEATHER TO STICK
STICK TO JAWBONE
JAWBONE TO STONE
STONE TO FROG
FROG TO WOOL
WOOL TO BONE
BONE TO BIRD PELLET
BIRD PELLET TO STONE
STONE TO SHEEP'S HORN
SHEEP'S HORN TO PINE CONE
PINE CONE TO BARK
BARK TO BEECH NUT
BEECH NUT TO STONE
STONE TO THE END OF THE WALK

DARTMOOR 1983

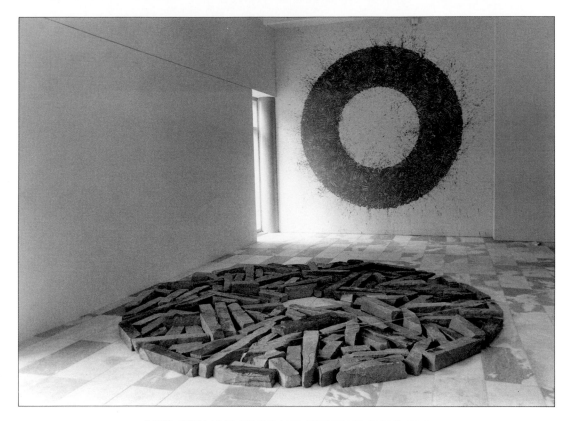

RIVER AVON MUD CIRCLE AND TENNESSEE STONE RING

NEW YORK 1984

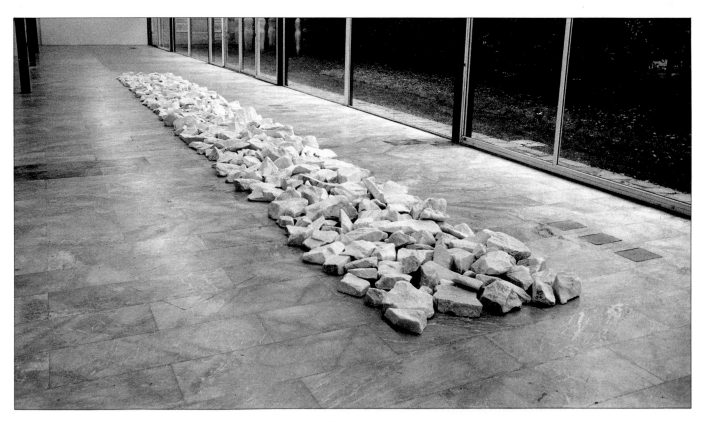

CARRARA LINE

MILAN 1985

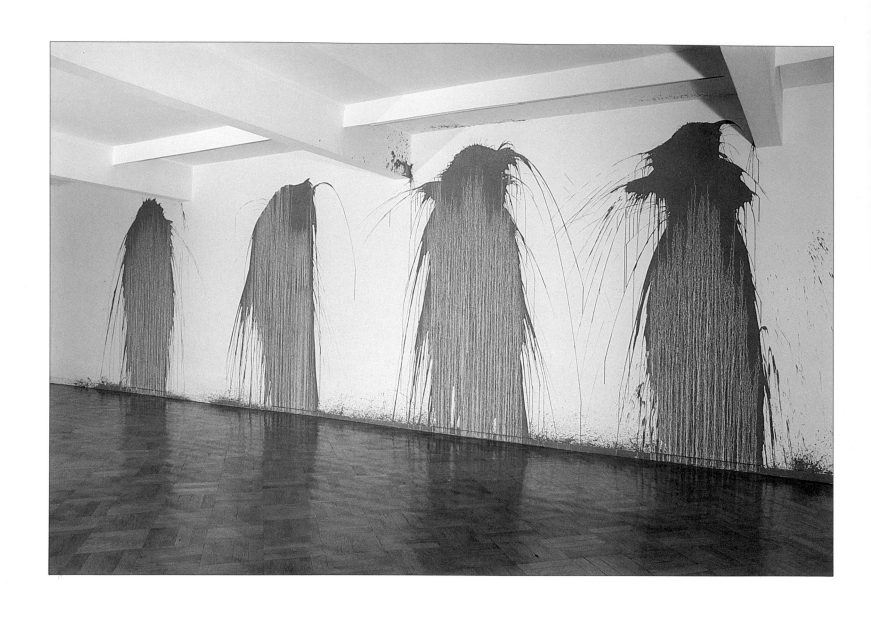

MUDDY WATER FALLS

LONDON 1984

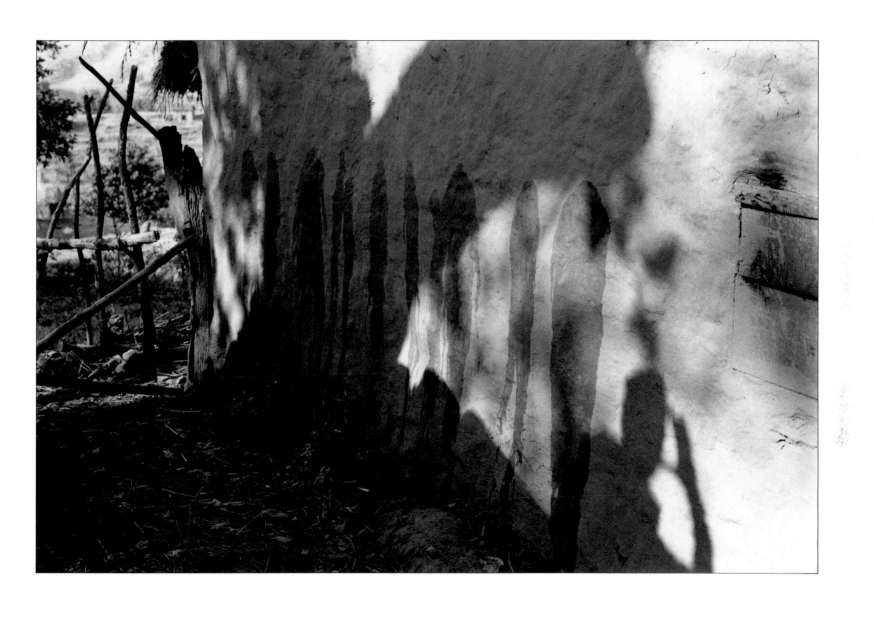

SHADOWS AND WATERMARKS

A MUD WALL BY A RESTING PLACE NEAR THE END OF A 21 DAY WALK IN NEPAL

1983

A MOVED LINE IN JAPAN

1983

PICKING UP CARRYING PLACING
ONE THING TO ANOTHER
ALONG A 35 MILE WALK
AT THE EDGE OF THE PACIFIC OCEAN

SHELL TO CRAB
CRAB TO FEATHER
FEATHER TO FISH
FISH TO BAMBOO
BAMBOO TO CARROT
CARROT TO PINE CONE
PINE CONE TO CHARCOAL
CHARCOAL TO JELLYFISH
JELLYFISH TO STICK
STICK TO SHELL
SHELL TO SHELL
SHELL TO SEAWEED
SEAWEED TO PEBBLE
PEBBLE TO DOG SKELETON
DOG SKELETON TO STICK
STICK TO MERMAID'S PURSE
MERMAID'S PURSE TO BAMBOO
BAMBOO TO CACTUS LEAF
CACTUS LEAF TO FLOWERS
FLOWERS TO LOG
LOG TO FEATHER
FEATHER TO PEBBLE
PEBBLE TO CROW
CROW TO CRAB
CRAB TO PEBBLE
PEBBLE TO THE END OF THE WALK

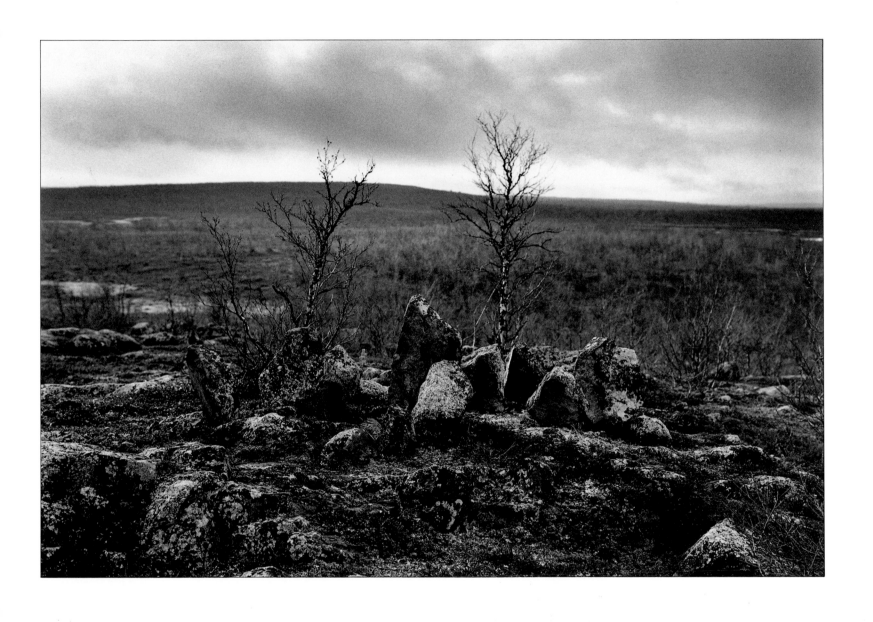

A LAPPLAND WALK

SLIPPERY STONES
SLEEPING MARKS
THROWING WATER
SEVEN DAYS AND NIGHTS

FINLAND AUTUMN 1983

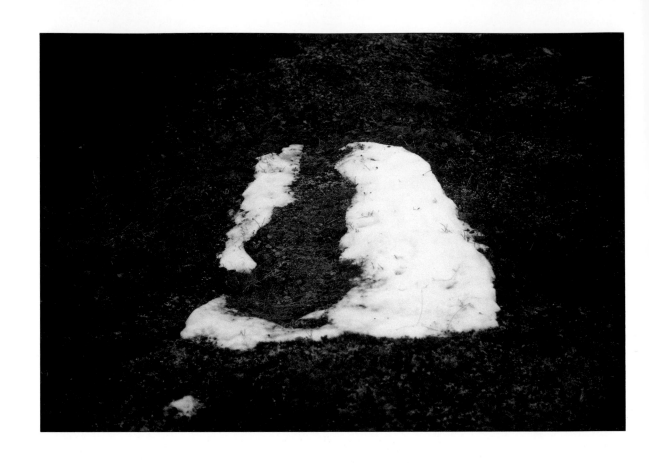

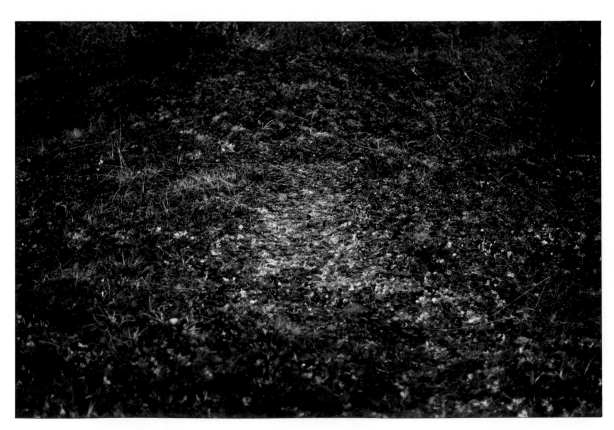

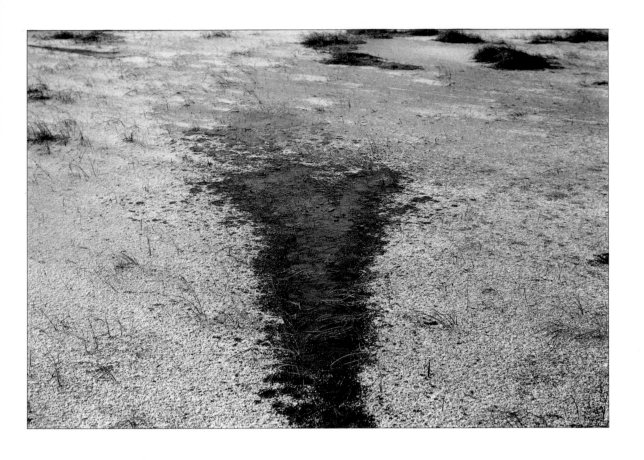

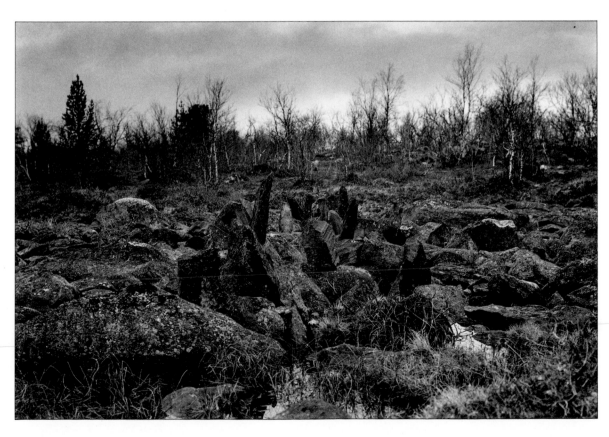

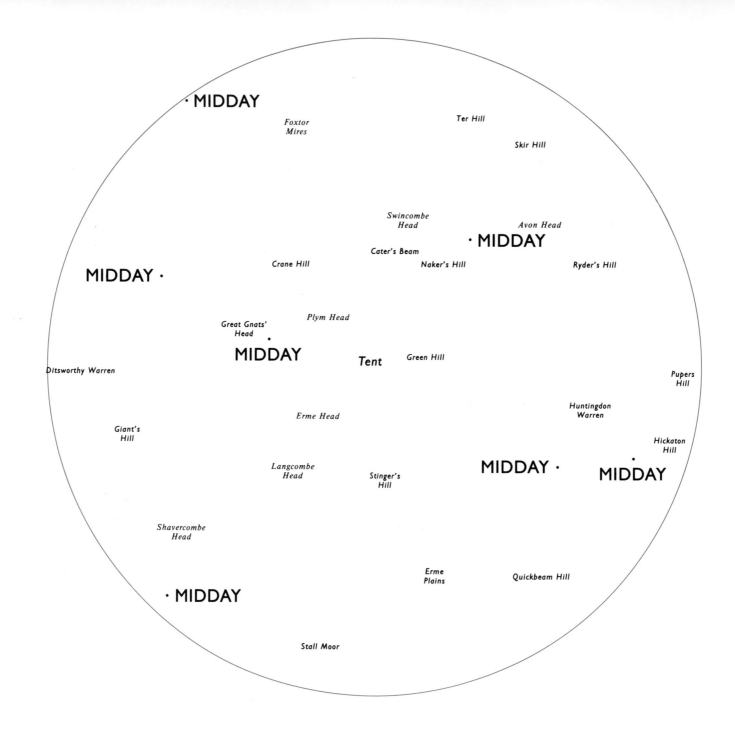

A SEVEN DAY CIRCLE OF GROUND

SEVEN DAYS WALKING WITHIN AN IMAGINARY CIRCLE 5½ MILES WIDE

DARTMOOR ENGLAND 1984

CROSSINGS AND SIGHTINGS

A SIX DAY WALK IN THE ADIRONDACK MOUNTAINS

A NIGHT OF THUNDERSTORMS
A RACOON
A BLACK BEAR
PATCHES OF SUNLIGHT
A BEAVER
A WEST WIND
OUT OF THE TREELINE
AN HOUR OF DISTANT SOUNDS
INTO THE TREELINE

NEW YORK 1985

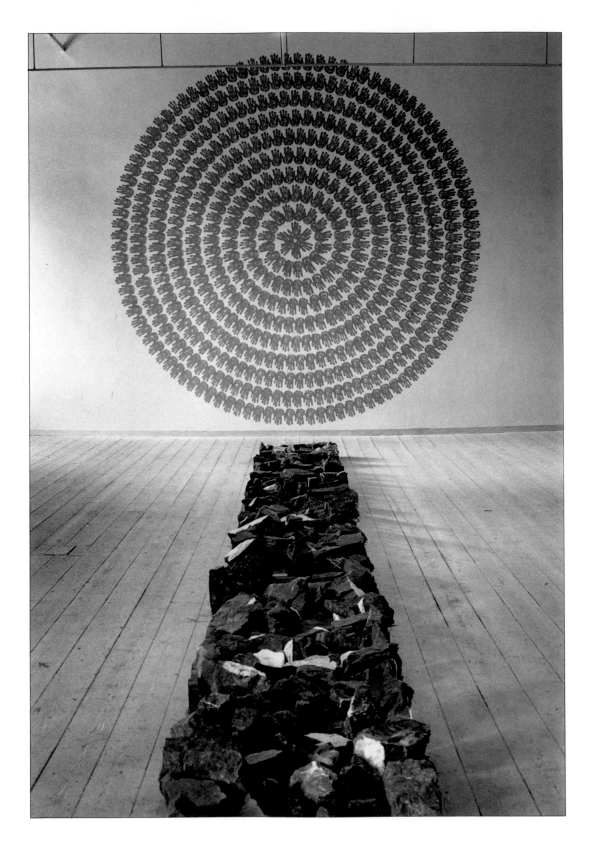

RIVER AVON MUD HAND CIRCLES AND DUBLIN LINE

DUBLIN 1984

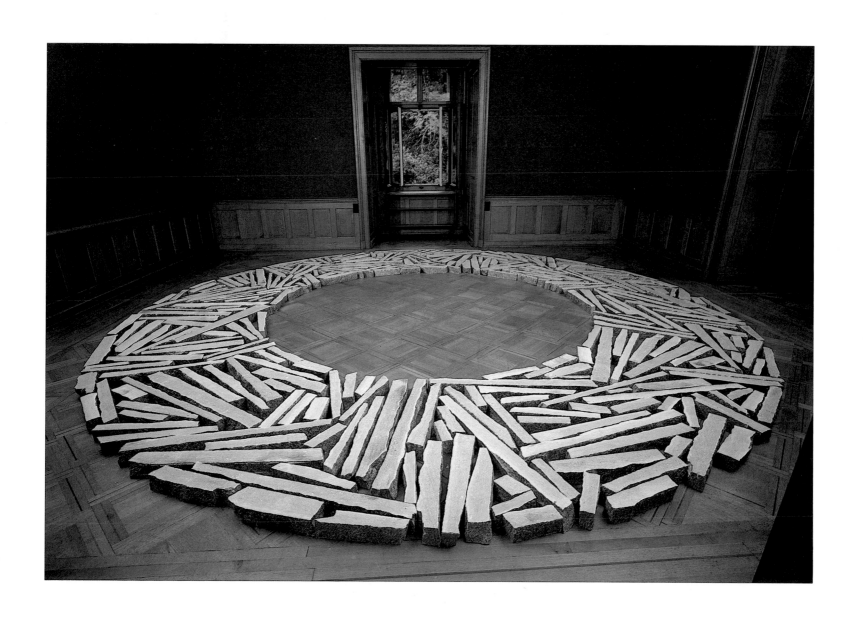

SWISS GRANITE RING

FÜRSTENAU 1985

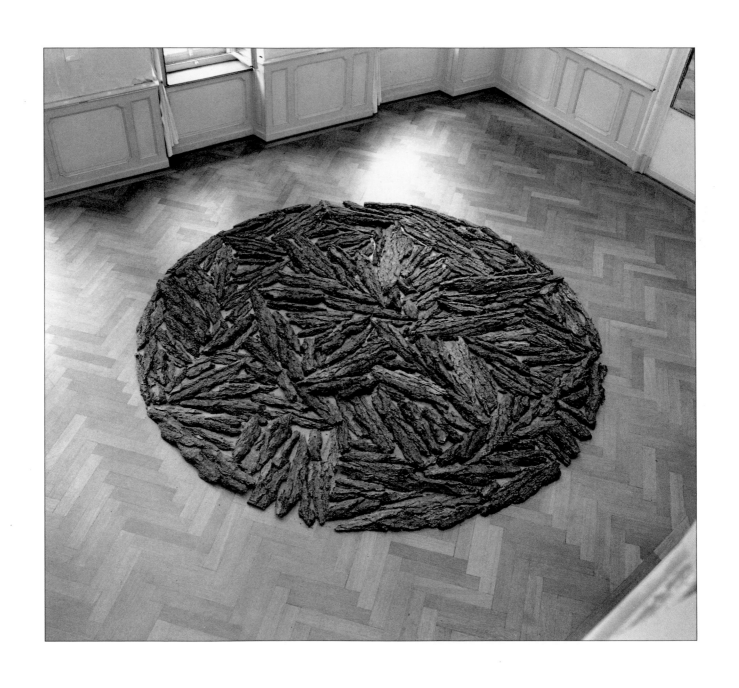

PINE TREE BARK CIRCLE

FÜRSTENAU 1985

STRAIGHT MILES AND MEANDERING MILES

A 294 MILE WALK FROM LAND'S END TO BRISTOL
WALKING NINE STRAIGHT MILES ALONG THE WAY

THE STRAIGHT MILES

CARNAQUIDDEN DOWNS CORNWALL
BROCKABARROW COMMON BODMIN MOOR
HURSTON RIDGE DARTMOOR
DUNKERY HILL EXMOOR
WILLS NECK QUANTOCK HILLS
THE FOSS WAY SOMERSET
QUEEN'S SEDGE MOOR SOMERSET
BERROW FLATS SOMERSET
DOLEBURY WARREN MENDIP HILLS

ENGLAND 1985

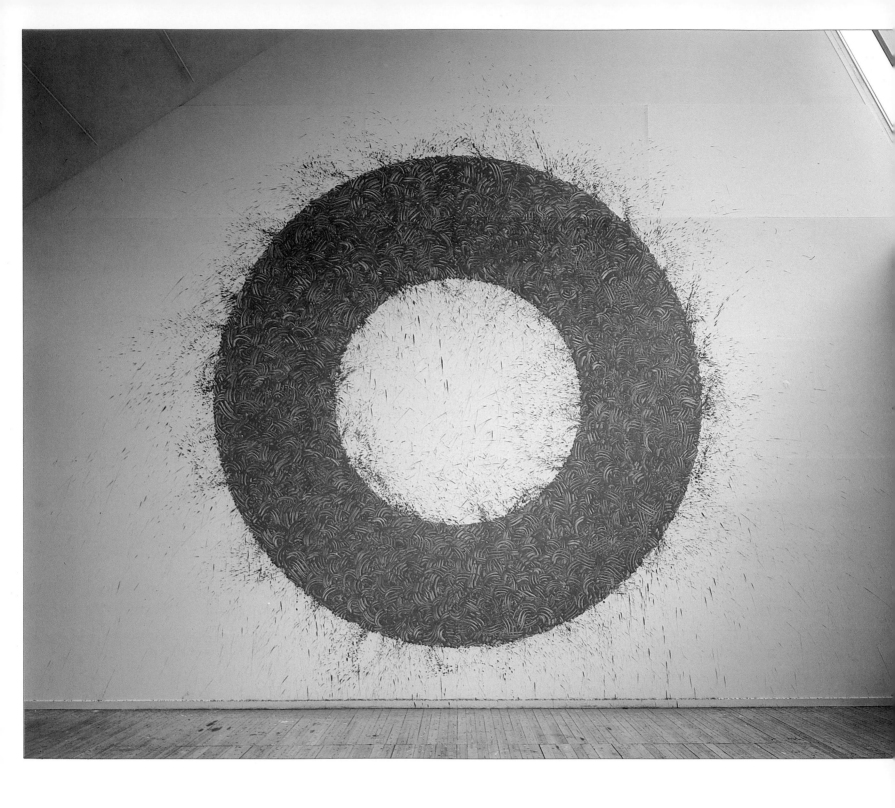

RIVER AVON MUD CIRCLES

MALMÖ 1985

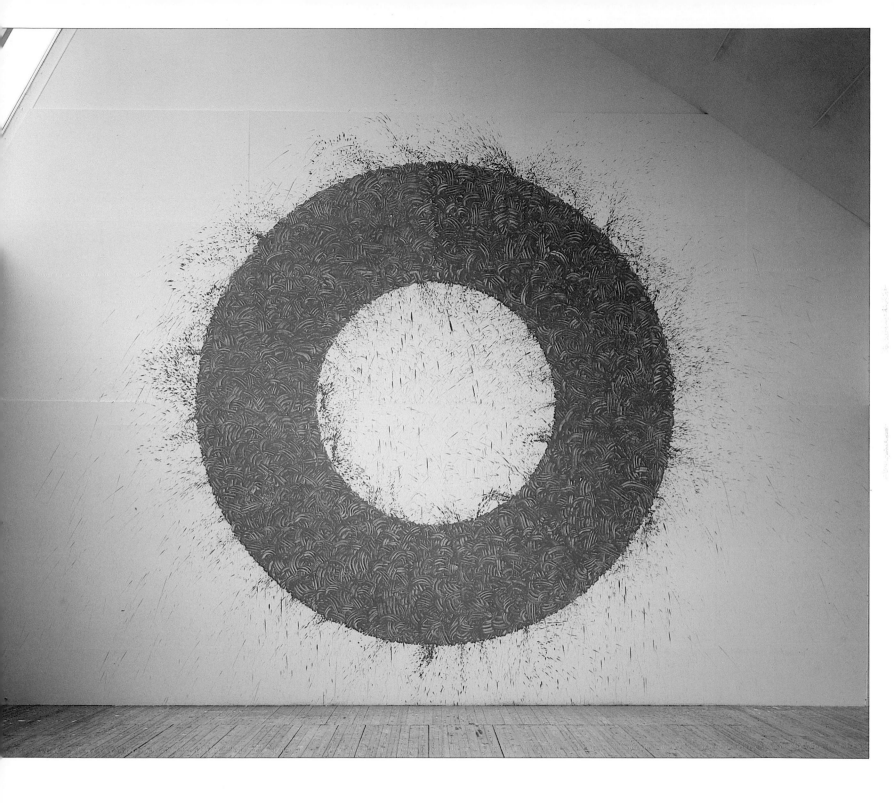

SPIDER ALIGNED SLABS CAWING STUB CAW SKULL BROWNISH MOSS LARK HAZE MOTH WARM SPLASH WATCHED GURGLING SLOPE CLITTER KICK SHEEP SQUINT SLANT SNIFF FLOODLINE BUBBLING SQUELCH TWIST HEATHER TUSSOCKS CRUNCHING ROCK SUNLIGHT LOPING DOWNHILL WIND TOR BELCH SKYLINE REFLECTION SWISH GURGLE REEDS POOL RED BANK HOLLOW BREATHE BLUE SOFT SQUELCH SCUFF ICE GRASS SHADOW JUMP YELLOWISH PANTING SLITHER DROPPINGS SCRUNCH

ONE HOUR

A SIXTY MINUTE CIRCLE WALK ON DARTMOOR 1984

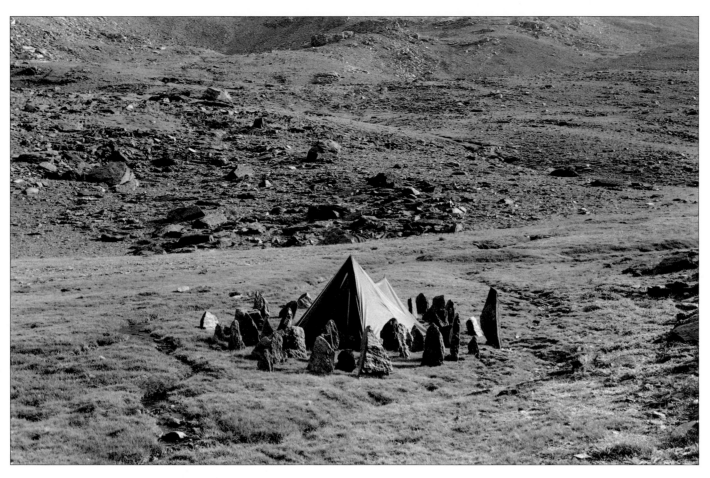

CAMP-SITE STONES

SIERRA NEVADA SPAIN 1985

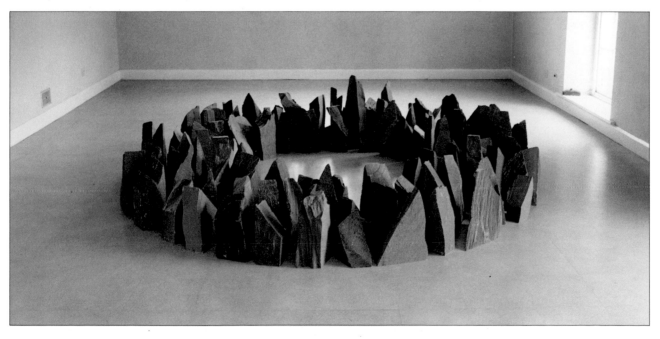

ELTERWATER STONE RING

KENDAL 1985

223

SNIOUGOUTSE LA

FROM PASS TO PASS

FROM PRINKITI LA
TO SNIOUGOUTSE LA
TO SIRSIR LA
TO BOUMITSE LA
TO SENGI LA
TO KUBA LA
TO NETUKSI LA
TO BAMI LA
TO PINGDON LA
TO PARKACHIK LA
TO UMBA LA
TO RUNCHEN LA

A 12 DAY WALK FROM LAMAYURU TO DRAS
IN THE ZANSKAR MOUNTAINS OF LADAKH

NORTHERN INDIA 1984

STONE WALK

FROM ONE STONE TO ANOTHER, PICKING UP AND CARRYING EACH STONE TO THE PLACE OF THE NEXT STONE

STONE TO STONE ALLT TO BLANYOY
STONE TO STONE BLANYOY TO HAY BLUFF
STONE TO STONE HAY BLUFF TO TWMPA
STONE TO STONE TWMPA TO Y DÂS
STONE TO STONE Y DÂS TO GIST WEN
STONE TO STONE GIST WEN TO CORN DÛ
STONE TO STONE CORN DÛ TO PEN Y FAN
STONE TO STONE PEN Y FAN TO CRIBIN
STONE TO STONE CRIBIN TO WAUN FÂCH
STONE TO STONE WAUN FÂCH TO PENTWYNGLAS
STONE TO STONE PENTWYNGLAS TO TAL TRWYNAU
STONE TO STONE TAL TRWYNAU TO Y FAN
STONE TO STONE Y FAN TO TWYN TAL-Y-CEFN
STONE TO STONE TWYN TAL-Y-CEFN TO BWLCH-BACH
STONE TO STONE BWLCH-BACH TO BÂL-MAWR
STONE TO STONE BÂL-MAWR TO GARN-WEN
STONE TO STONE GARN-WEN TO SUGAR LOAF
STONE TO STONE SUGAR LOAF TO ALLT

A 101 MILE WALK IN THE BLACK MOUNTAINS AND BRECON BEACONS

WALES 1984

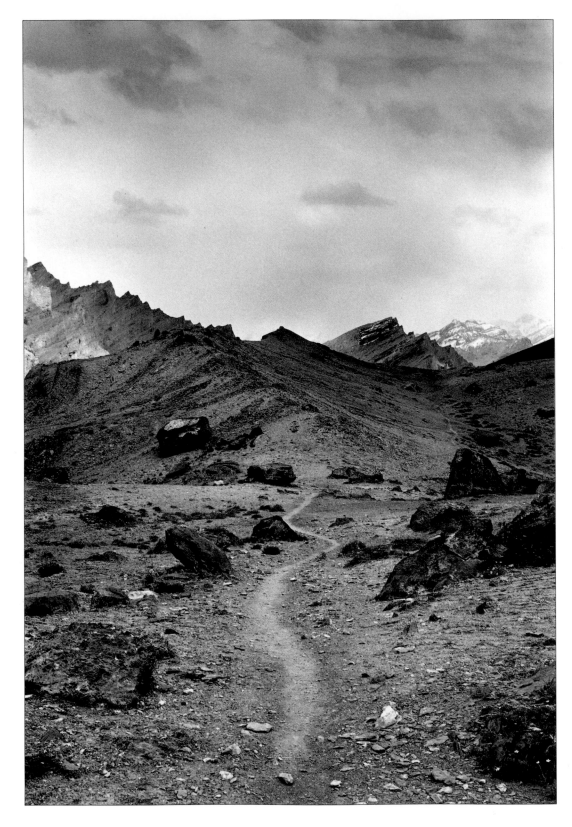

WALKING LINES ALONG THE FOOTPATH

A 12 DAY WALK IN THE ZANSKAR MOUNTAINS OF LADAKH

NORTHERN INDIA 1984

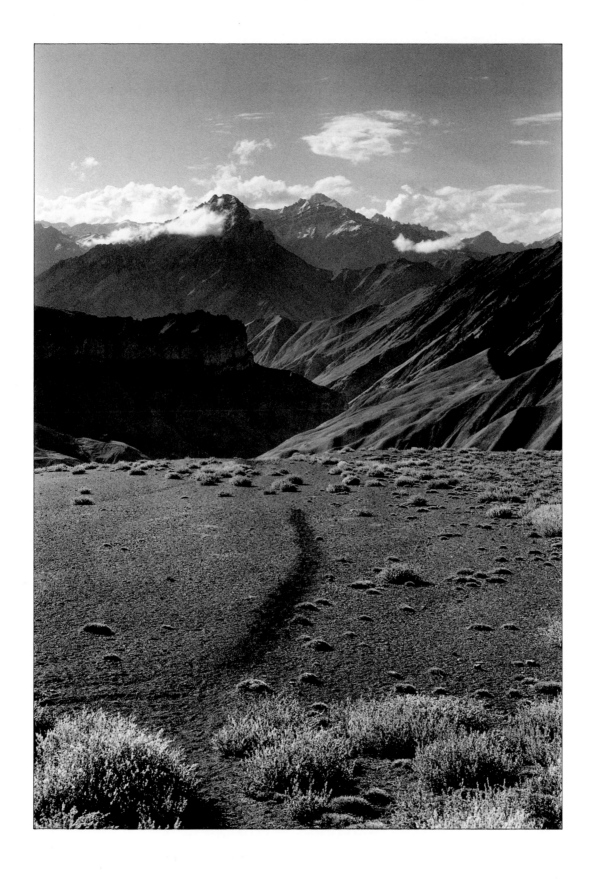

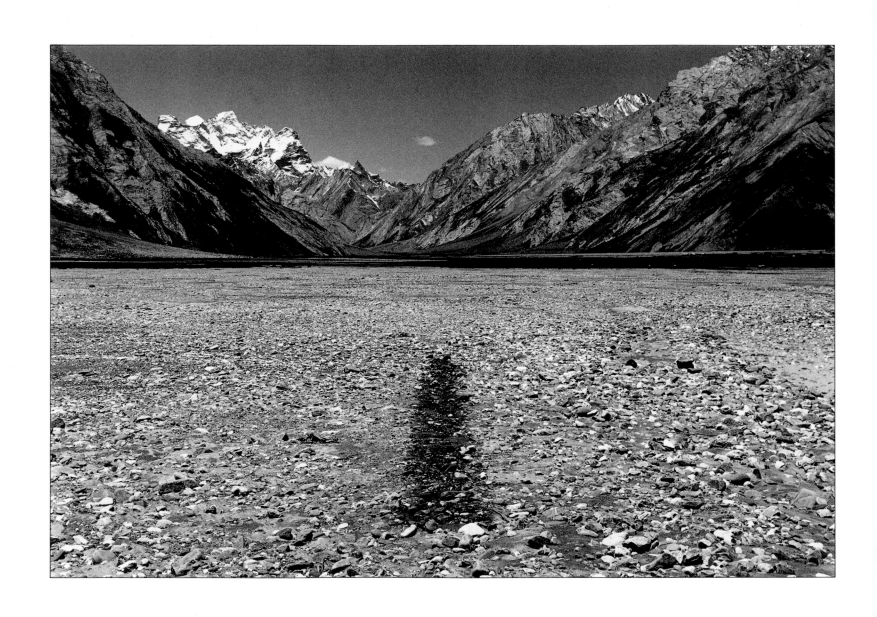

WATER LINES IN LADAKH

CROSSING RIVERS ON A 12 DAY WALK IN THE ZANSKAR MOUNTAINS OF LADAKH

NORTHERN INDIA 1984

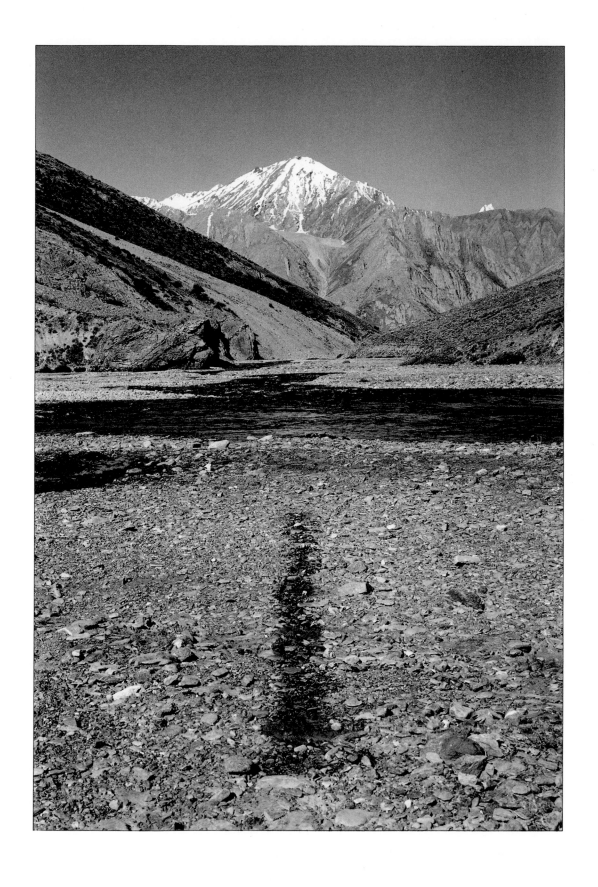

Water

One of Richard Long's earliest works, constructed in 1967, was a line of water in cut turf, slowly seeping into the earth. Only recently, in the Zanskar mountains of Ladakh, he made lines by pouring water on gravel. They disappeared in the warmth of the sun. His fascination with water has been constant and, like stone and wood, water has frequently been a material. There is a beautiful symmetry here: where land ends, water begins. The surface of the earth, which is Richard Long's working ground, consists of land and water. And above water and land, the air. Of course the work of Richard Long is not methodical in its involvement with these three universal elements but there is, it seems, a strong awareness, all the time, of the fact that land and water are closely joined, interdependent opposites. When, for instance, he uses riverbeds as footpaths, as he has done in various cases (*With the River Towards the Sea* or *Dartmoor Riverbeds*), he respects the water's intelligence in having found, millions of years before him, the most logical way downhill. The river looks for a bed, which is given to it by the land: by the alterations in height, by rocks and vegetation. This is the perfect match which Richard Long would want for his sculpture's placement in the landscape. Or, as the river follows the ground's lead, going down straight, then curving, going faster or going slower, pouring noisily around boulders in narrow gorges or streaming majestically and silently through wide, flat land, it is an image of a walk itself, the precise image of going over ground.

Yet, if he, Richard Long, follows the river, wading through it, the going is not that easy. The lightness of the river's flow is deceptive. Water is elusive, it is eternally moving; as he walks through it the stream carries his footprints invisibly towards the sea. Just as the walk through water leaves no trace (or the trace is the river itself), so water itself will never take on permanent form – except, maybe, in the high mountains or in the Arctic seas where it freezes solid like rock. When seen from the air, the land seems to hold the water of the river fairly tightly, but walking in or close to the river (or the sea) it is apparent that this is not so. Water laps and thunders, water seeps in and out through little holes, water erodes. In a night of frost a little water can split a rock. Water never stops tiring the earth. Water is stronger than rock because, like a walker, it is mobile. So the surface shape of the sea or a river (especially the River Avon, with the second highest tide of all the rivers in the world) is continually changing: coming up, receding. All the driftwood sculptures recall the movement of water which left them behind. Other works deal more specifically with this fact of nature, like, for instance, the Mississippi driftwood work, walking beside the river, or the *Moved Line in Japan* walking beside the ocean. In 1980 he made a circular walk in Scotland in which the circular form was interrupted by lakes: in those segments the solid abstract form of the circle suddenly becomes elusive and changeable, because of the formlessness of water.

On a larger scale, water is also a measurement for a mass of land. In his work, *Isle of Wight as Six Walks*, Richard Long by covering six distances, alternately, north to south and south to north, precisely portrays the physical shape of the island as it lies in the sea. Similarly, the 126-mile walk across England (*Footstones*) precisely indicates, in another type of cross-section, the changing elevation of the land by being marked by five piles of stones along the way, the number of stones equalling the number of feet that place lies above sea level.

Any points of reference can provide the structural elements for walks, as long as they provide an original view or point-of-view. The River Avon, especially, figures often in his work. Thus he made by canoe *A Journey the Same Length as the River Avon*, 84 miles, along the River Severn (into which the Avon flows); the same length was used for a walk along the Foss Way, a Roman road which crosses the Avon. On a bicycle journey down the river,

from the first to the last bridge, he crossed it ten times, his road echoing the bends in the river. He made a companion work, a one-day bicycle ride of 138 miles, down the River Thames. The River Avon is, like Dartmoor, a standard prototype, used in a geographical sense. Other rivers, often unnamed, provide locale and atmosphere, the chiaroscuro in the imagery, like works made in a Mexican riverbed, or the great walk, within the span of an epic twenty-five-day walk in Nepal, *Walking with the River's Roar,* in which the river is neither measurement nor footpath but, literally, the walker's companion: where the river is the landscape itself, grand and full of history and majestic, like a mountain.

The River Avon is also a reservoir of material: driftwood and water, or, more recently, mud. On several occasions Richard Long has used water to make lines or passing marks on the ground, in Ladakh and in California, and against rock, in the Avon Gorge, in Mexico and in other places. Just as the *Standing Stones* (in Iceland, Wales, Switzerland and other places) are the toughest works, using rock just as rock (not even as form: line or circle), so are the water drawings the most impermanent works. Water marking rock.

In the last few years, Richard Long has found the combination of water and rock in mud – an ambivalent material, first taken from the Avon Gorge where the river has lined its bed with mud – in which the opposition between water and land seems to be suspended. Mud is created by the water's movement, whipping up the soil, and is then left behind, heavier than water. It feels like an old material, recalling the beginning of time and the birth of the earth itself. Richard Long has started to do two new types of mud works which, like the word-pieces earlier, turn out to be a major movement in his work. Of course he had used mud, or rather clay, earlier as a material for interior walking pieces: walking certain forms or distances on a gallery's floor with muddy boots. In these works the mud is then explicitly associated with the act of walking – which is only one of the physical aspects of the way he makes his works. With the new mud works he began to articulate another aspect: picking up things with his hands. The walking works are about touching the ground. Some put an emphasis on perception (while walking or sitting down to rest); and often enough picking up, moving and putting down is part of a walk, and certainly an important part in making a sculpture. The mud circles, which are made of handprints, are made out of a material which mixes the two basic materials of the earth, water and rock; they recall the picking up of things in a material, water, which, paradoxically, cannot be held: it can be thrown or, mixed with mud, it can be handprinted.

Paradoxical as they are, the mud circles have a great emotional depth because they combine, in their simple form and simple procedures, so many things which are basic to Richard Long's work. The water gives the mud its flexibility, as the rock (mud) gives the water a certain staying-power and visibility. In the same way – the one aspect flowing into the other – all the great walks are composed. In Ladakh in 1984 he walked over high ground, *From Pass to Pass.* With his boots he traced a circle in the wet gravel on Pingdon La. Moisture, just under the surface of the ground, was enough to make the circle visible. He passed some long, sharp stones which he put upright under the sun. Walking up and down along the curving footpath, footprint was added to footprint to make visible nine curving lines. At a crossing point, by a river, he poured a water line from his flask. In such a walk, here described as bare skeleton, the whole world is present, at least a complete world: water, land, air, light.

Richard Long can speak about the world in a circle, about water at the crossing place; he can speak about the sea and the mountains; he can walk a path to the horizon, the beginning of the sky.

WIND STONES

LONG POINTED STONES

SCATTERED ALONG A 15 DAY WALK IN LAPPLAND
207 STONES TURNED TO POINT INTO THE WIND

1985

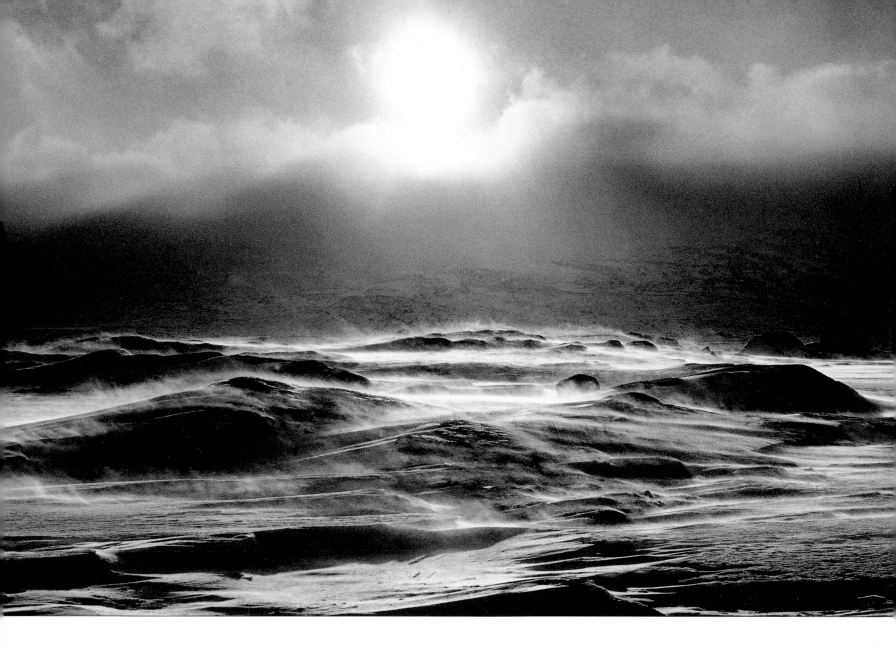

ARCTIC SPINDRIFT

A DAY WALKING THROUGH SNOW, WIND AND SUNLIGHT
ON A FIFTEEN DAY WALK IN LAPPLAND.

SWEDEN AND NORWAY 1985

WIND LINE

A STRAIGHT TEN MILE NORTHWARD WALK ON DARTMOOR

1985

From FIVE SIX PICK UP STICKS, SEVEN EIGHT LAY THEM STRAIGHT 1980

I like simple, practical, emotional,
quiet, vigorous art.

I like the simplicity of walking,
the simplicity of stones.

I like common materials, whatever is to hand,
but especially stones. I like the idea that stones
are what the world is made of.

I like common means given the
simple twist of art.

I like sensibility without technique.

I like the way the degree of visibility
and accessibility of my art is controlled
by circumstance, and also the degree to which
it can be either public or private,
possessed or not possessed.

I like to use the symmetry of patterns between time,
places and time, between distance and time,
between stones and distance, between time and stones.

I choose lines and circles because they do the job.

My art is about working in the wide
world, wherever, on the surface of the earth.

My art has the themes of materials, ideas,
movement, time. The beauty of objects, thoughts, places
and actions.

My work is about my senses, my instinct, my own scale
and my own physical commitment.

My work is real, not illusory or conceptual.
It is about real stones, real time, real actions.

My work is not urban, nor is it romantic.
It is the laying down of modern ideas in
the only practical places to take them.
The natural world sustains the industrial world.
I use the world as I find it.

My art can be remote or very public,
all the work and all the places being equal.

My work is visible or invisible. It can be an
object (to possess) or an idea carried out and equally
shared by anyone who knows about it.

My outdoor sculptures and walking locations
are not subject to possession and ownership. I like the fact
that roads and mountains are common, public land.

My outdoor sculptures are places.
The material and the idea are of the place;
sculpture and place are one and the same.
The place is as far as the eye can see from the
sculpture. The place for a sculpture is found
by walking. Some works are a succession
of particular places along a walk, e.g.
Milestones. In this work the walking,
the places and the stones all have equal importance.

My talent as an artist is to walk across
a moor, or place a stone on the ground.

My stones are like grains of sand in
the space of the landscape.

A walk expresses space and freedom
and the knowledge of it can live
in the imagination of anyone, and that
is another space too.

A walk is just one more layer, a mark, laid
upon the thousands of other layers of human
and geographic history on the surface of the
land. Maps help to show this.

A walk traces the surface of the land,
it follows an idea, it follows the day
and the night.

A road is the site of many journeys.
The place of a walk is there before the
walk and after it.

A pile of stones or a walk, both
have equal physical reality, though
the walk is invisible. Some of my
stone works can be seen, but not
recognised as art.

The creation in my art is not in the common
forms – circles, lines – I use, but the
places I choose to put them in.

A good work is the right thing in the right
place at the right time. A crossing place.

Fording a river. Have a good look, sit down, take off boots
and socks, tie socks on to rucksack, put on boots,
wade across, sit down, empty boots, put on socks and boots.
It's a new walk again.

From WORDS AFTER THE FACT 1982

The source of my work is nature. I use it with respect and freedom. I use materials, ideas, movement and time to express a whole view of my art in the world. I hope to make images and ideas which resonate in the imagination, which mark the earth and the mind.

In the mid-sixties the language and ambition of art was due for renewal. I felt art had barely recognised the natural landscapes which cover this planet, or had used the experiences those places could offer. Starting on my own doorstep and later spreading, part of my work since has been to try and engage this potential. I see it as abstract art laid down in the real spaces of the world.

My work is simple and practical. I may choose rolling moorland to make a straight ten mile walk because that is the best place to make such a work, and I know such places well.

I like the idea of using the land without possessing it.

A walk marks time with an accumulation of footsteps. It defines the form of the land. Walking the roads and paths is to trace a portrait of the country. I have become interested in using a walk to express original ideas about the land, art, and walking itself.

A walk is also the means of discovering places in which to make sculpture in 'remote' areas, places of nature, places of great power and contemplation. These works are made of the place, they are a re-arrangement of it and in time will be re-absorbed by it. I hope to make work for the land, not against it.

I like the idea that art can be made anywhere, perhaps seen by few people, or not even recognised as art.

My photographs and captions are facts which bring the appropriate accessibility to the spirit of these remote or otherwise unrecognisable works.

Time passes, a place remains. A walk moves through life, it is physical but afterwards invisible. A sculpture is still, a stopping place, visible.

The freedom to use precisely all degrees of visibility and permanence is important in my work. Art can be a step or a stone. A sculpture, a map, a text, a photograph; all the forms of my work are equal and complementary. The knowledge of my actions, in whatever form, is the art. My art is the essence of my experience, not a representation of it.

My work has become a simple metaphor of life. A figure walking down his road, making his mark. It is an affirmation of my human scale and senses: how far I walk, what stones I pick up, my particular experiences. Nature has more effect on me than I on it. I am content with the vocabulary of universal and common means; walking, placing, stones, sticks, water, circles, lines, days, nights, roads.

1945 RICHARD LONG born Bristol, England

One-Man Exhibitions

1968	Düsseldorf	Konrad Fischer
1969	New York	John Gibson
	Düsseldorf	Konrad Fischer
	Krefeld	Museum Haus Lange
	Paris	Yvon Lambert
	Milan	Galleria Lambert
1970	New York	Dwan Gallery
	Mönchengladbach	Städtisches Museum
	Düsseldorf	Konrad Fischer
1971	Turin	Gian Enzo Sperone
	Oxford	Museum of Modern Art
	Amsterdam	Art and Project
1972	London	Whitechapel Art Gallery
	New York	The Museum of Modern Art Projects
	Paris	Yvon Lambert
1973	Amsterdam	Stedelijk Museum
	Antwerp	Wide White Space
	Düsseldorf	Konrad Fischer
	London	Lisson Gallery
1974	New York	John Weber
	Edinburgh	Scottish National Gallery of Modern Art
	London	Lisson Gallery
1975	Düsseldorf	Konrad Fischer
	Antwerp	Wide White Space
	Paris	Yvon Lambert
	Amsterdam	Art and Project
	Basel	Rolf Preisig
	Plymouth	Plymouth School of Art
1976	Rome	Gian Enzo Sperone
	Düsseldorf	Konrad Fischer
	Antwerp	Wide White Space
	London	Lisson Gallery
	Venice	British Pavilion, Venice Biennale
	Tokyo	Art Agency Tokyo
	Bristol	Arnolfini
	New York	Sperone Westwater Fischer
1977	London	Whitechapel Art Gallery
	Amsterdam	Art and Project
	Poznan	Gallery Akumalatory
	Basel	Rolf Preisig
	London	Lisson Gallery
	Bern	Kunsthalle
	Melbourne	National Gallery of Victoria
	Sydney	Art Gallery of New South Wales
1978	Amsterdam	Art and Project
	Paris	Yvon Lambert
	Düsseldorf	Konrad Fischer
	London	Lisson Gallery
	Leeds	Park Square Gallery
	New York	Sperone Westwater Fischer
	Hamburg	Ausstellungsraum Ulrich Rückriem
1979	Zürich	InK
	London	Anthony d'Offay
	Basel	Rolf Preisig
	Londonderry	Orchard Gallery
	Southampton	Photographic Gallery, Southampton University
	Eindhoven	Stedelijk van Abbemuseum
	London	Lisson Gallery
	Tokyo	Art Agency Tokyo
	Oxford	Museum of Modern Art
1980	Athens	Karen and Jean Bernier
	Amsterdam	Art and Project
	Cambridge	Fogg Art Museum, Harvard University
	New York	Sperone Westwater Fischer
	London	Anthony d'Offay
	Düsseldorf	Konrad Fischer
1981	New York	Sperone Westwater Fischer
	Edinburgh	Graeme Murray
	Zurich	Konrad Fischer
	London	Anthony d'Offay
	Toronto	David Bellman
	Bordeaux	CAPC Musée d'art contemporain
1982	Amsterdam	Art and Project
	Paris	Yvon Lambert
	Los Angeles	Flow Ace Gallery
	New York	Sperone Westwater Fischer
	Ottawa	National Gallery of Canada
1983	Toronto	David Bellman
	Bristol	Arnolfini
	London	Anthony d'Offay
	Turin	Antonio Tucci Russo
	Tokyo	Art Agency Tokyo
	Tokyo	Century Cultural Center
	Düsseldorf	Konrad Fischer
1984	London	Coracle Press
	Naples	Lucio Amelio
	Paris	Galerie Crousel-Hussenot
	Athens	Jean Bernier
	New York	Sperone Westwater
	Dallas	Dallas Museum of Art
	Kilkenny	The Butler Gallery, Kilkenny Castle
	Londonderry	Orchard Gallery
	London	Anthony d'Offay
	Düsseldorf	Konrad Fischer
1985	Basel	Galerie Buchmann
	London	Anthony d'Offay
	Kendal	Abbot Hall
	Malmö	Malmö Konsthall
	Milan	Padiglione d'Arte Contemporanea
1986	Madrid	Palacio de Cristal
	Paris	Galerie Crousel-Hussenot
	New York	Solomon R. Guggenheim Museum

Publications by the artist

RICHARD LONG SKULPTUREN, Städtisches Museum, Mönchengladbach 1970
FROM ALONG A RIVERBANK, Art and Project, Amsterdam 1971
TWO SHEEPDOGS CROSS IN AND OUT OF THE PASSING SHADOWS THE CLOUDS DRIFT OVER THE HILL WITH A STORM, Lisson Publications, London 1971
SOUTH AMERICA, Konrad Fischer, Düsseldorf 1972
FROM AROUND A LAKE, Art and Project, Amsterdam 1973
JOHN BARLEYCORN, Stedelijk Museum, Amsterdam 1973
INCA ROCK CAMPFIRE ASH, Scottish National Gallery of Modern Art, Edinburgh 1974
THE NORTH WOODS, Whitechapel Art Gallery, London 1977
A HUNDRED STONES, Kunsthalle, Bern 1977
A STRAIGHT HUNDRED MILE WALK IN AUSTRALIA, John Kaldor, Project 6, Sydney 1977
RIVERS AND STONES, Newlyn Art Gallery, Cornwall 1978
RIVER AVON BOOK, Anthony d'Offay, London 1979
RICHARD LONG, Stedelijk van Abbemuseum, Eindhoven 1979
AGGIE WESTON'S No 16, Coracle Press, London 1979
A WALK PAST STANDING STONES, Anthony d'Offay 1980
FIVE, SIX, PICK UP STICKS, Anthony d'Offay 1980

TWELVE WORKS 1979-1981, Anthony d'Offay 1981
RICHARD LONG BORDEAUX 1981, CAPC Musée d'art contemporain, Bordeaux 1981
MEXICO 1979, Stedelijk van Abbemuseum, Eindhoven 1982
SELECTED WORKS OEUVRES CHOISIES 1979-1982, National Gallery of Canada, Ottawa 1982
TOUCHSTONES, Arnolfini, Bristol 1983
COUNTLESS STONES, Richard Long, Stedelijk van Abbemuseum Eindhoven and Openbaar Kunstbezit 1983
FANGO PIETRE LEGNI, Galleria Tucci Russo, Turin 1983
PLANES OF VISION, Ottenhausen Verlag, Aachen 1983
SIXTEEN WORKS, Anthony d'Offay Gallery, London 1984
MUD HAND PRINTS, Coracle Press, London 1984
RIVER AVON MUD WORKS, Orchard Gallery, Londonderry 1984
POSTCARDS 1968-1982, CAPC Musée d'art contemporain de Bordeaux 1984
RICHARD LONG, Century Cultural Foundation, Tokyo 1984
RICHARD LONG, Fonds Régional d'Art contemporain Aquitaine 1985
MUDDY WATER FALLS, MW Press, Noordwijk 1985
IL LUOGO BUONO, Padiglione d'Arte Contemporanea, Milan 1985
PIEDRAS, Ministerio de Cultura, Madrid 1986

Index of Works

Compiled by Judy Adam, Anthony d'Offay Ltd

Sizes of the works are unspecified unless stated in the title or given in the index. The sizes are in centimetres, height preceding width.
 Photography is by Richard Long unless otherwise stated.
 For the purpose of this book only, some works have been edited or appear in a slightly different form. The information in this index refers to the work as it was made. 'Public Freehold' signifies a work independent of ownership. If recorded by a photograph, it may or may not exist as a framed work, it may be recorded by more than one view, the size may vary, it may exist as more than one print, but never as an edition. All other photographic works are made as unique, framed, black and white prints. Framed works consist of one panel unless otherwise stated, and all sizes include the frame.

 Where a work is identified in the text by a place-name rather than a title (e.g. stone line on Cul Mór, p. 135), a cross-reference may be found under the location. Page numbers in *italic* refer to illustrations; those in roman type refer to mentions in the text.

LIBRARY
ST. LOUIS COMMUNITY COLLEGE
AT FLORISSANT VALLEY